PRETTY CITY NEW YORK

DISCOVERING NEW YORK'S BEAUTIFUL PLACES

SIOBHAN FERGUSON

The
History
Press

Cover images by Siobhan Ferguson except:
Back cover, top left: @mangelka
Back cover, top far right: @chloejg
Back cover, bottom far left: @diannnneee
Back cover, bottom middle: @heydavina

@theprettycities, @prettycitiesnewyork and all other contributing
Instagram accounts are operated independently and are not
affiliated with, endorsed or sponsored by Instagram LLC.

First published 2019

The History Press
97 St George's Place,
Cheltenham GL50 3QB
www.thehistorypress.co.uk

British Library Cataloguing in Publication Data.
A catalogue record for this book is available from the British Library.

ISBN 978 0 7509 9070 7

Design by Katie Beard
Printed in Turkey by Imak

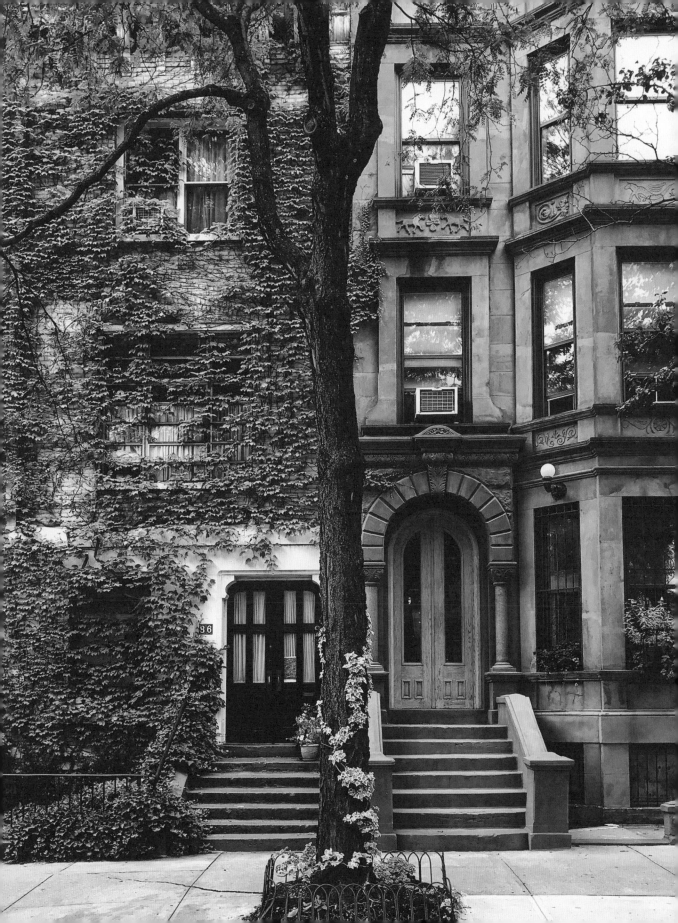

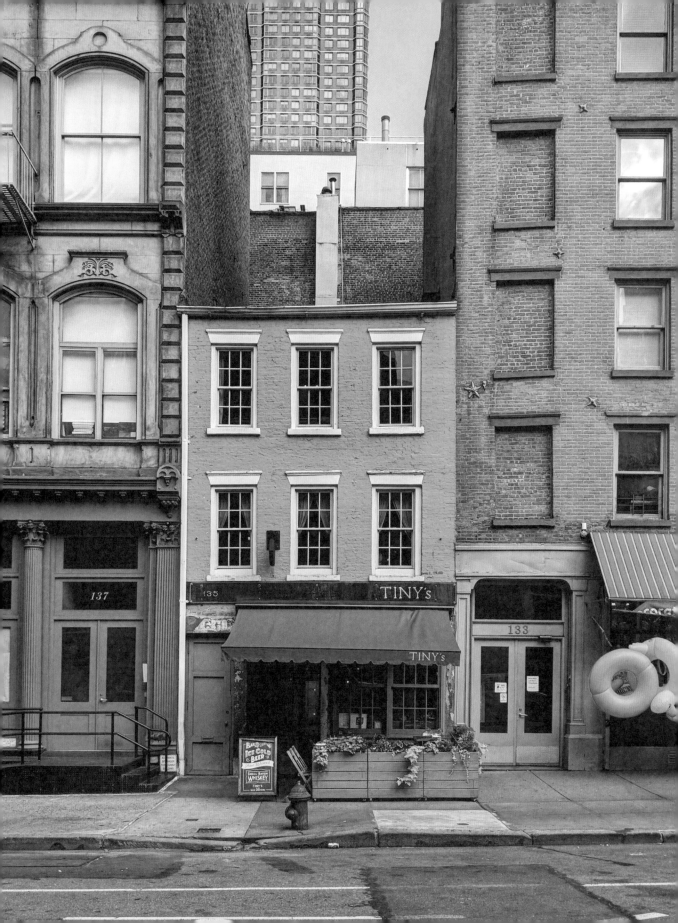

CONTENTS

INTRODUCTION

There's something in New York's air that makes sleep useless, perhaps it is because your heart beats more quickly here than elsewhere.

Simone de Beauvoir

New York is a wonderful city, bustling, multi-layered, vibrant and extremely hectic, the capital of creativity; home to gigantic skyscrapers, steamy manholes, yellow cabs, bagels and lox, rooftop bars and chic boutiques. A city where dreams come true and hearts are broken – 'if you can make it here you'll make it anywhere'. A city that, visited even for the first time, feels extremely familiar, thanks to the hundreds of movies set there. A city unable to sprawl, confined by two beautiful rivers, so instead moves upwards.

When I thought about dedicating my second book in the 'Pretty City' series to New York, I must admit I hesitated. Could this city with its fast pace and dense population meet my Pretty City criteria? My hesitation faded when I thought about the charming enclaves of the city: a city rich in history and ever-changing, a city that I enjoy exploring with friends and by myself in equal measure. I recalled my second-ever trip here, with the pressure off (I had ticked off the main attractions on the first), I was able to slow down and explore the 'off the beaten path' aspects to the city, and found calm oases in the strangest places, artisan cafes, centuries-old bakeries, and independent shops everywhere I turned. I loved exploring at my leisure, slowly, and getting to chat to the locals – locals so proud of their city and happy to share their own tales and tips on where to go. I loved the unanticipated moments I experienced: a group of friends gathered in Washington Square Park, a knowledgeable manager at Le Coucou happy to share his insider knowledge on his local neighborhood of Williamsburg, stumbling upon a fashion photo shoot down Freeman Alley, a chat with the owner of a beautiful Soho gallery, getting lost in the off-grid streets of the Village.

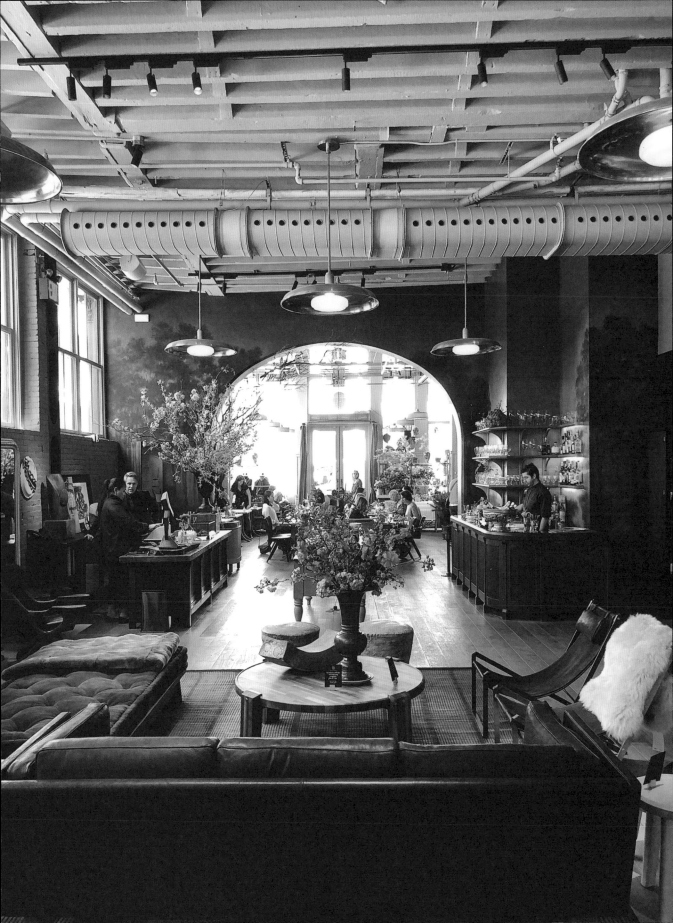

The more I thought about it, the more I realized that this city and its wonderful nuances more than deserved to be the focus of my book. Consequently, I kicked off a series of trips to New York armed with an energy to tackle the bustle to find the charm, tips from local friends, several guidebooks, online research and my own curiosity to explore. I walked every inch of the city with fresh eyes and a huge passion to find the most charming places to share with you. While I feel I didn't really scratch the surface and believe my research might in fact warrant several volumes, I am thrilled to share my findings here. This book also aims to complement the Instagram feeds @prettycitiesnewyork and @theprettycities, and is a celebration of the beautiful places I discovered all over New York. It features a bucket list of itineraries and some helpful tips on how to capture and create your very own postcards of Pretty City New York. It contains many images kindly submitted by local photographers, as well as my own images.

It is about the pretty, it is about the charm, but most of all it is about a New York that is there for all to enjoy. There are no exclusive clubs; sure, it includes some of the most expensive neighborhoods in the world, but it is to inspire you to explore and enjoy these without breaking the bank.

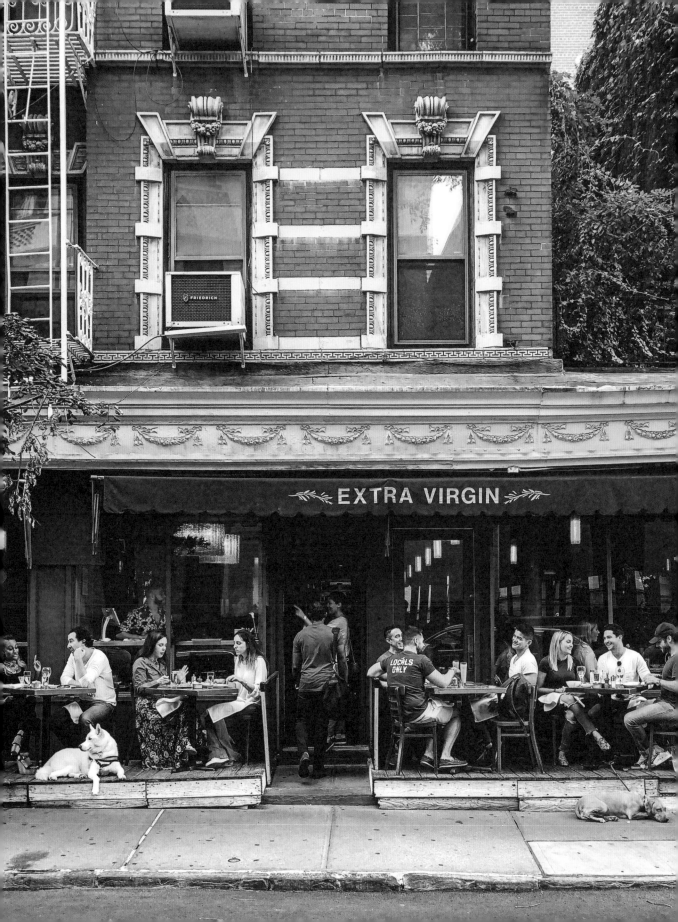

HOW TO USE THIS BOOK

The book is for the most part a visual celebration of the most beautiful places in New York. It includes four key sections: photography tips, neighborhoods, through the seasons, and, finally, a bucket list of things to do in Pretty City New York.

The book is intended to complement the popular Instagram feeds @prettycitiesnewyork and @theprettycities, so will include many references to the social app throughout. Despite this, it is hoped that, given its visually beautiful content, it can equally be enjoyed by those of you not familiar with Instagram. It also hopes to inspire anyone either traveling to New York or locals looking for spare-time travel inspiration.

The photography tips section includes helpful advice written by Mendy Waits on how to take beautiful captures to share with @prettycitiesnewyork and @theprettycities.

The neighborhoods section, as the name suggests, is arranged by the areas of the city that truly represent the Pretty City aesthetic and charm. Some areas are grouped together in one section, as to explore them together makes logistical sense and they have features that complement each other. This section also features a variety of locations worth visiting that are easy to capture, from shops to cafes, galleries to parks. Some areas contain a sample guided walk whereas others simply list the streets to visit.

'Through the seasons' is a short section celebrating the changing seasons in Pretty City New York, and finally the bucket list section is a beautifully curated list of ideas of things to do in the city to truly experience the essence of Pretty City New York. Some of the bucket list items have been suggested by local photographers.

The maps at the beginning of each section, illustrated by Holly Webber, are an indication of what to expect in the area rather than being to scale.

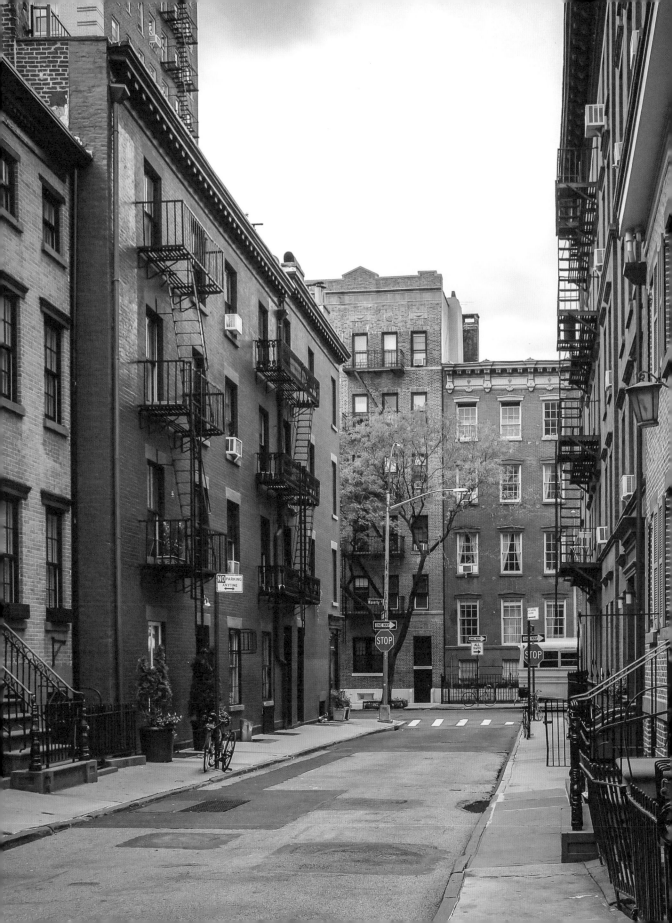

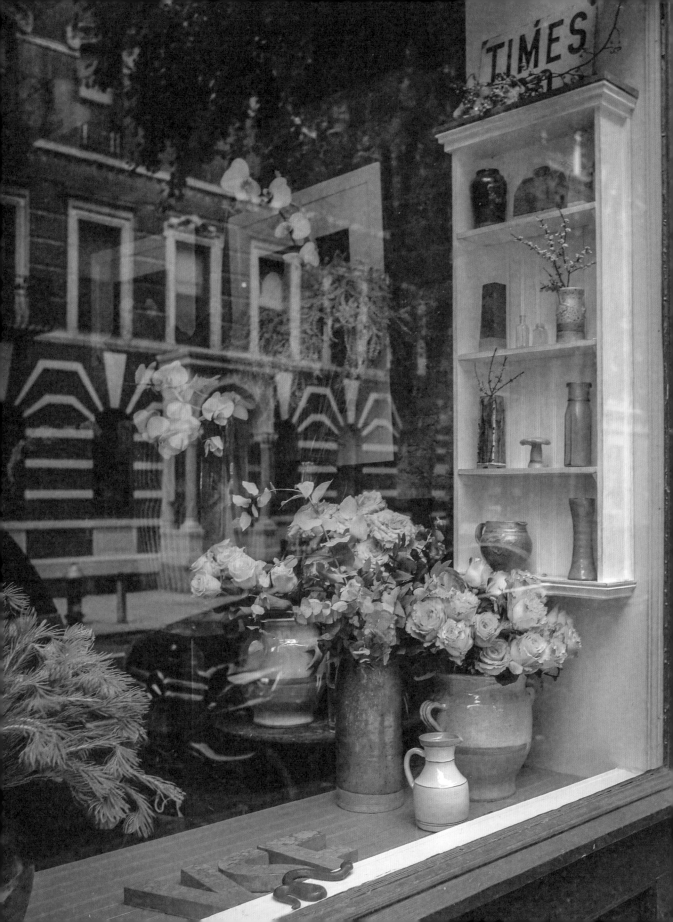

PART I

PHOTOGRAPHY TIPS

The @prettycitiesnewyork Instagram feed is full to the brim with beautifully captured images of New York, all with a similar aesthetic and vibe. The feed is curated by talented photographer and urban explorer Mendy Waits (@angrybaker) and is primarily focused on the city's unique and characterful neighborhoods, their intricacies, residents and visitors. Some of the historic landmarks feature, but in truth not too often. Perfect façades, pretty street scenes, a charming shopfront, cafe, boutique or bookstore all play a key role in the Pretty City story. New York's architecture, cobblestoned streets and quiet places are celebrated, and rightly so.

You will be pleased and perhaps surprised to learn that most of the shots shared on @prettycitiesnewyork are actually smartphone shots. Most people carry one all the time, so rarely miss a photo opportunity, and, best of all, it's discreet. That said, New York can be a tricky city to capture, so I asked Mendy for some expert tips for making the most of mobile photography in the city. Read on to learn what she has to say about capturing New York with a smartphone ...

Most of us don't travel with professional cameras, so chances are we're going to be taking photos to remember our visit with the handy phone in our pocket. I've been using my smartphone camera almost exclusively for seven years and they are extremely convenient to use while traveling (and bonus: it is much less conspicuous than a DSLR). It's an amazing tool, and I've learned a lot about what works with mobile photography and what doesn't. There are a few things to keep in mind while you're wandering New York City that will significantly improve the quality of your photos. The most important thing is your mindset: treat your phone like a proper camera and be thoughtful when you use it.

When in NYC, you will do a lot of walking. And then you'll do more walking after that! I find walking is not only the best vantage point, but also a great excuse to eat all of the wonderful food you're bound to consume. There is so much to see that you will miss if you're in a cab or underground. Sure, there are skyscrapers that offer expansive views of the concrete jungle, but on the street is where you will experience the atmosphere and vibe of each

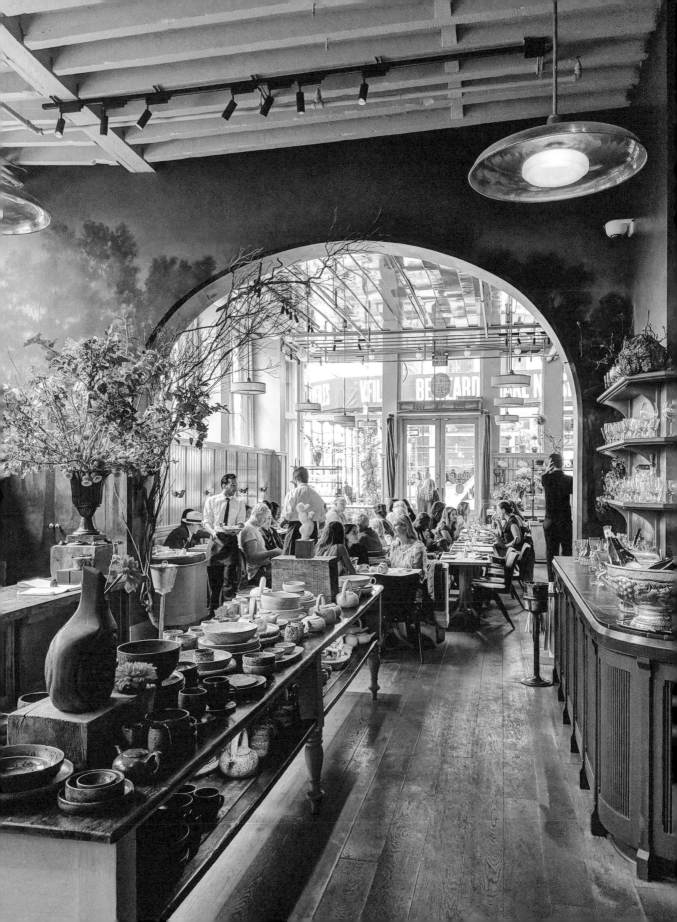

of the neighborhoods. And in these neighborhoods is where you're going to find the local side of life. I know 'local' has become a buzzword for modern living, but it has always been the foundation of interesting and engaging photography. The what/where/why of how people live is fascinating and memorable stuff.

ARCHITECTURE TIPS

There are amazing buildings everywhere, whether it's the cobblestoned old-world New York of Stone Street, the grandeur of the Rose Reading Room in the New York Public Library, the modern sleekness of the Oculus, the gleaming art deco Chrysler building, or the Minton tile ceiling in the arcade of Bethesda Terrace in Central Park – you will want to take photos, and your smartphone has a wide focal length making it an excellent choice to capture the scale of architectural gems scattered across the city.

First things first – try to reduce any camera shake and be as still as possible. Easier said than done for many people! Camera shake is what leads to fuzzy or out of focus pictures, so I often try to find something to rest or lean my camera against as a makeshift tripod, because – let's be honest – none of us wants to spend the time or energy carrying one of those around. There are so many things on the street that can help: lampposts, public mailboxes, bike racks, cafe chairs, railings, or the wall of another building. It creates a nice crisp photo when you can steady your smartphone, and it also helps with perspective, keeping your phone more aligned than it would be in only your hands. If I can't find anything nearby, I will anchor my arms at my side, and tuck my elbows right next to my torso to minimize hand shaking. Admittedly, it looks a bit weird, but it gets the job done.

Secondly, use the grid in your photography app! The grid lines are very helpful as you prepare for your shot and can save you from glaring perspective distortion (when it looks like a building is leaning away from you). We tend to tilt our phones when taking photos and the grid visually assists you while you line up the horizontal (for example, the roof of a building) and vertical (columns, walls, doors), allowing you to capture the image straight on. I usually take a few steps back before I take photos of a

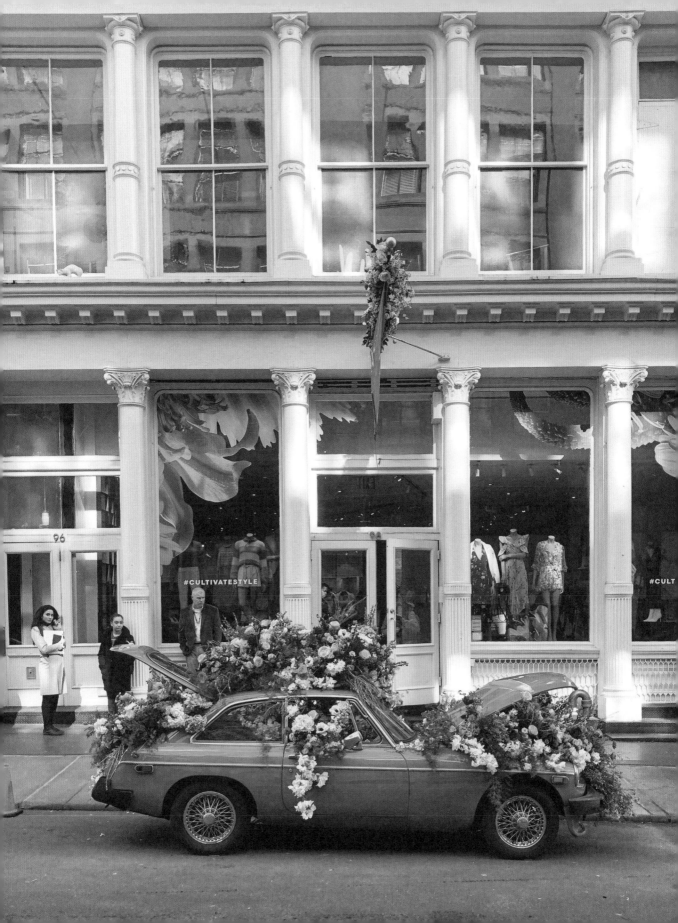

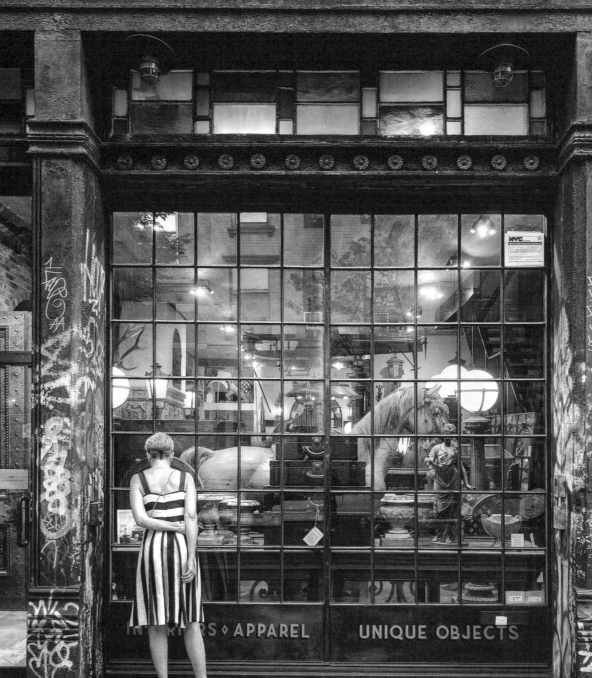

façade, so there will be some extra space in the frame to work with when I edit the photos and correct for perspective. This is a simplified explanation of a technical aspect of photography that many people don't give much thought, but it drastically improves the look of architecture in your images.

TIMING AND TROUBLESHOOTING

Capturing a scene at just the right moment is personally and visually satisfying. The blur of a yellow cab adds that classic NYC feel to your photo. So, think about your timing. Take several photos of the street at different intervals, depending on the result you want. I like photos without a lot of people or traffic, so I do a lot of waiting. I'll wait twenty minutes, taking photos in the breaks in traffic or pedestrians.

Sadly, there's not much luck involved with empty shots. A photo without people or cars in a bustling city takes patience, early alarms, and creative angles. When traveling, I get out around sunrise to take street shots before the city wakes up. I eat at off times to get an emptier restaurant shot, or plan to be there a few minutes before it opens (particularly on weekdays). I go to coffee shops after 2 p.m. If the street is lined with parked cars, I'll stand between them to take a photo of a façade from different angles or, if it's a small car blocking my frame, I'll stand in the street and raise my hands over the top of it to get the photo. In busy cafes, I'll find that one corner where there are not rows of people glued to their laptops.

There are obviously situations where you cannot avoid a crowd, or you simply prefer the reality of the space. This becomes all about composition, placement, and multiple captures. Again, taking photos at different intervals is going to afford you more options for your personal preference. My usual approach is to center someone or something in the middle of the chaos. I find identifying what you want the viewer to look at first in your photo helps you compose and find your focus. For example, I love to photograph the Rose Room at the New York Public Library because its scale and symmetry are impressive and incredibly beautiful. It is a public space and the many people using it for research and studying are integral to the image and atmosphere. I try to showcase the symmetry of the room

and visual look by waiting for a time when everyone is seated. I don't want a person walking down the center of the aisle to become the focus of my image, so I will sit near the spot where I want to take photos and then watch the flow of people coming in and out. When there is a natural break in the flow and everyone is seated, I'll hop up and take some photos. And then I'll wait again for another break because that will give me several photo options of people placement.

If you want to include the individual and smaller details of the places you are photographing, I would recommend using the 'portrait mode' that is now available on many smartphones. Basically, this mode artificially creates the bokeh effect (where the subject is in focus and the background falls out of focus) we associate with professional cameras. When the background is blurry, your eyes are naturally drawn to the in-focus subject, making it stand out. It works well most of the time and can really make an image pop if done well. Play around and experiment with it in good natural light. I think you will find it's kind of fun and useful!

STREET PHOTO ETIQUETTE AND SAFETY

I'm sure this won't come as much of a shock, but NYC is a very busy city and you can run into some hazards (or become one) if you are not looking where you're going and distracted by your phone viewfinder. No one wants to walk behind someone stopping every few minutes to take a photo! Be considerate – move to the side of the sidewalk, mind the flow of pedestrian traffic, and always be careful when stepping into the street. If there are no cars, there might be cyclists or scooters in a matter of seconds. If you're traveling with another person, ask them to keep an eye out for you. Photography is generally allowed in most shops and restaurants, but it's always polite to ask if you're unsure. I think you'll find that New Yorkers are much more friendly than you've been told.

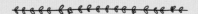

CHASE THE LIGHT

No matter the type of photography, light is essential to any great photo and natural lighting is simply the best. The iPhone can capture brilliant photos with ample light. I prefer to shoot on overcast days, or otherwise during golden hour, i.e. early in the day or later in the evening. New York gets plenty of sunshine and the days it arrives in all its glory are the hardest days to shoot in. If there is no cloud cover, seek out the shade and get the indoor shots out of the way in the middle of the day when the light's at its harshest. In a nutshell, you should try to find soft, natural light, as it will make a significant difference to the result. If you are trying to capture a coffee or pretty breakfast scene, and have to do so indoors, seek the table near the window and get snapping. Although, it must be said, it's best to avoid direct sunlight through the windows, as that will give you the same problems as shooting in direct sun outside. Instead, seek that soft overcast light. Train your eye to find it; trust me, once you do you will never look at clouds in the same way again.

HAVE YOUR CAMERA OR SMARTPHONE READY AT ALL TIMES

New York really is a photographer's dream and there is always something special to capture. When I go to a particular area to shoot, I like to seek an individual who epitomizes the style of the area – be it a quirky fashionista walking down Green Street or a hipster in Williamsburg. I am forever on the lookout.

I love the capture of a beautiful West Village façade on the next page. The tone and color palette is perfect for @prettycitiesnewyork. The inclusion of the walking people in the frame adds an extra layer to the composition; true, the façade alone would have been beautiful, but by including people the photograph has a little more depth.

CHECK FOR THE DETAILS

The characterful neighborhoods of New York have stunning details in abundance, be it a leafy façade, a coffee scene, a group of friends gathered to dine al fresco on a summer's evening, that charming boutique or tranquil Central Park scene – they all need to be captured. Take your time, compose yourself and think about the story you want to tell through your image. If you have found the perfect façade you want to capture but would like to include a person, be patient and wait for the right one to enter the frame. New York is full of quirky residents so you won't have to wait too long. Look at the entire frame through your viewfinder and try to eliminate obstructive subjects. Think about color as well. I like the softer tones to fill the feed and complement the current season, for example Central Park really pops in the fall. Winter, and especially Christmas time, is the Upper East Side's finest season. Some areas are beautiful all year round.

Perspective plays a vital role in capturing any city. Try to find a unique angle. Get creative with the parked cars, unless of course it's a nice vintage model. Instagram prefers straight-on shots for façades and shopfronts, and top-down shots for food and coffee scenes.

EDITING

The vast majority of images shared on my Instagram feeds have probably gone through some form of editing. While we all do it differently, it's important to find your signature style. Less is often, or indeed always, more. My favorite smartphone apps for editing are Lightroom and VSCO (A6 or A5). Lightroom is fantastic for correcting light, color balance and perspective, and VSCO is used to enhance the tone and give it that final pop at the end of the process. Both are available for mobile. I don't follow a strict go-to editing process but I do always play with a couple of basics in most of my captures. I like my Instagram images to be bright, crisp and clean, so I tend to pump up brightness, add a little contrast, play with the highlights and shadows, and add a little sharpening sparingly. I typically add a small amount of VSCO Cam filter (A5/A6) at the end.

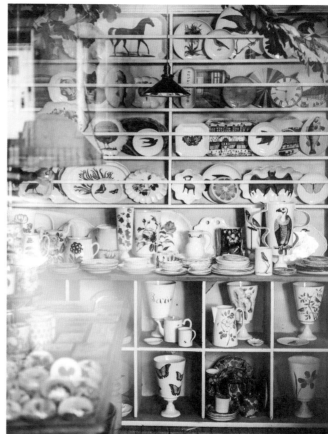

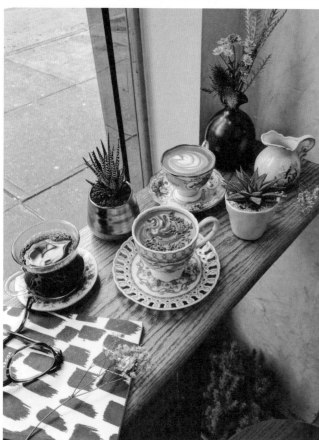

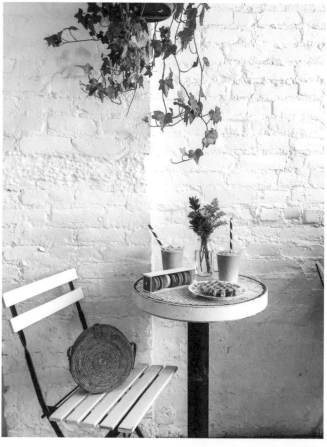

SHARING ON INSTAGRAM

So you have been using Instagram for a while now and have figured out how it works, and wish now to up your game a little and increase your following. Here are a few quick tips to make a difference:

- Think of Instagram as your portfolio, your way of letting potential clients see your work. A rule of thumb is not to overshare. Post regularly but don't overdo it; once a day seems to work well on most accounts.

- Try to develop a cohesive style with your images. Unsure what that style is? Take a step back and analyze the photos you have taken and continue to take – do you see a pattern emerging? I am sure you will be surprised at how quickly you identify your own style. Settling on a theme or style can really help you beautify your feed.

- Plan your posts. There are many planning apps on the market; I use UNUM to strategically plan my posts and see how they balance with one another. I like the colors – and indeed themes – of my photos to complement one another.

- Use hashtags. Instagram hashtags are one of the best ways to grow your Instagram account. Using the right hashtag (or combination of hashtags) can help you expose your work to large and targeted audiences. In fact, your chances of attracting new followers, getting more likes, and increasing engagement are vastly increased by the use of hashtags. Popular and trending hashtags are a great way to develop your Instagram presence. Rather than use the common ones like #love or #cat, try something more relevant and meaningful.

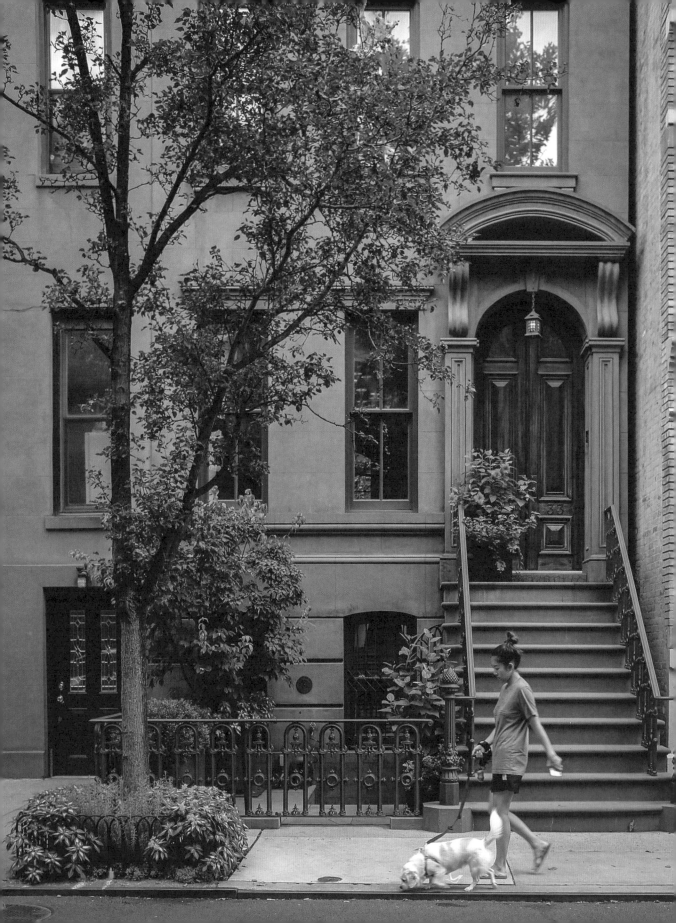

PART II

NEIGHBORHOODS

CHELSEA, MEATPACKING, AND GREENWICH VILLAGE

ARTSY ENCLAVES,
THE HIGH LINE,
AND VILLAGE CHARM

VILLAGES, CHELSEA
& MEATPACKING

#prettycitynewyork

 BILLY'S BAKERY 184 9th Ave
OLD ROSE 113 Jane St
THE SPOTTED PIG 314 West 11th St
EXTRA VIRGIN West 4th St

 631 Hudson St, Friends Apt.
90 Bedford St, 445 West 21st St,
415 West 23rd St, The High Line,
West 4th St

 WHITNEY MUSEUM
99 Gansevoort St

 THE WILD SON 53 Little West 12th St
SANT AMBROEUS 259 West 4th St

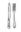 HIGH LINE HOTEL 180 10th Ave
SOHO HOUSE 29-35 9th Ave

 THE UPPER RUST 143 7th Ave
GREENWICH LETTERPRESS
15 Christopher St
PINK OLIVE 30 Charles St

PRETTY CITY

NEW YORK

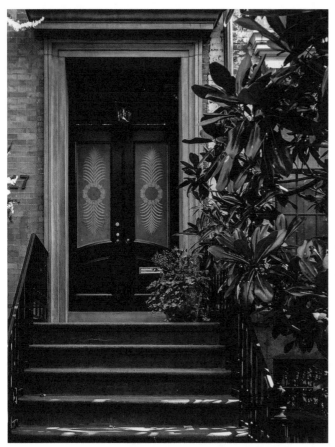

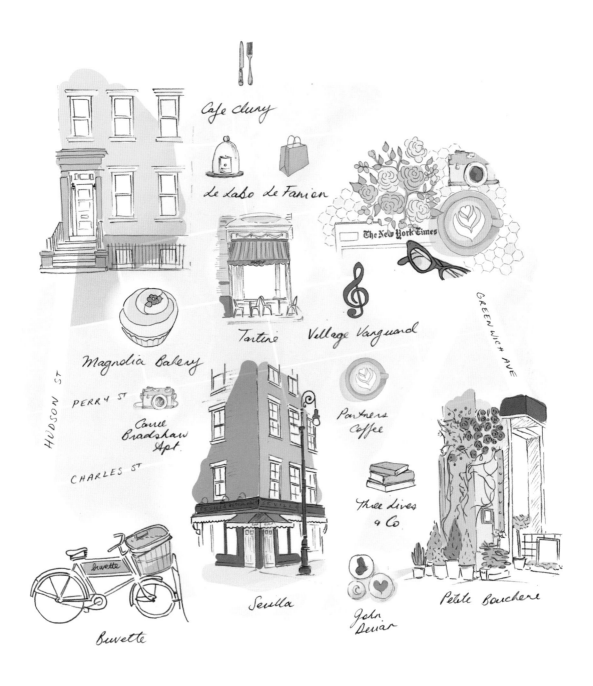

WEST VILLAGE

#prettycitynewyork

 TARTINE 253 West 11th St
SEVILLA 62 Charles St
BUVETTE 42 Grove St
CAFE CLUNY 284 West 12th St
PETITE BOUCHERIE 14 Christopher St

 PARTNERS COFFEE 44 Charles St
MAGNOLIA BAKERY 401 Bleeker St

Carrie Bradshaw Apartment 66 Perry St

JOHN DERIAN 18 Christopher St
LE LABO 296 West 4th St
LE FANION 299 West 4th St

THREE LIVES & CO 154 West 10th St

 PRETTY CITY
NEW YORK

CHELSEA AND THE MEATPACKING DISTRICT

Developed on former farmland, Chelsea really began to take shape in or around 1850, when most of it was owned by Clement Clarke Moore (the acclaimed writer best known for the story *'Twas the Night Before Christmas*). Following a gritty period, fashionable Chelsea emerged. When Macy's arrived at Herald Square, retail and garment districts popped up around it. Aside from the addition of gigantic apartment buildings and warehouses, there are many buildings in the eastern part of Chelsea that remain unchanged since Victorian times. Some of New York's finest art galleries emerged here in the 1990s, but the most notable highlight has been the development of the High Line.

Between Chelsea and the West Village is the 150-year-old Meatpacking district. This style-setting neighborhood overflows with fashionistas, drawn to its impressive establishments, including some of the trendiest places to shop and dine. The High Line – the new Manhattan landmark – and the Whitney Museum of American Art are its main draws.

INSTAGRAM HOTSPOTS

415 West 23rd Street: residential street, nice for a stroll
The High Line Hotel: 180 10th Avenue
Wild Son for pancakes – West 12th Street
Rooftop drinks at the **Standard**
The High Line
The Whitney Museum of American Art
Barneys of Chelsea

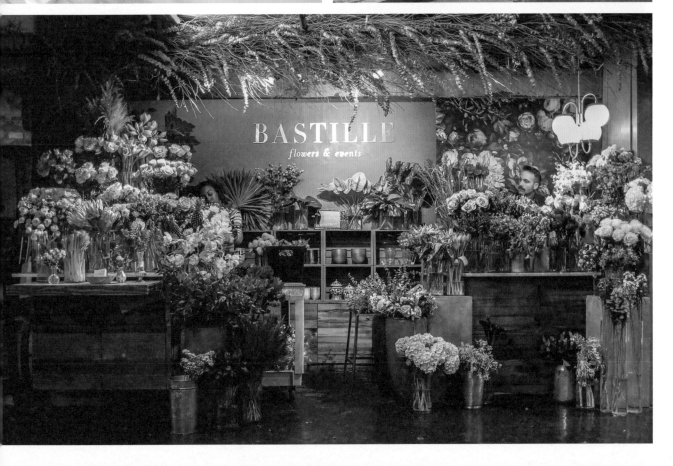

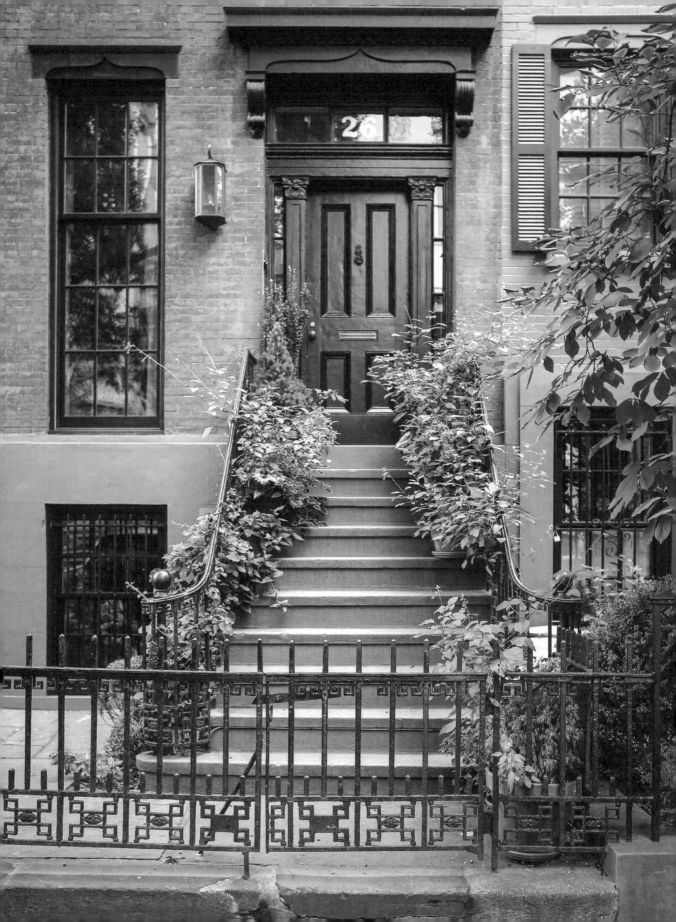

Suggested route:

Start with breakfast at Citizens of Chelsea, an Australian cafe best known for its selection of healthy small meals. Follow breakfast with a walk down 9th Avenue to West 23rd Street; this leafy street is simply beautiful all year round but, like so many others in this area, it truly pops in the fall with its foliage and pumpkin-adorned stoops. After a leisurely stroll along these residential streets, it might be an idea to explore one of Chelsea's many art galleries – most found between West 20th and West 26th. After a gallery visit head for a refuel at Intelligentsia. Nestled in the quirky lobby of the High Line Hotel, you will find this delicious cafe. Sip an espresso or enjoy matcha tea in one of its cozy nooks, or in warmer weather sit outside, where the coffee is served from a newly refurbished 1963 Citroën coffee truck.

Don't leave the area without a walk along the High Line – once an elevated railroad, now an urban sanctuary with amazing views. It was founded in 1999 by community residents who fought for its preservation at a time when it was under severe threat of demolition. The walkway features stunningly manicured plants, commissioned local artwork, and amazing views of the waterfront's high-end living, shopping and dining. The multiple entrances along the 1.4-mile stretch mean you can pop up and down when and as you like. The overlook at Gansevoort Street, 15th Street Bridge (offering great views of the 1930 sky bridge crossing West 15th Street), 10th Avenue and the final section along 12th Avenue are my favorite viewing points.

CHELSEA MARKET

Originally the Nabisco factory and the birthplace of the famed cookie Oreo in 1912, today the building is a bustling indoor food market-meets-shopping mall, with media offices in the mix too. It houses a large variety of specialty food shops selling dishes from around the world, overflowing with butchers, cheesemongers, florists, shops, and small-business vendors. I highly recommend a trip.

CHELSEA'S GALLERY SCENE

More prominent between 20th and 26th Street, stepping in and out of these galleries is a quintessential New York thing to do. The serene Rubin Museum of Art and Whitney Museum of American Art are among my favorites, but be sure to pick up a free guide at any gallery.

CHELSEA FLOWER DISTRICT

Follow the scent to find it between 28th Street and 6th and 7th Avenue. This stretch has been home to New York's floral wholesalers since the 1870s, with the vendors using the city sidewalks as an extension of their display spaces. If you are planning a visit be sure to get there early before the floral designers and party planners snag the best.

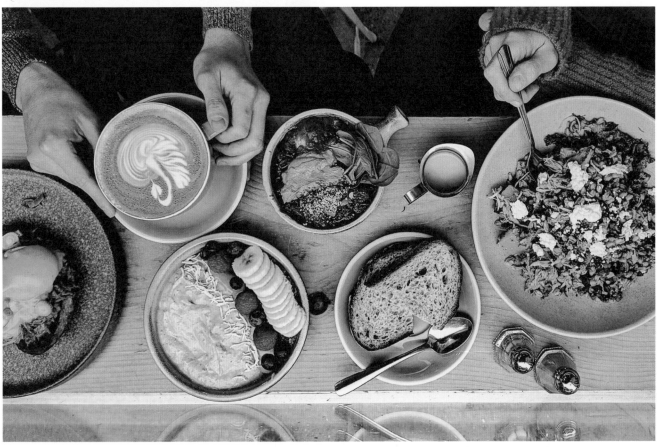

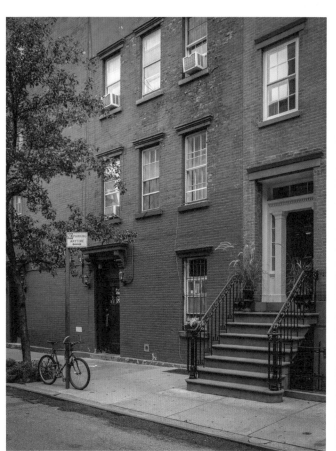

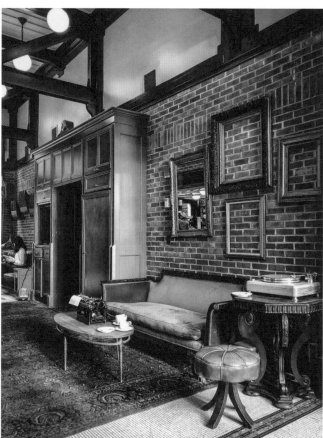

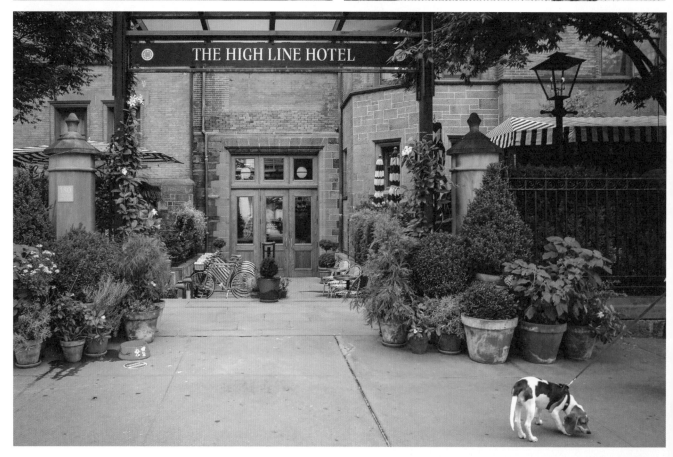

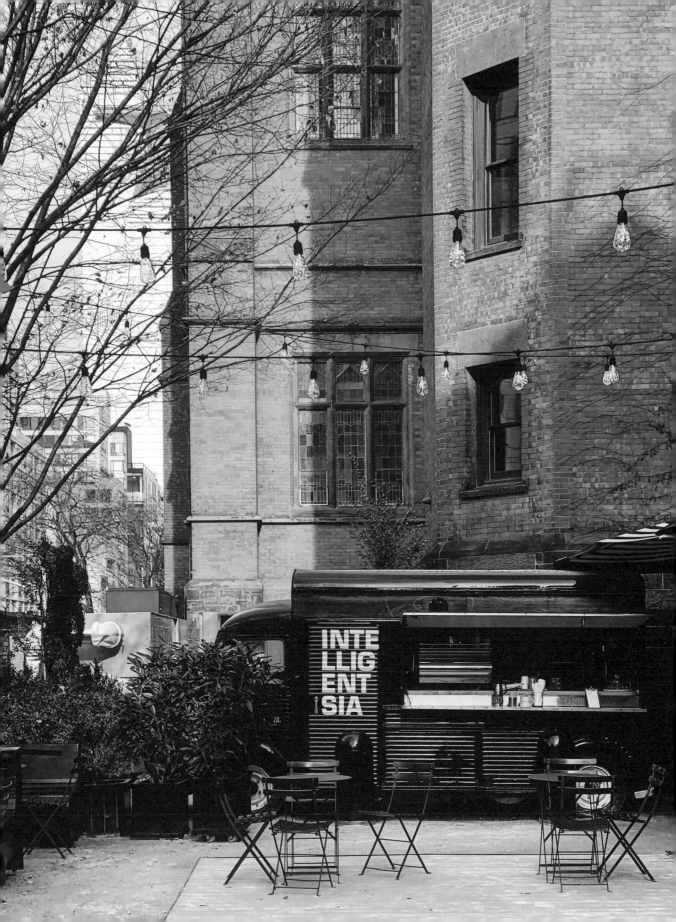

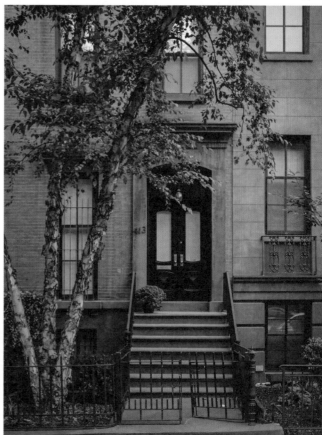
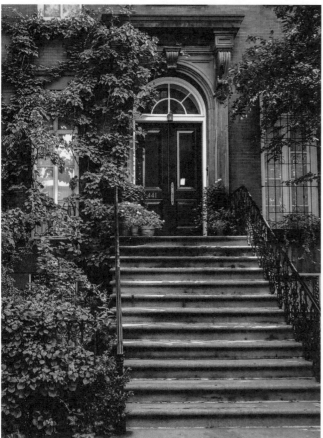
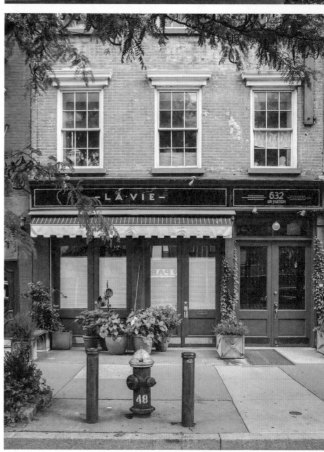

ARCHITECTURE TOURS FROM CHELSEA PIERS

Guided by members of the American Institute of Architects, the New York City architecture tour will take you in a 1920s-style yacht on a full circumnavigation of the island of Manhattan. During the two-and-a-half-hour cruise, you will explore recent and innovative national and international award-winning architects, skyscrapers, beautiful art deco and Beaux Arts icons, and waterfront parks. Light refreshments and complimentary champagne are included.

BARNEYS OF CHELSEA

The New York icon, which moved back to its original location in 2016, has a beautiful gallery-like vibe, befitting of the area.

BEST BARS

Pierre Loti: 258 West 15th Street: a warm and inviting wine bar
The Tippler: 425 West 15th Street: a rustic tavern with old rails from the High Line and vintage decor; go for the cocktails.
Gallow Green: 542 West 27th Street: rooftop bar at the McKittrick Hotel
Top of the Standard: 848 Washington Street, Standard Hotel: killer views over the Hudson River

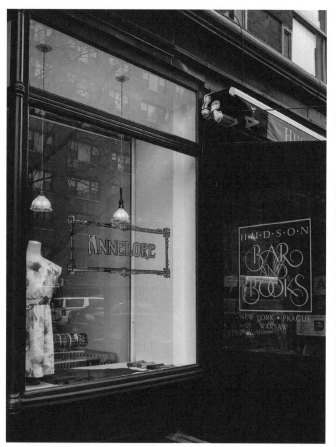
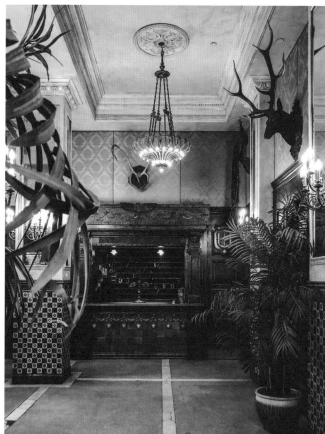

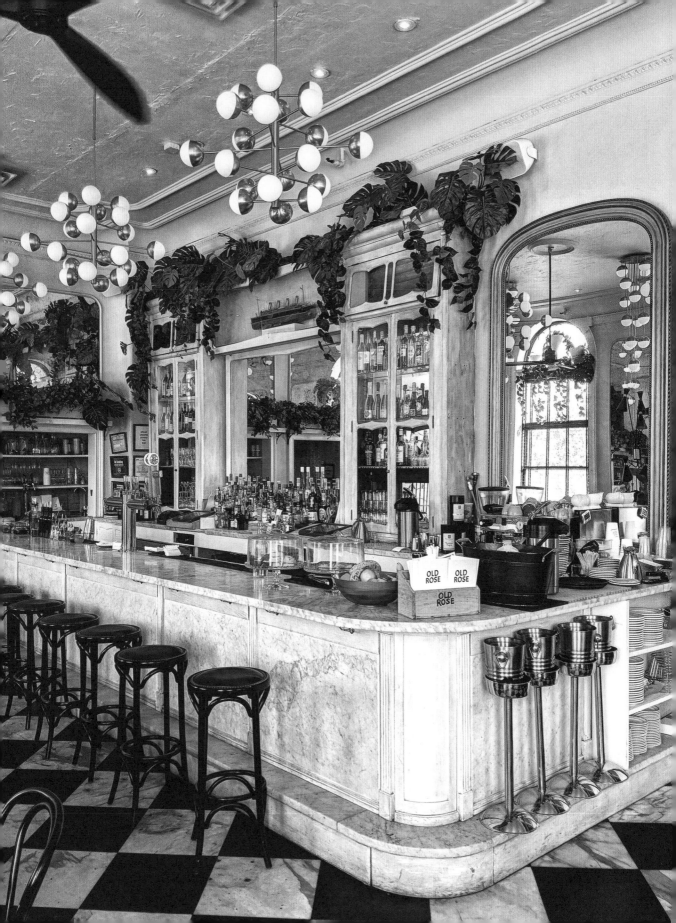

WEST VILLAGE AND GREENWICH VILLAGE ('THE VILLAGE')

Without doubt, New York's most beautiful neighborhood is the Village. The West Village is a neighborhood in the western section of the larger Greenwich Village. It is traditionally bounded by the Hudson River to the west, West 14th Street to the north, Greenwich Avenue to the east, and Houston Street to the south. Broadly, Greenwich Village is bounded by 14th Street to the north, Broadway to the east, Houston Street to the south, and the Hudson River to the west.

With its leafy façades, quaint off-grid streets, specialist shops, nineteenth-century townhouses, and stylish residents, it certainly feels like a real-life movie set. Much of its charm rests in its brownstones and cobbled streets, but this bijou enclave has been the site of many social movements, including the gay liberation movement and the Greenwich Village Society for Historic Preservation. In the twentieth century, Greenwich Village was known as an artists' haven, the bohemian capital, and the cradle of the modern LGBT movement. Greenwich Village is also home to Washington Square Park and New York University.

Unlike the rest of New York, the village layout follows its own rules, breaking from the grid structure of Uptown (north of 14th Street), resulting in smaller streets that run at a variety of angles. Its smaller winding streets, low Federal and Greek revival row houses, and artisan stores give the neighborhood a European feel. Visit here and you would almost believe that you have left New York entirely. Its off-grid structure makes it difficult to design a suggested route so instead just head for the area, take a stroll through, and get lost along its winding streets to discover its unrivaled charm.

HUDSON STREET

A main thoroughfare with plenty to see. I love the little stretch of shops around 630 Hudson, between Jane and Horatio Street; here you will find English purveyors Myers of Keswick, a traditional British food store selling pork pies, sausages, and other British delights. The charming Hudson Bar and Books, a dedicated cigar bar with traditional decor, and the consignment store La Vie, surrounded by landmarked townhouses and brownstones, make this cluster of shops a must visit.

WEST 12TH STREET

Don't miss a visit to Cafe Cluny (284 West 12th) – a cute French bistro great for brunch, lunch or dinner, and even better for people watching. Quaint and charming interiors complement its delicious food and friendly, casual service.

BLEECKER STREET

The five-block stretch in the West Village between Christopher and Bank Street was, until a year or so ago, like a mini Fifth Avenue, brimming with high-end names.

This once bohemian hotspot and then high-end fashion theme park hosted no fewer than six Marc Jacob stores; others included Brooks Brothers, Comptoir des Cotonniers, Mulberry, and Juicy Couture. These have now all closed and the once luxe stretch is starting to return to its former glory. Instead of out-of-reach, high-end stores, this charming street is now home to many digital native brands like Margaux, Buck Mason,

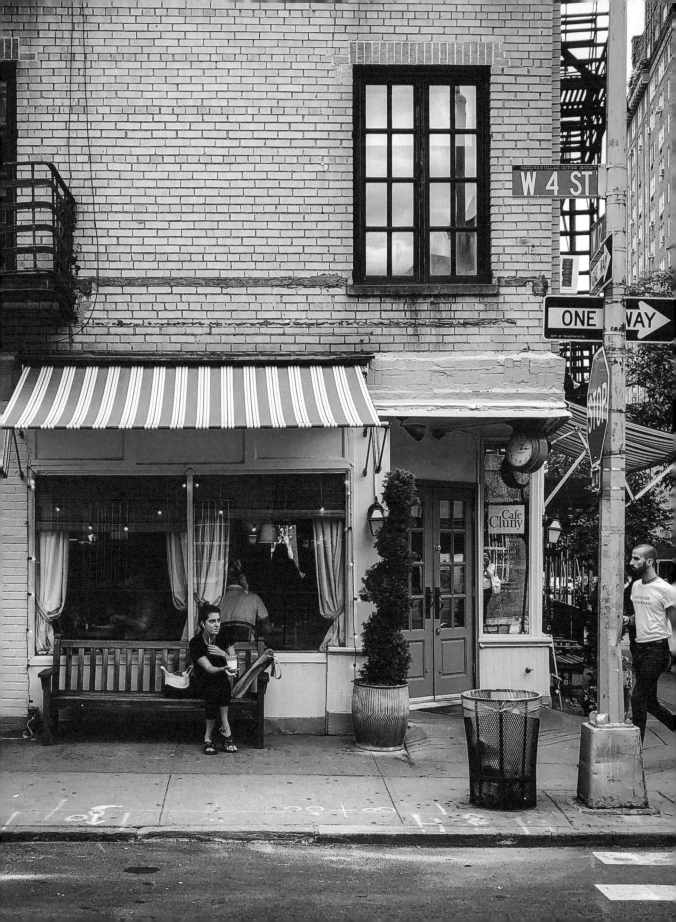

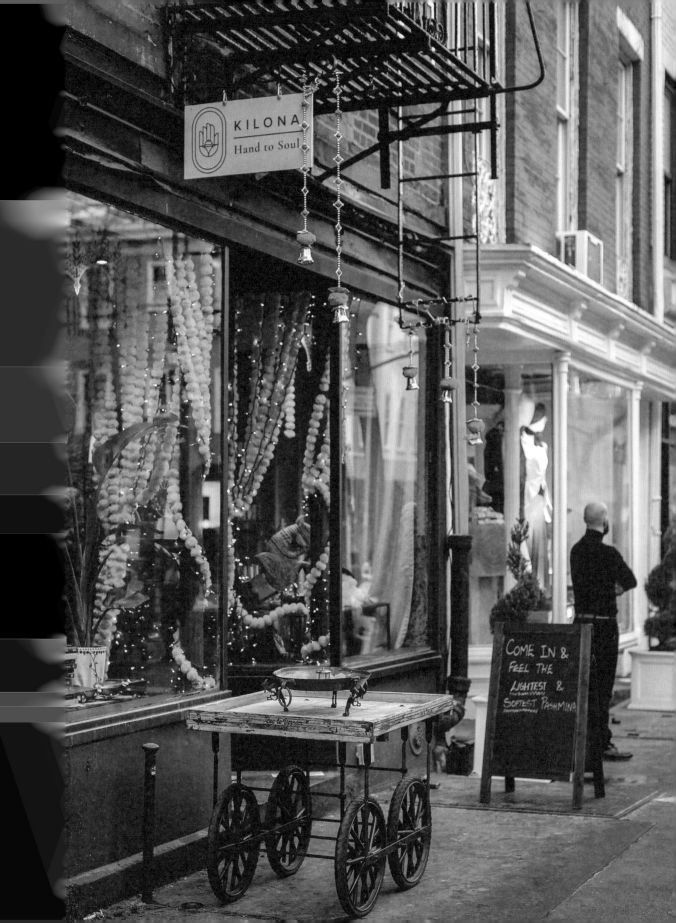

and Slightly Alabama. Hill House Home lies at number 395 and stocks its signature embroidered pillows, as well as a beautiful bath line. You will also find other beautiful gems like Marc Jacob's Bookmarc, ballet slipper label Margaux, and St. Frank.

This quaint stretch is also home to *Sex and the City* favorite Magnolia Bakery. The cupcakes, under 1950s bell jars in the window of this old-fashioned bakeshop, are what people travel all over town for, even if these days you will find outposts dotted around the city. You can opt to take them away in boxes or find a bench outside and enjoy them in all their sugary glory.

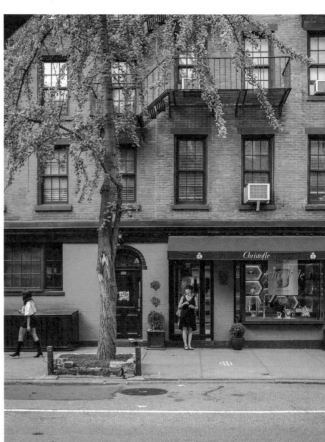

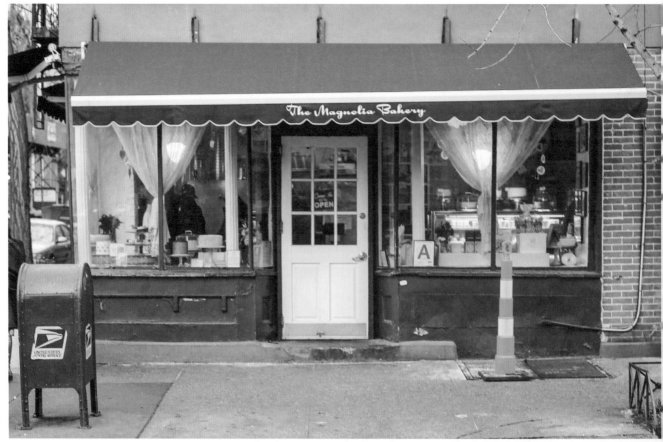

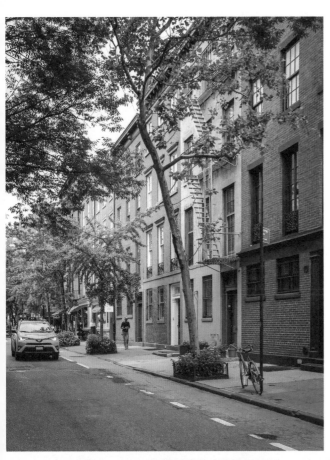

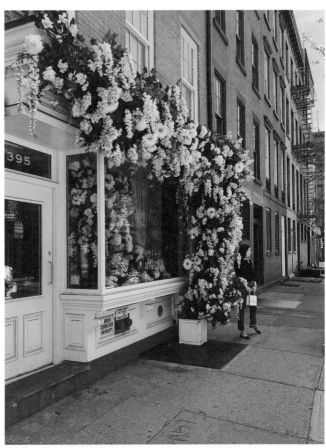

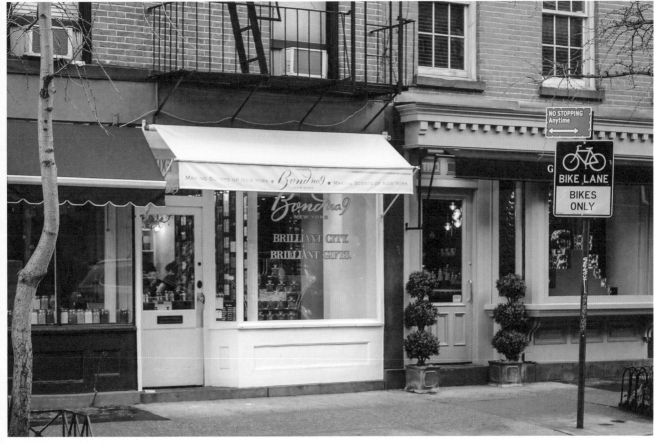

PERRY STREET

At 66 Perry Street, you will find the famed fictional home of Carrie Bradshaw from *Sex and the City*. You should find it immediately as the sidewalk around it is likely to be packed with tourists.

WEST 4TH STREET

For me, this street is quintessential West Village and I recommend setting aside an hour or five to enjoy its many wonderful gems. My favorites include:

Le Fanion – 299 West 4th Street: for beautiful handmade Paysanne pottery.
Sant Ambroeus – corner of Perry and West 4th Street: this intimate Italian restaurant is cozy and atmospheric all year round. I especially love it in warmer months when it is just wonderful to sit outside.
Extra Virgin – 259 West 4th Street: perfect for a date or catch-up with friends. A local's favorite.
Le Labo – corner of Bank Street: a beautiful perfumery specializing in candles and bespoke fragrances. Worth a visit for the interiors alone, but there is a lot more to see and enjoy besides. Launched in 2006 from its humble flagship on Elizabeth Street, Le Labo has today established itself as a wonderful artisanal brand.

7TH AVENUE SOUTH

The Upper Rust – 143 7th Avenue South: a beautiful antique store with gems literally spilling out of its rustic doors.
Baby Brasa – 173 7th Avenue South: a Peruvian restaurant best known for its organic rotisserie chicken; the cocktails are worth a try too.
Village Vanguard – 178 7th Avenue South: jazz and cocktails see no limits here.

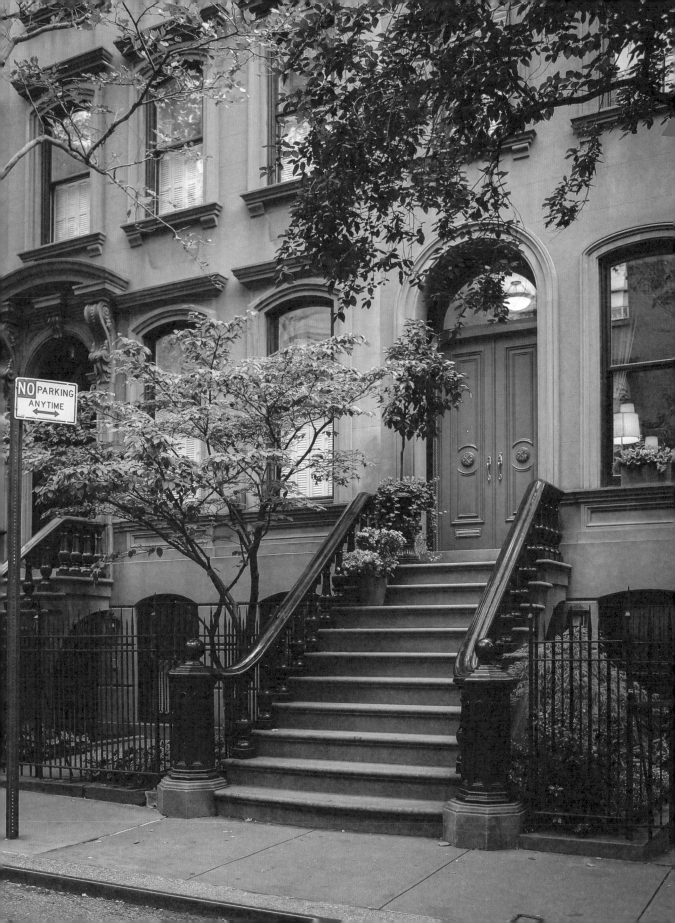

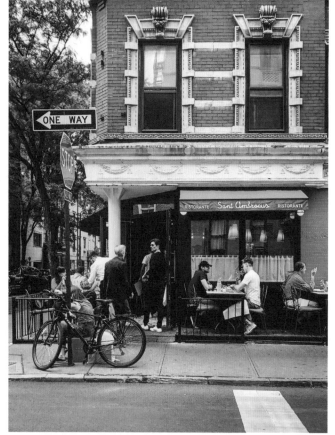

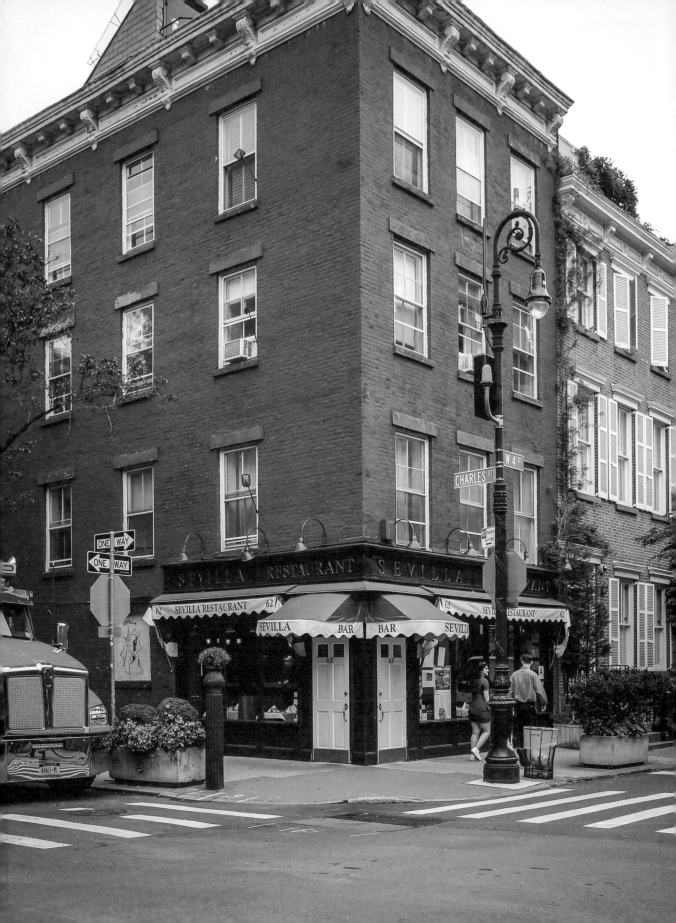

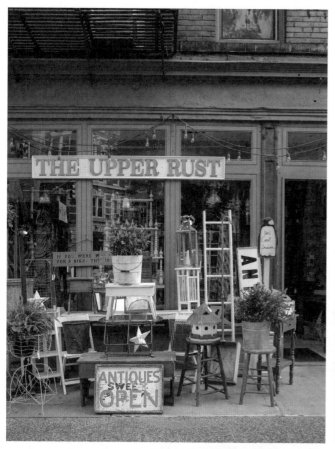

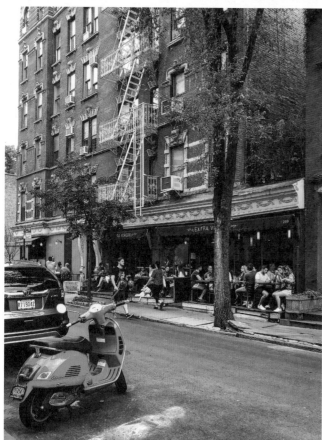

CHRISTOPHER STREET

John Derian recently opened here at number 18, housed in an early nineteenth-century Federal-style building. Going inside is like stepping into a whimsical fantasyland. Derian's magpie taste means he has gathered together an eclectic assortment of old images, decoupage dishes, paperweights, and a beautiful soft furnishings range. The beautiful old-worldly charm of the building provides the perfect backdrop to his style; he has also collaborated with my favorite, Astier de Villatte, to produce a beautiful range of ceramics, all of which are displayed on custom shelving in this exquisite store.

A couple of doors up you'll find Petite Boucherie – another traditional French restaurant to try, serving timeless classics and cocktails from an open kitchen.

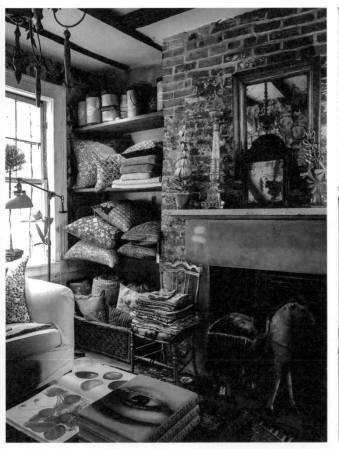
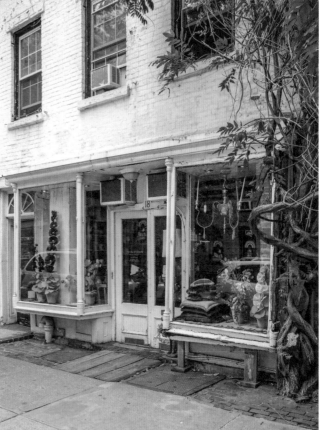

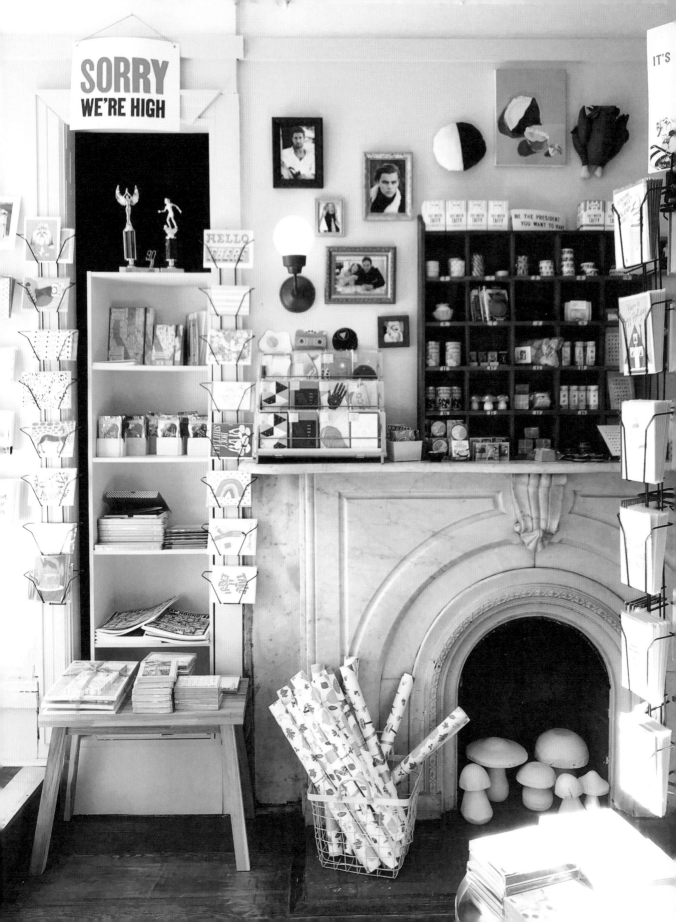

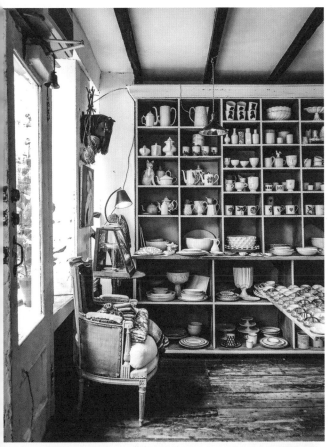

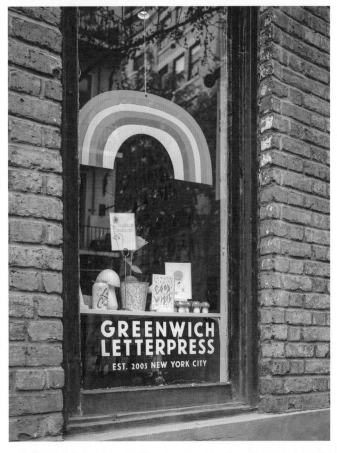

Greenwich Letter Press, at number 15, exudes West Village charm. Specializing in stationery, it is definitely worth a visit. Owned by sisters Amy Swanson and Beth Salvini, everything is designed in-house and produced on a Gutenberg-style press.

McNultys Tea and Coffee Company, a purveyor dating back to 1895, is also on this street (at number 109) and well worth a visit.

GAY STREET

Between Waverly Place and Christopher Street, just west of 6th Avenue, you will find a short atmospheric stretch called Gay Street. I like to stand and look toward Waverly Place for the best views – its charming Federal-style buildings and leafy vibe make it extremely popular for photoshoots.

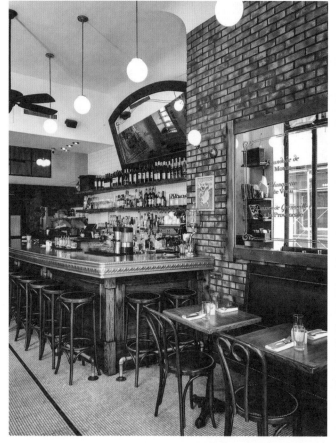
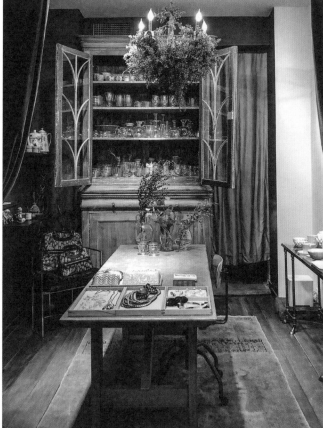

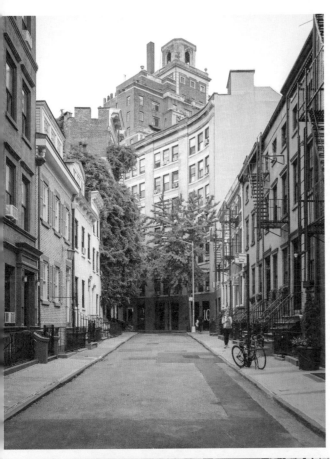

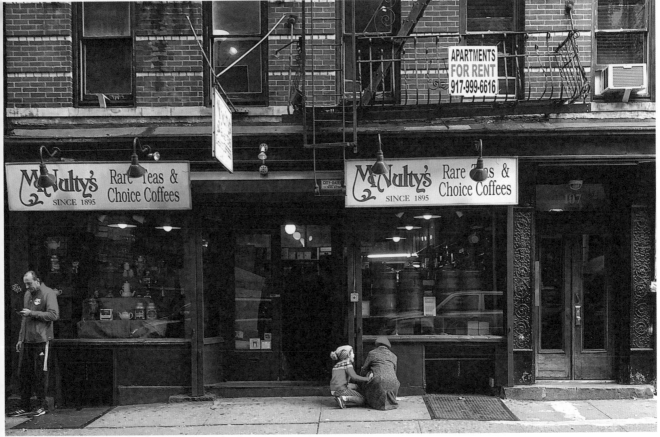

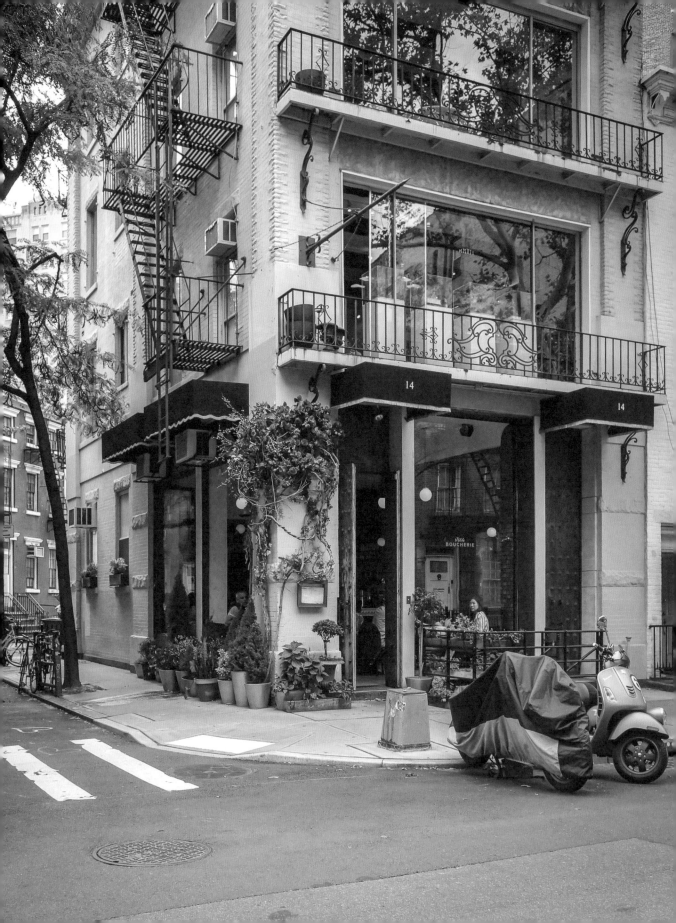

CHARLES STREET

Pink Olive, at number 30, is an adorable card and gift shop with inspiring window displays. Follow a mooch here with a refuel across the way at Partners Coffee Roasters (formerly Toby's Estate). Housed within a landmark 1920s artists' studio, the cafe is inspired by the historical West Village brownstone. Here you will also find their Manhattan Brew School for coffee classes, while the small menu offers delicious sandwiches and daily pastries from local vendors.

GROVE STREET

The most popular spot on this pretty street is undoubtedly the *Friends* apartment building, located at 90 Bedford Street, at the corner of Grove Street. Today it's worth going there for the cozy and romantic Little Owl – a Mediterranean-inspired restaurant (reservations recommended).

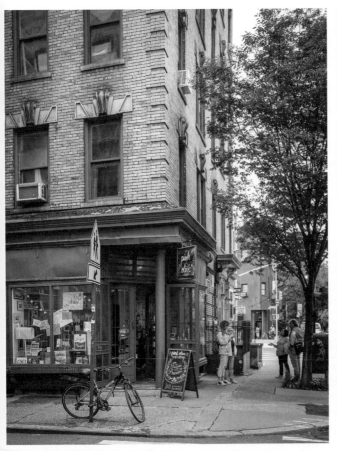

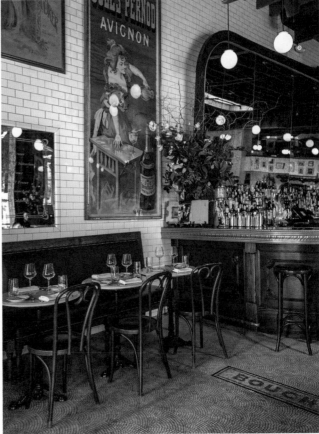

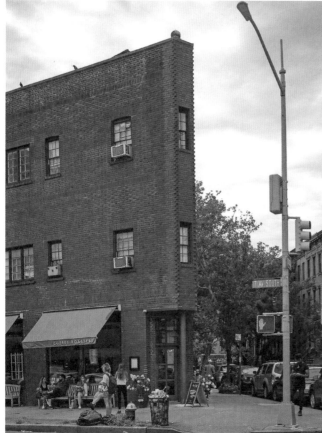

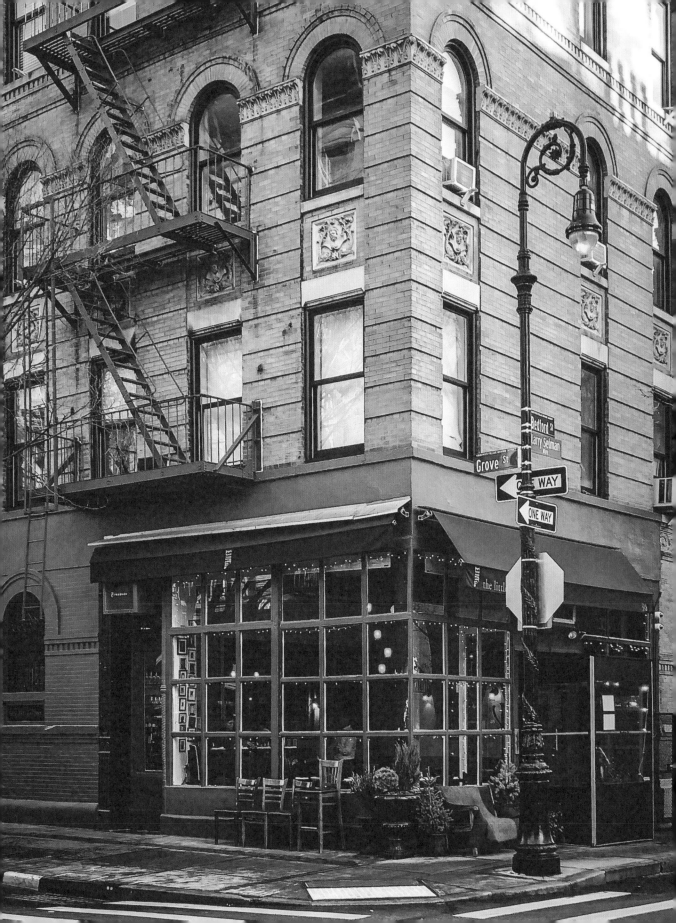

GROVE COURT

Nestled between 10 and 12 Grove Street you'll find the most charming little courtyard with six brick-faced private townhouses. Worth a little visit, especially at Halloween, when you'll find the courtyard adorned with pumpkins.

MACDOUGALL ALLEY AND WASHINGTON SQUARE NORTH

Two charming alleys lined with quaint structures that apparently were built as stables for the fine mansions they border.

WAVERLY PLACE

At the western end is another quintessential village street, home to beautiful façades and the Waverly Inn (on the corner of Bank and Waverly Place). Once a semi-private restaurant that was difficult to get into, these days it has thankfully morphed into a pleasant neighborhood staple.

GREEN SPACE

Washington Square Park, Abingdon Square Park, Bleecker Playground

HOTELS

High Line Hotel, The Standard, Dream Downtown, Soho House Hotel

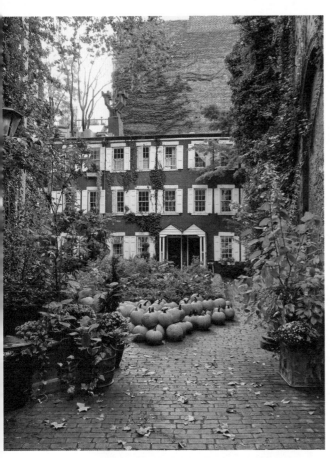

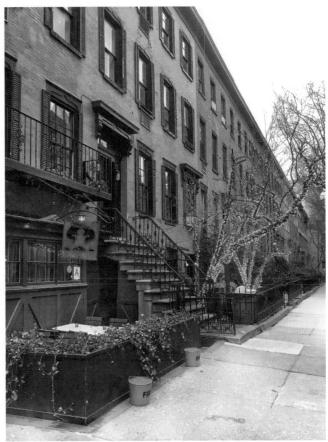

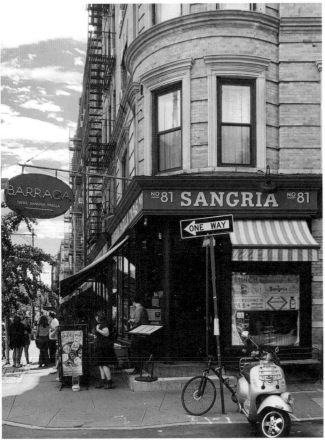

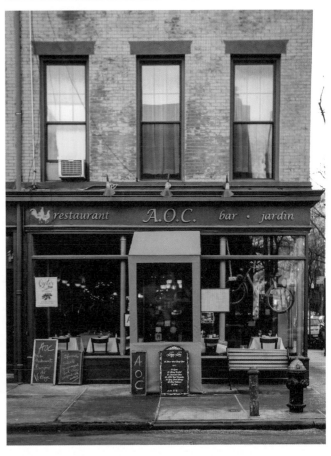

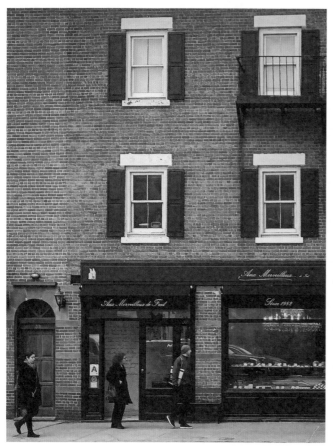

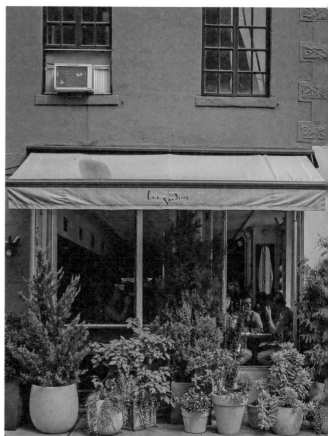

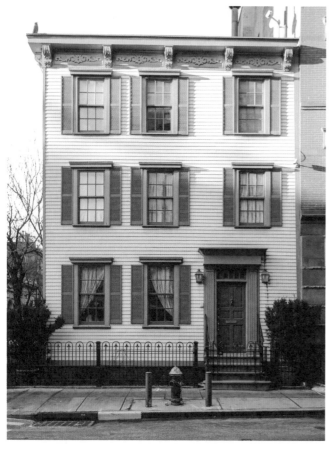

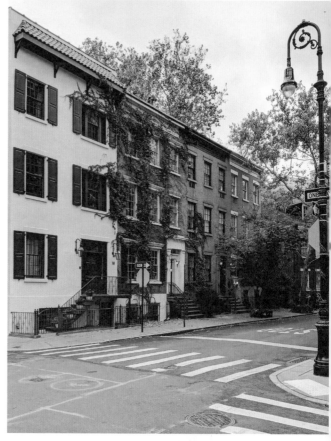

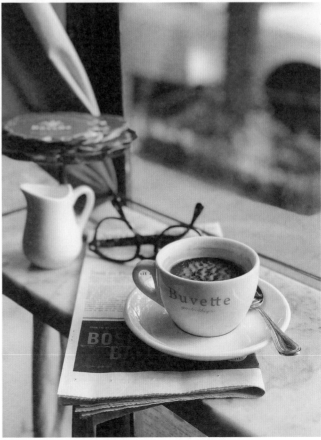

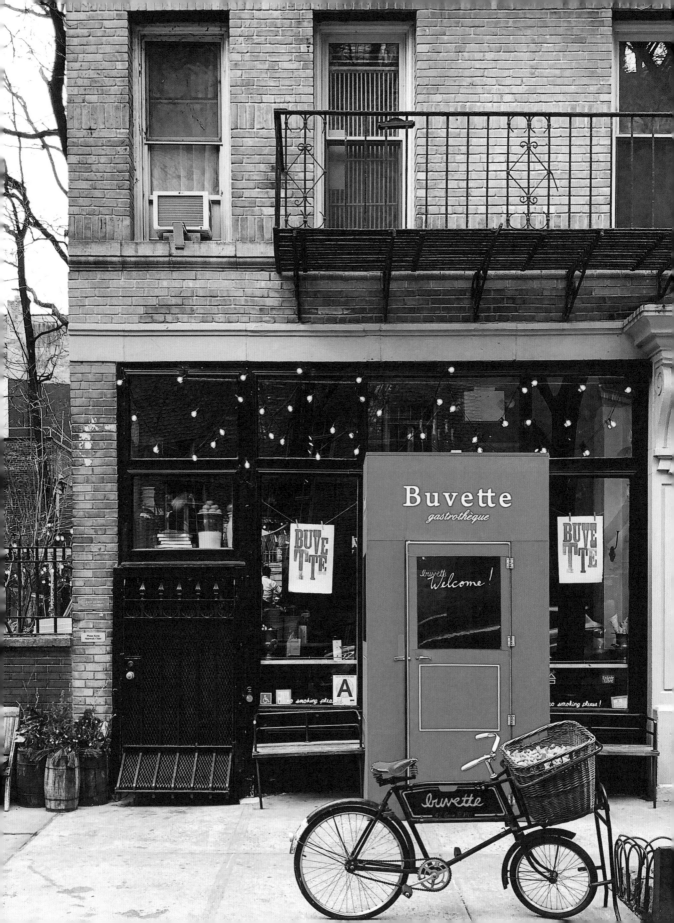

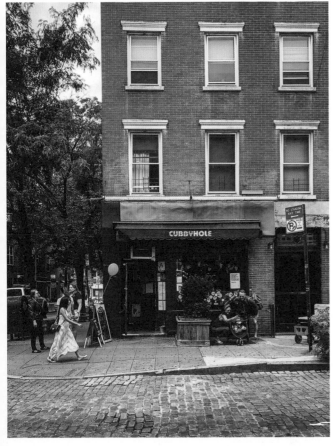

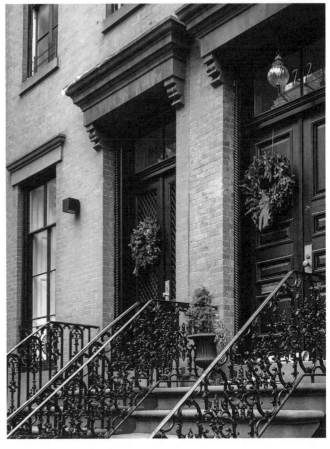

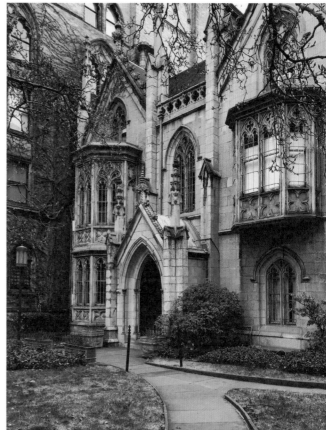

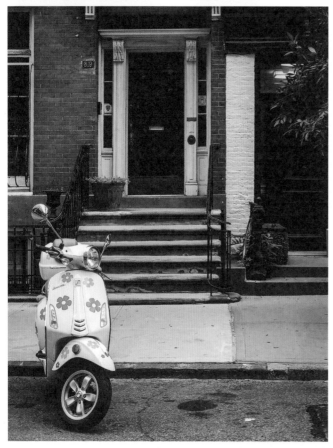

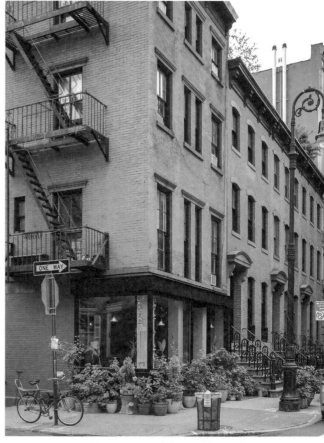

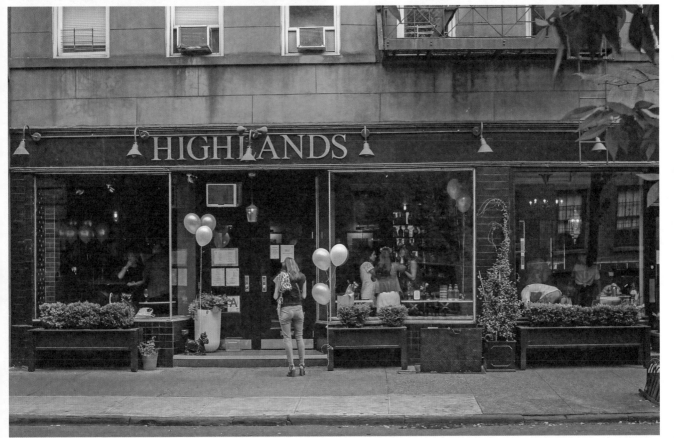

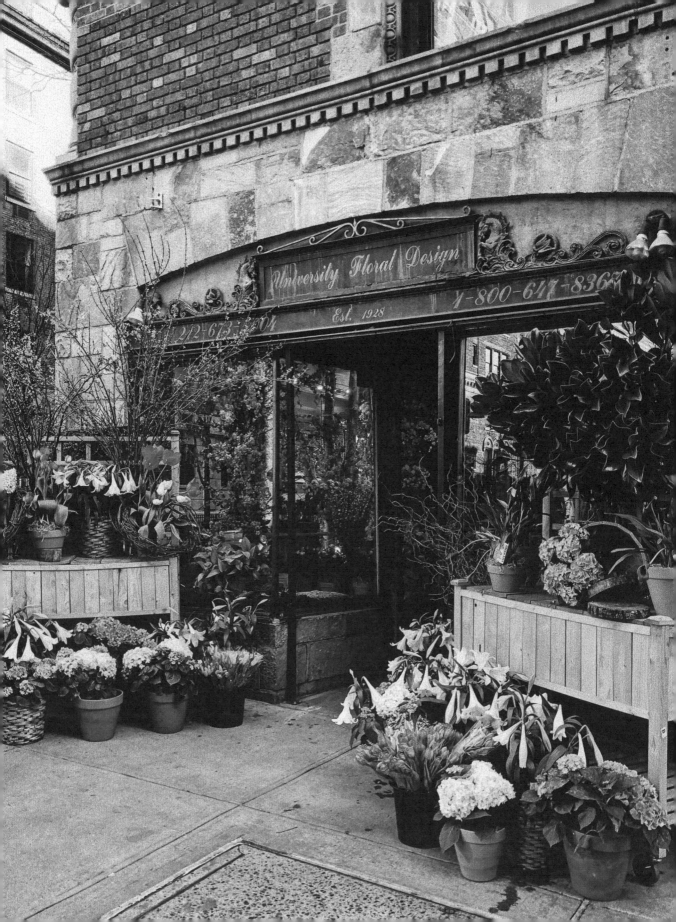

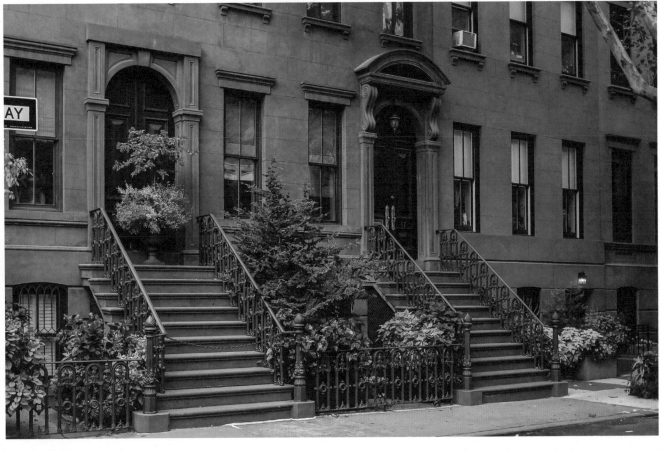

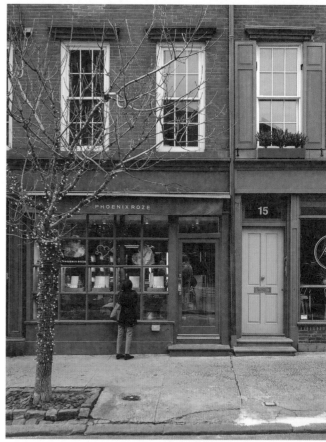

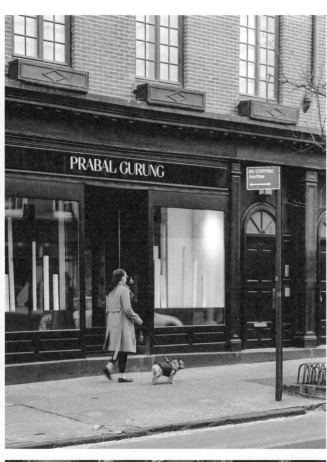

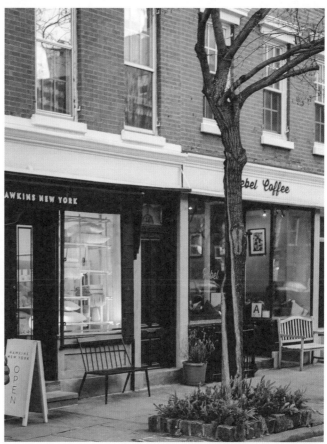

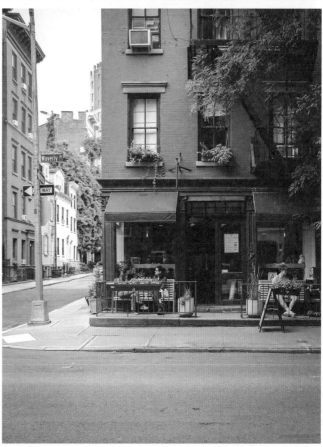

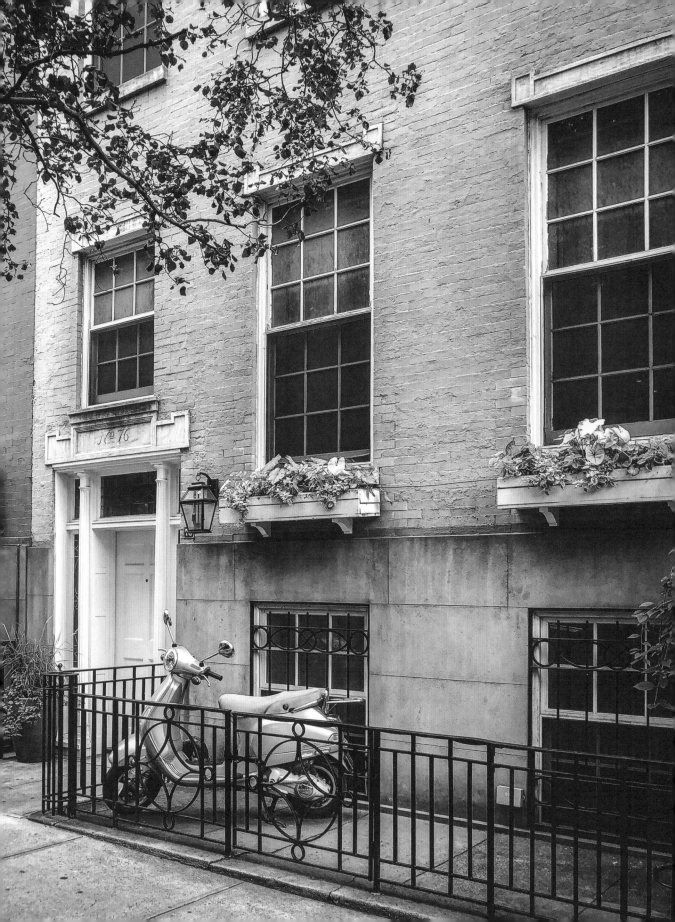

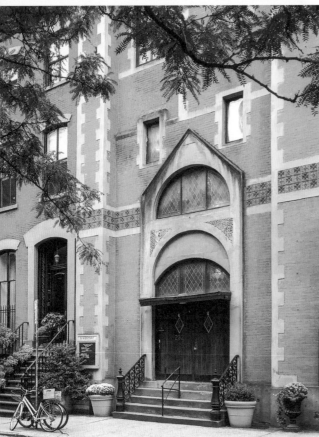

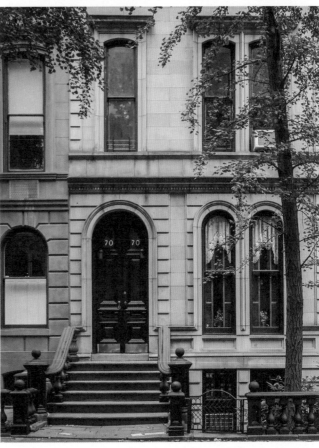

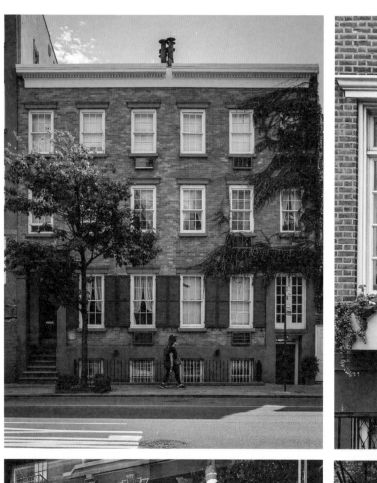

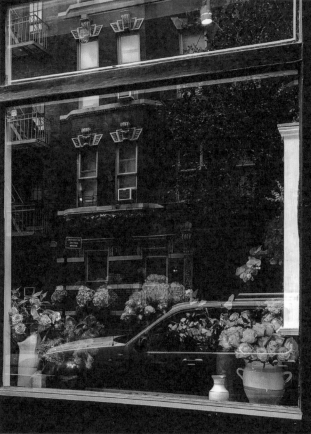

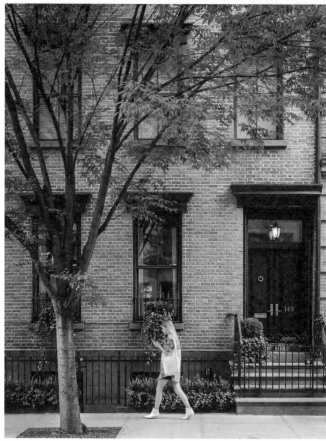

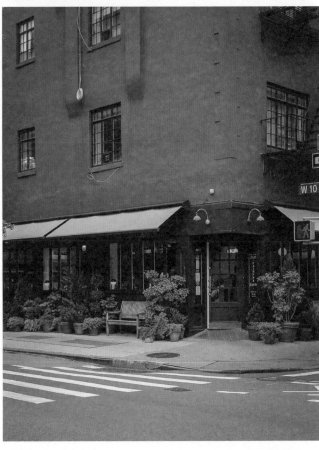

TRIBECA, SOHO, AND NOLITA

CHIC BOUTIQUES,
LOFTY SPACES,
AND COZY CHARM

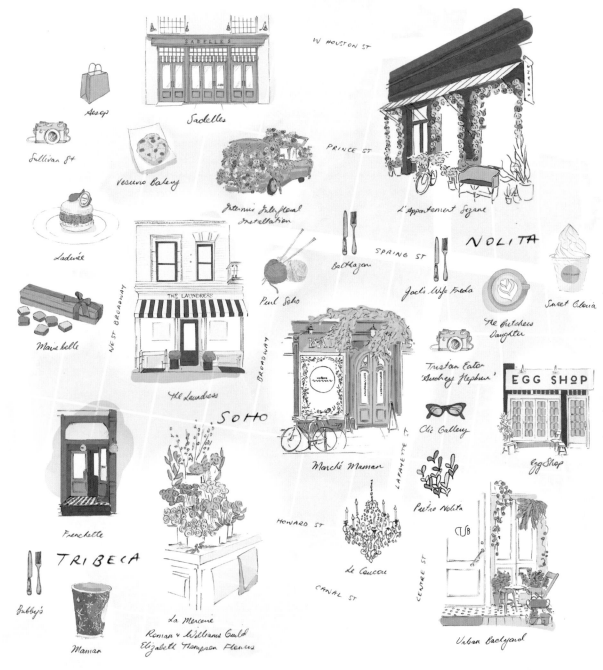

T R I B E C A , S O H O & N O L I T A

#prettycitynewyork

LA MERCERIE 53 Howard St
BUBBY'S 120 Hudson St
JACK'S WIFE FREDA 224 Lafayette St
FRENCHETTE 241 West Broadway
EGG SHOP 151 Elizabeth St
SADELLES 463 West Broadway
LE COUCOU 138 Lafayette St

Sullivan St, Intermix Floral
Installation (Prince St), Tristan
Eaton 'Audrey Hepburn'

MARCHÉ MAMAN 237 Centre St
PIETRO NOLITA 174 Elizabeth St
URBAN BACKYARD Kenmare St
BUTCHERS DAUGHTER 19 Kenmare St
MARIEBELLE 484 Broome St
SWEET GLORIA Mott St
LADURÉE 398 West Broadway
VESUVIO BAKERY 160 Prince St

ELIZABETH THOMPSON FLOWERS
53 Howard St

PURL SOHO 459 Broome St
ROMAN AND WILLIAMS
GUILD 53 Howard St
AESOP 438 West Broadway
THE LAUNDRESS 199 Prince St
CLIC GALLERY 255 Centre St
L'APPARTEMENT SEZANE
254 Elizabeth St

In New York, Downtown refers to a large patch of Manhattan beneath 14th Street, but it is also true to say it refers to a fashionable lifestyle, best experienced on the cobblestoned streets of Soho and Tribeca, where former industrial districts now house high-end boutiques and eateries. The once decaying industrial area known as TriBeCa (Triangle Below Canal) began to be converted into residential lofts in the late 1970s by artists leaving Soho due to rising rents. This area, now home to around 17,000 residents and the Tribeca Film Festival, boasts chic boutiques, trendy bars, and a host of vibrant dining opportunities. Today the area is completely gentrified and its appeal lies in its cast-iron architecture and still mostly gritty vibe.

In the mid 1990s Soho was the center of New York's art scene – that is, until many of fashion's big names started to move in and take over the historic buildings. The elegant cast-iron architecture, the zigzag fire escapes, cobblestone streets, the bottle-glass sidewalks that allow light into the basements below, and traces of the area's graffiti heritage give Soho a look and feel like no other. The neighboring Nolita (North of Little Italy) is home to some of my favorite boutiques, artisan cafes, and some of the prettiest street art in the city. Hiding to the east of lower Broadway and sandwiched between the villages, you will find Noho (just north of Houston). The area occupies a small nook with a bohemian spirit and eclectic vibe. Expansive lofts, chic boutiques, and quaint cafes abide in this pocket-sized neighborhood.

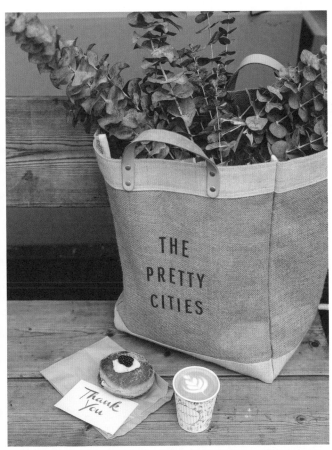

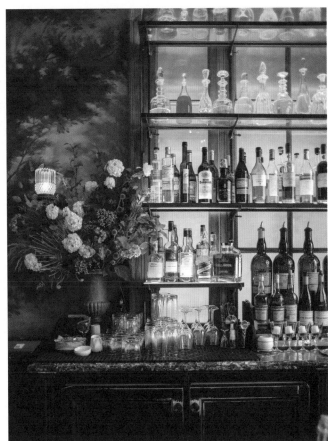

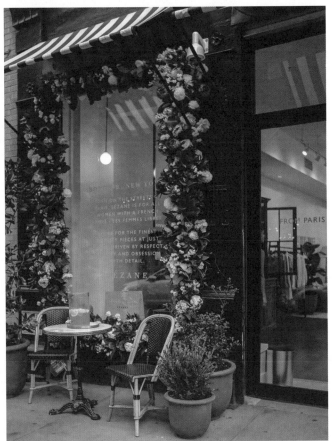

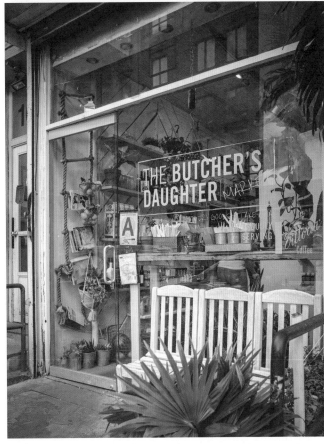

TRIBECA

Set aside a morning or entire afternoon to stroll around buzzy and fashionable Tribeca. Despite being a mecca for A-list celebrities, Robert De Niro among them, it still feels largely unpretentious.

WEST BROADWAY

Frenchette – 241 West Broadway: chefs Riad Nasr and Lee Hanson have worked side by side for many years under acclaimed chef Keith McNally (Balthazar, Pastis, and Minetta Tavern), but this is their first venture on their own. Just over a year old but doing really well, they have a brasserie-inspired menu. You can opt to dine at the zinc bar up front or snag a table at the back; either way, I'm sure you will love your visit.

Tiny's & the Bar Upstairs – 135 West Broadway: the rustic interior and picture-perfect exterior of this historic townhouse had me at 'hello'. The tin ceilings, antique wallpaper, and reclaimed wood alone make it the perfect cozy spot. Add it to your list for sure.

Rag and Bone – 228 West Broadway: a store with 'man cave' qualities, including a turntable, Wii, and whiskey served at the bar. The dressing rooms have been decorated by local artists, and much of the furniture was designed by Rag and Bone itself.

The Liquor Store – 235 West Broadway: home to the J. Crew menswear flagship for the last ten years, but sadly this is now closed. However, the old-world façade still adds plenty of charm to the corner.

Maman Tribeca – 211 West Broadway: as with Maman Hudson, this cafe, restaurant, and event space – which currently shares its home with Paper Source, a premier paperie and gift store selling a beautiful selection of artisanal papers, stationery, greeting cards, and gifts – is a dream to visit.

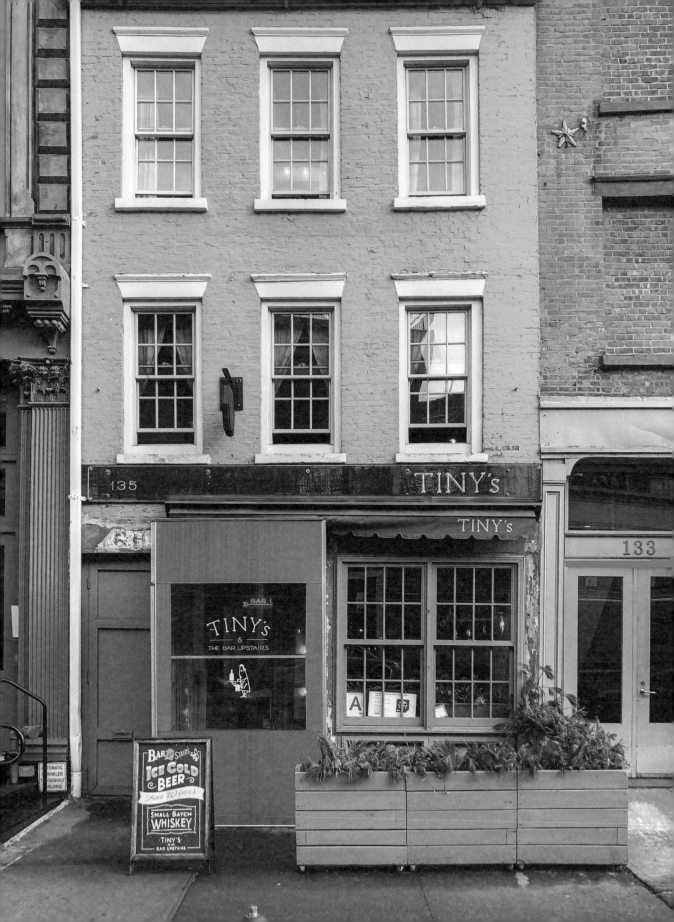

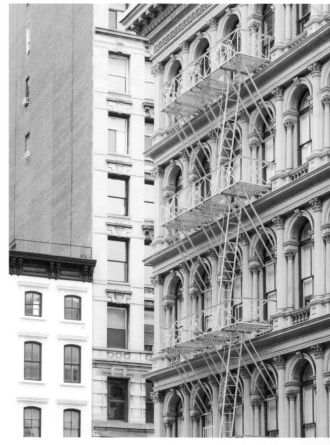

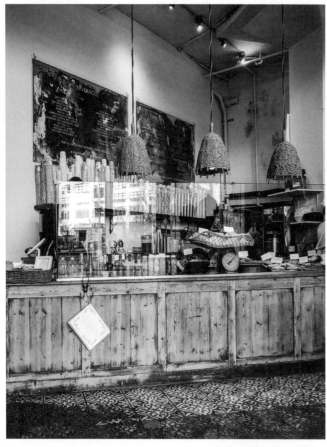

GREENWICH STREET

Locande Verde – 377 Greenwich Street: a rustic Italian trattoria with a fantastic atmosphere to boot. It is a true Tribeca draw: expect queues down the sidewalk.

FRANKLIN STREET

Aire Ancient Baths – 88 Franklin Street: escape the bustling downtown streets into this oasis of tranquility. These ancient baths, housed in a nineteenth-century textile factory, are the perfect treat for mind, body, and soul.

HUDSON STREET

Maman Hudson – 205 Hudson Street: signature rustic interiors and delicious food; I highly recommend the breakfast sandwich made with homemade bourbon bacon.

OTHERS

Roxy Hotel – 26th Avenue: a flatiron-style red-brick building houses this stylish and fun hotel. You'll find a jazz club in the basement, a cocktail bar, and a ninety-nine-seat cinema elsewhere. Guests have access to Aire Ancient Baths and can use the complementary vintage bikes or the twenty-four-hour gym.

Hook and Ladder Company No. 8 – 14 North Moore Street: this handsome fire station's claim to fame is revealed by the logo painted on the sidewalk outside. Yes, it starred as the base of the iconic *Ghostbusters* films of the 1980s, and again in the recent remake, apparently being chosen for its 1903 Beaux Arts building.

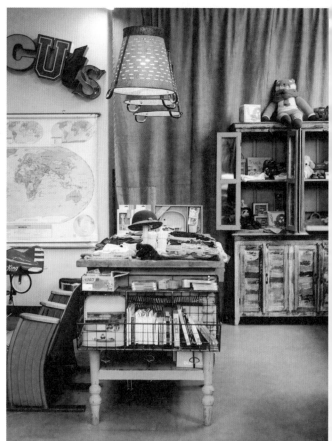

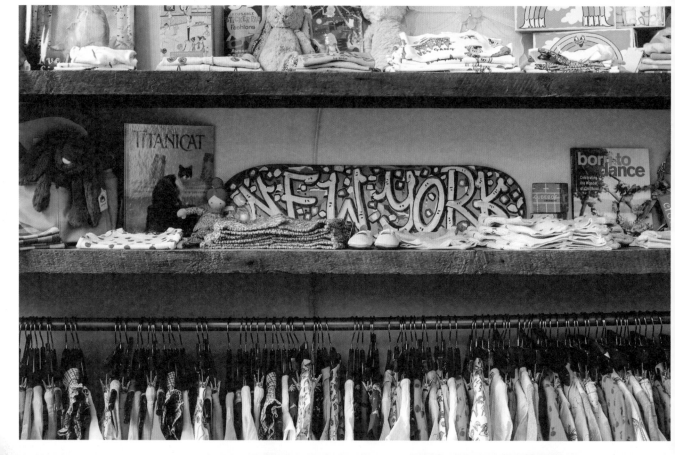

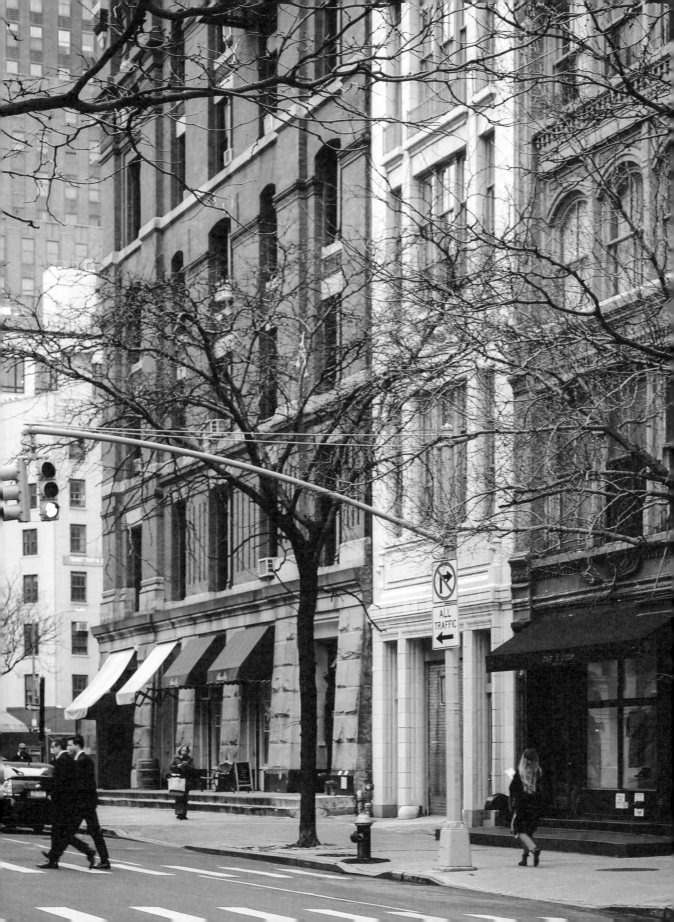

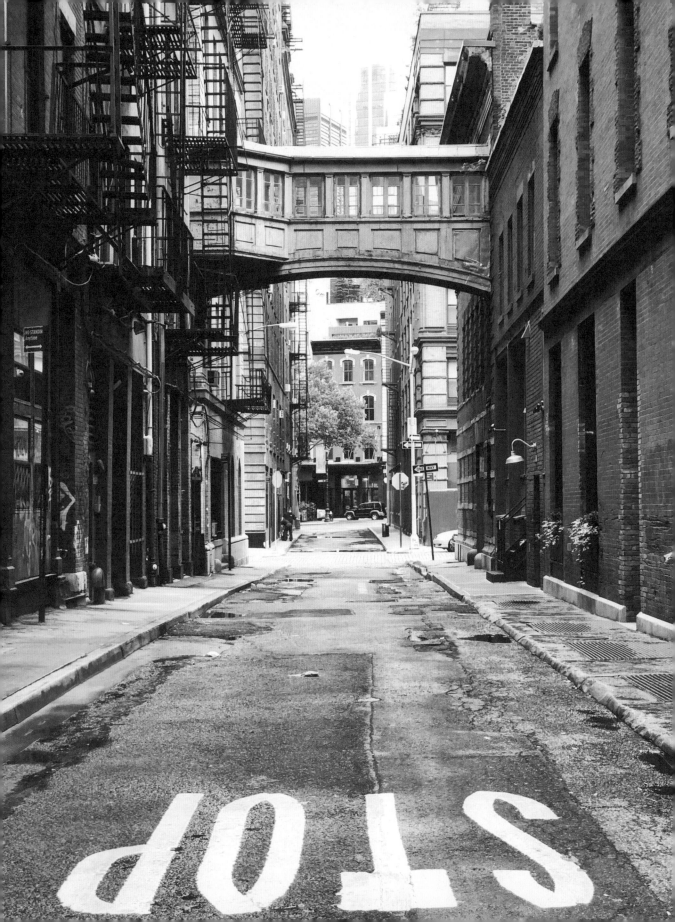

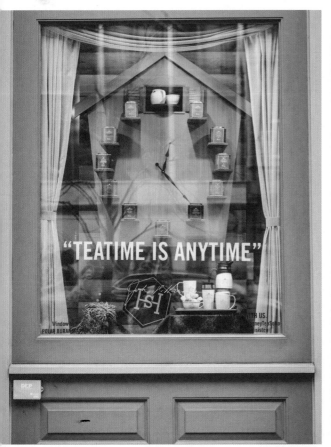

"TEATIME IS ANYTIME"

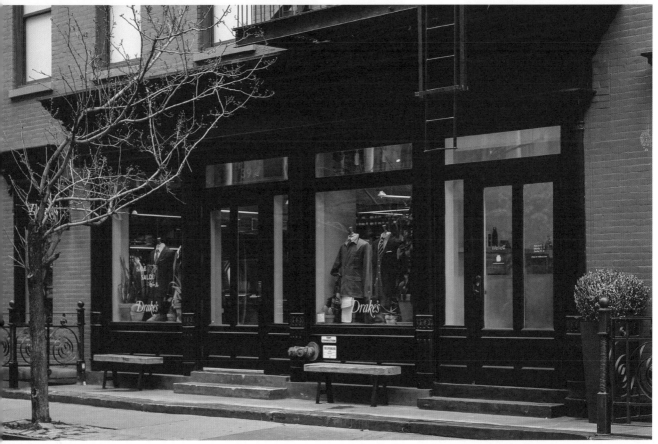

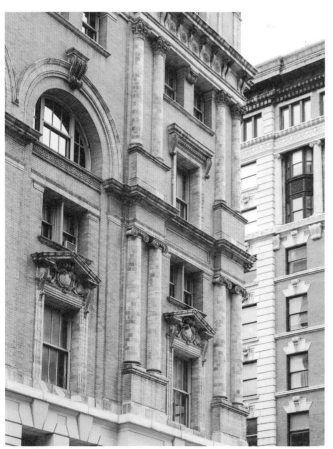

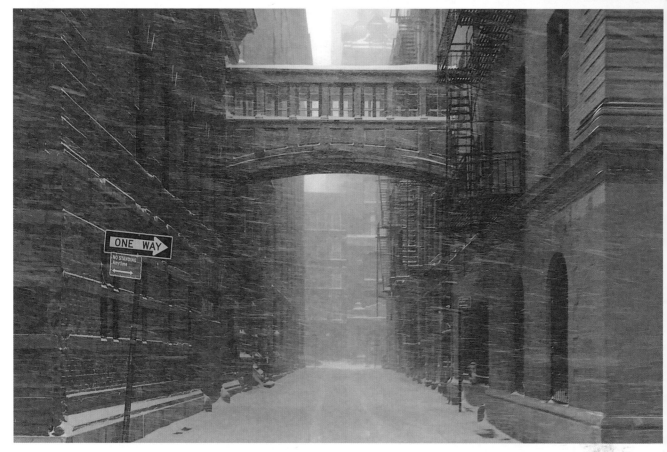

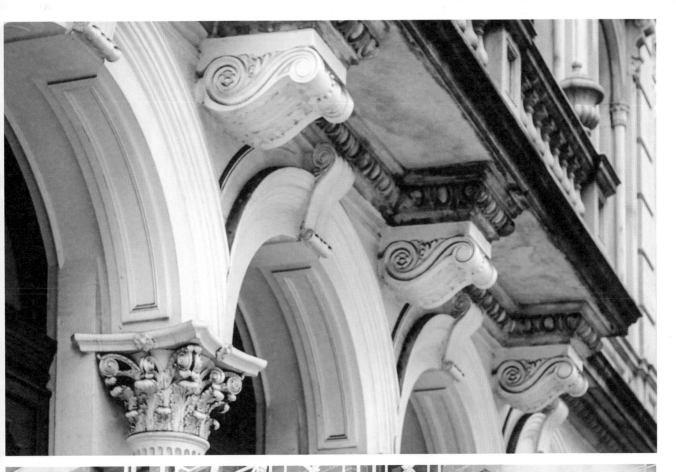

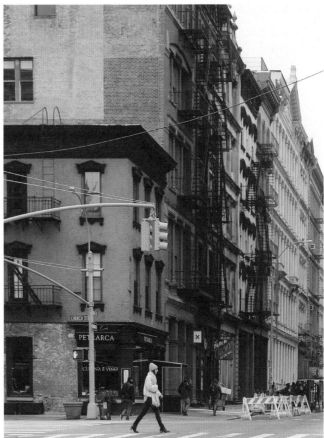

FRIED EGG – 2
ROASTED CHICKEN – 4
SMOKED SALMON – 5
SLICED AVOCADO – 3
BALSAMIC MIXED GREENS – 3
TOAST WITH BUTTER – 4
HERBED FETA – 4

*GLUTEN FREE

@_MAMANNYC_ #MAMANNYC

ICED MATCHA – 3/3.5
EVIAN WATER – 3
BADOIT (SPARKLING) – 3
ANTIPODES WATER – 4.75
SOFT DRINKS – 4
ALAIN MILLIAT JUICES – 4
FRESH OJ 8 GRAPEFRUIT JUICE – 4/4.5
COLD PRESSED JUICE – 8

ALMOND/OAT/COCONUT MILK – .5
EXTRA SHOT – 1.25

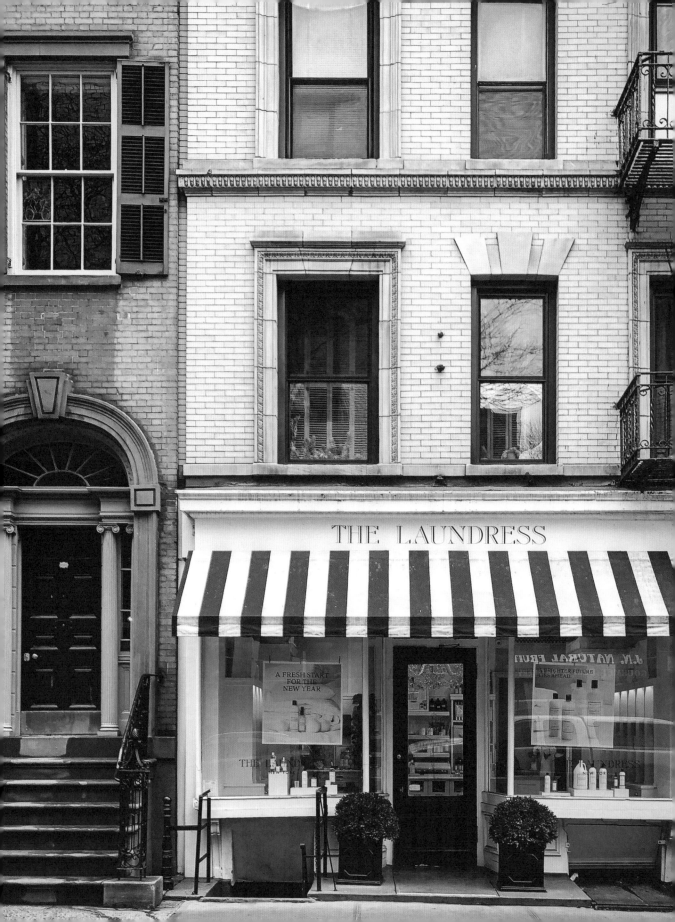

SOHO

Soho's shopping grid spans from Broadway west to 6th Avenue, and Houston Street south to Call Street. Broadway is the most commercial stretch and indeed my least favorite; I like instead to meander down streets like Prince, Spring, West Broadway, and Broome.

PRINCE STREET

I like to kick off my meander around Soho with a walk through upmarket Prince Street – a beautiful thoroughfare that is simply stunning to wander along, with landmark buildings to see. I begin my walk near The Laundress, the flagship store at number 199 specializing in home cleaning products. The iconic black and white awning and its exquisite façade and interiors are hard to resist.

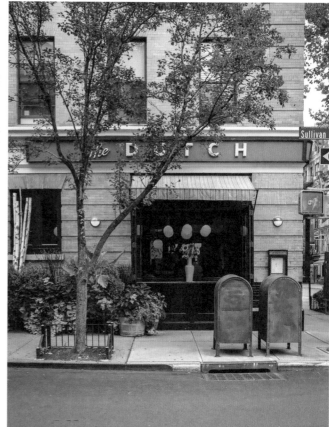

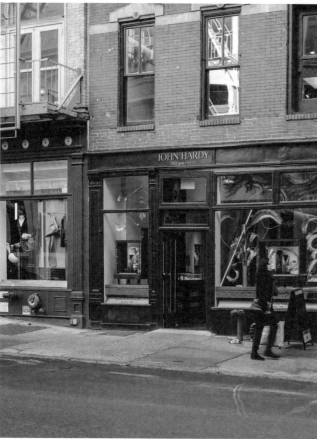

Also on Prince you will find a modern city bakery, which is lovely to photograph, with original signage by the historic Vesuvio Bakery. Sadly, this gorgeous Vesuvio Bakery, with its eighty-nine-year history, closed in 2008. Save your appetite for other eateries, but the charming façade does photograph well. Next door to The Laundress sits the Little Prince Restaurant – another local favorite. It's busy and trendy with great French-inspired food – add this to your list for sure. If you can't manage a spot at the Little Prince, try The Dutch, serving American food on the corner of Sullivan and Prince. The restaurant has three main dining areas, all white brick and rubbed wood. The beautiful aesthetics complement the delicious food (thanks to chef Andrew Camellini – also Locanda Verde).

From here you can walk left down Sullivan Street – another little respite from Soho's bustle. Here you will find gems like Atelier d'Emotion (a beautiful jewelry boutique) and Westbourne (a cozy LA-inspired cafe serving healthy breakfasts).

Back on Prince Street, it would be wise to note Raoul's, a classic French-inspired bistro run by the lovely Catherine since 1976.

WEST BROADWAY

West Broadway, the stretch between Prince and Spring with its wider than average sidewalks, is home to my favorites: Aesop, the very beautiful French macaron house; Ladurée the tea salon; and many other wonderful global brands. This eighteenth- and nineteenth-century-decorated three-part salon is a sight to behold. Whether you walk through Ladurée's doors to take away a box of their famed pastel macarons from their pretty boutique or decide to dine in for a full fancy French dining experience, don't leave without stepping out to their beautiful patio garden.

Another gem worth visiting is Gucci Wooster Street, located at 375 West Broadway (there's another entrance on 63 Wooster). Entering from West Broadway, you immediately find yourself in the bookstore, curated by Dashwood Books. The intimate reading nook lies adjacent to the cinema room and complements the museum-like qualities of this unique and artistic store. Don't leave the area without a wonderful mooch inside – its new design has lingering shoppers in mind.

BROOME STREET

Visit Maribelle and Cacao Bar for old-world decadent charm and delicious hot chocolate. Enjoy special tasty options like white chocolate with banana or freshly ground hazelnut.

Purl Soho: A must-see knitting boutique with floor-to-ceiling cubbyhole shelves filled to capacity with colorful yarn. Founded in 2002 by Joelle Hoverson, Purl Soho is a beautiful gem and doing a roaring trade thanks to the crafting revival. Who said knitting was just for grannies?

The Broome Hotel: A boutique hotel complete with an open-air Moroccan tiled courtyard and Parisian vibes.

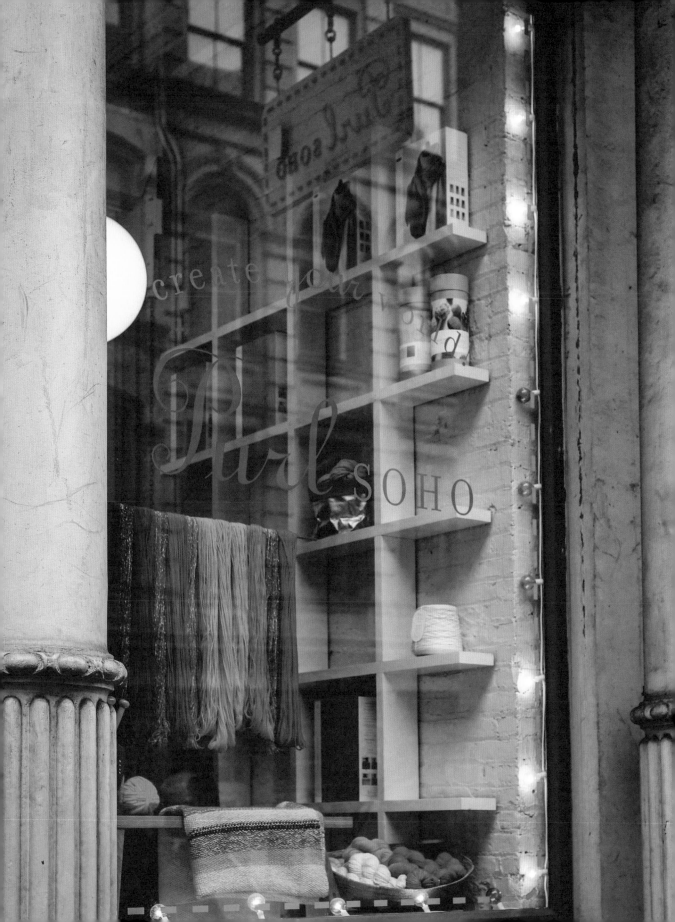

GREENE STREET

Soho is noted for its striking cast-iron architecture and cobblestoned streets. Some of the best examples are found on Greene Street. Numbers 28–30 – known as the Queen of Greene Street – and numbers 72–76 – the King of Greene Street – are splendid Corinthian-columned buildings created by Isaac F. Duckworth, one of the masters of cast-iron design. Meanwhile, numbers 15–17 Greene Street are examples of simple Corinthian style.

MERCER STREET

Roman and Williams Guild, on the corner of Mercer and Howard Street, is the brainchild of designers and husband-and-wife duo Robin Standefer and Stephen Alesh – and it is as marvelous as they come: part flower shop, library, restaurant, design gallery, and homewares shop. It is indeed a beautiful, creative design emporium, which eloquently showcases their founding collection: a mix of furniture, lighting, and accessories, together with pieces by local artisans. Located on the corner of Canal Street, the space of a former bank boasts a beautiful façade and light-filled interior. To the front you will find Emily Thompson Flowers, with beautiful bunches spilling over the rustic table and hidden behind a lush pink velvet curtain. The design duo share the space with La Mercerie – an all-day Parisian cafe and bakery.

The cafe is the perfect mix of old-world charm and contemporary refinement. Thanks are owed to Parisian chef Marie-Aude Rose for her simple French food (including buckwheat crêpes and freshly baked brioche). Visiting here is without doubt my number one thing to do in New York.

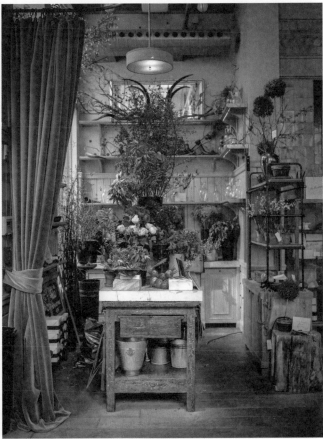

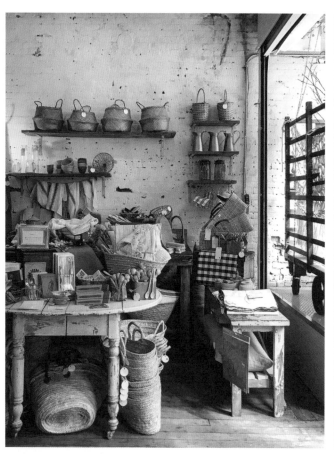
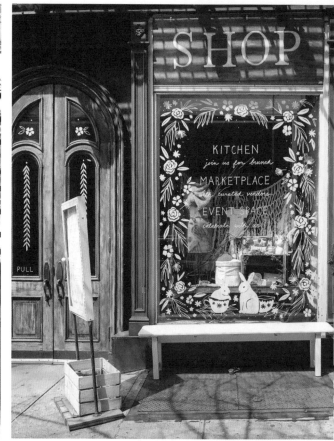
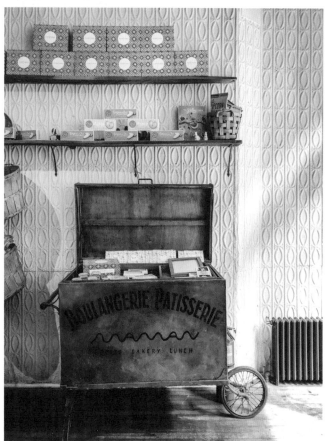

LAFAYETTE STREET

The Michelin star Le CouCou on 138 Lafayette Street was opened in 2016 by acclaimed chef Daniel Rose. After taking Paris by storm, Rose returned home and opened his first restaurant. The menu is a nod to elegant and classic French gastronomy, including *quenelle de brochet* served with lobster sauce, slivers of veal tongue dabbed with caviar, and that rustic delicacy *tout le lapin* (all of the rabbit).

Designed by Robin Standefer and Stephen Alesch of Roman and Williams Guild, the elegantly styled interiors perfectly complement the French-inspired cuisine by Rose. For me, the most beautiful element of the interiors is the hand-painted mural located behind the stunning bar. It is the work of local artist Dean Barker and was inspired by the eighteenth-century French landscape painter Hubert Robert.

The exquisite design and color palette of the entrance and bar area set the tone for the rest of the space, while the lighting, high ceilings, and tall candles all set a beautiful romantic mood.

CENTRE STREET

Opened in 2017 by Benjamin Sormonte and Elisa Marshall as part of the Maman chain of cafes, Marche Maman is located on and adjacent to the brand's original cafe, and is a shop and dining space. Maman brings to life childhood favorites, both savory and sweet, from North America and the south of France, and the results are nothing short of perfection. Go for the chocolate chip cookie and stay to browse. Stylish home accessories, flowers, textiles, and handmade ceramics are among the beautiful items for sale. With rotating vendors and chefs, everything always feels fresh. Breakfast, lunch, and brunch are served, and there is a little outdoor space too for when the weather allows an al fresco experience.

Clic Gallery, at 255 Centre Street, is a gallery-cum-fashion, lifestyle, book, and home goods store occupying a beautiful space on the street.

CROSBY STREET

A Firmdale hotel with the Kit Kemp signature aesthetic displayed on everything from the fabrics, wall coverings and artwork, Crosby Street Hotel is located at 79 Crosby Street. Built from scratch on the site of a former parking lot, the hotel boasts a residents-only courtyard garden, 360-degree rooftop views, basement cinema, and each room is unique. The Crosby Bar offers modern, American, all-day dining and a good cocktail menu.

NOHO

The area north of Houston Street (as contrasted with Soho which is south of it) is a landmarked neighborhood in NYC. It's a little quieter than Soho, with intimate bars, shops, and restaurants, and occupies just a few blocks, making it one of the city's tiniest neighborhoods. This oasis has Bond Street as its main thoroughfare. The ground floors of the nineteenth-century buildings, with façades of cast iron and marble, are thankfully restored to their origins as beautiful retail stores.

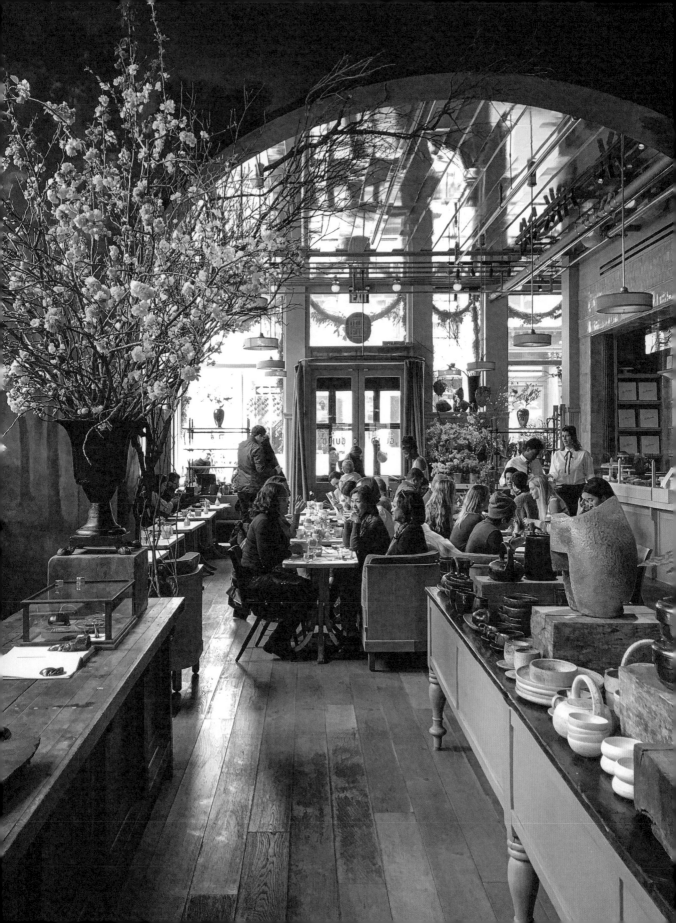

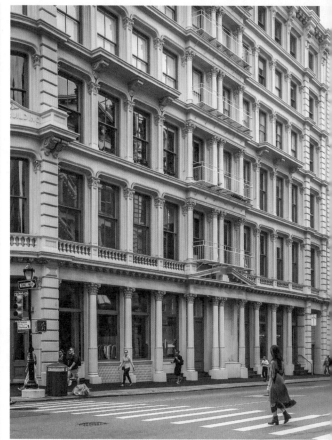
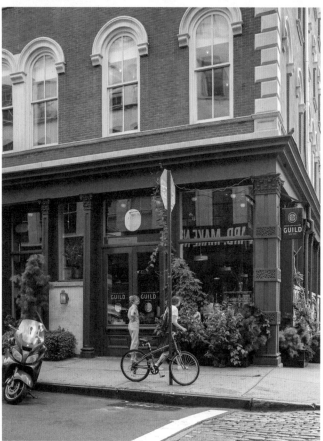
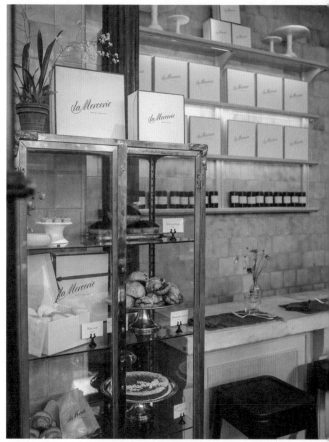

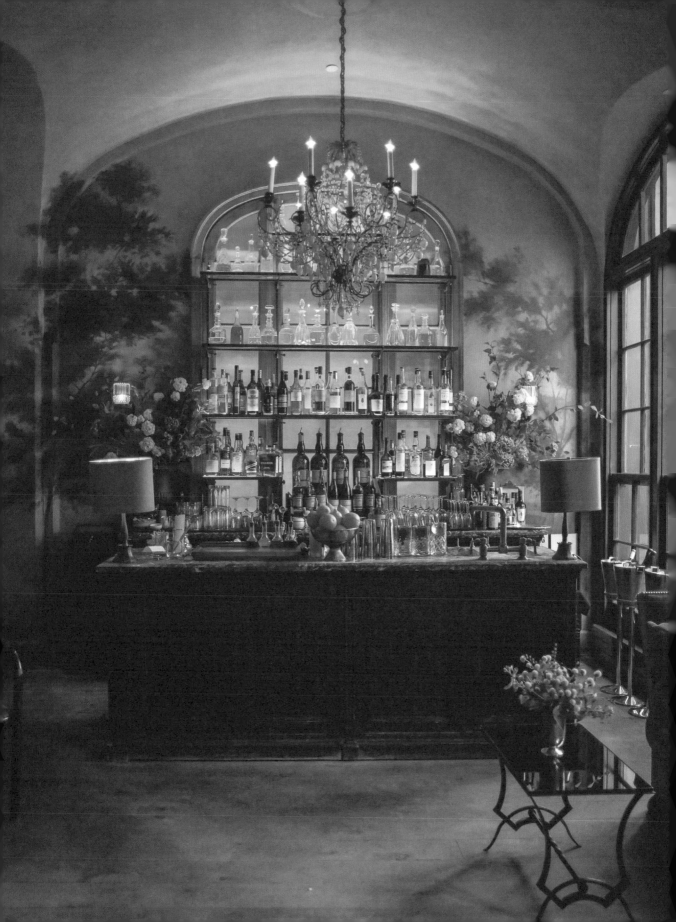

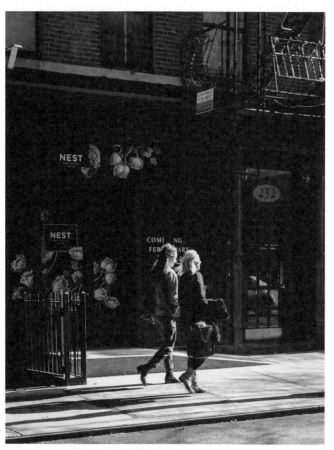
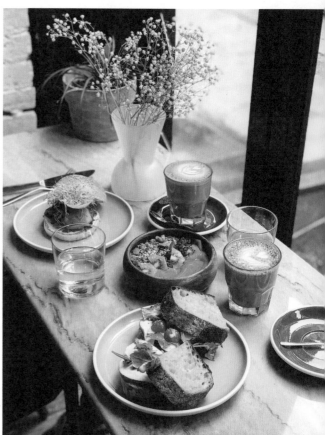

UNO₅₀

Madrid London Paris Milan New York Los Angeles Miami

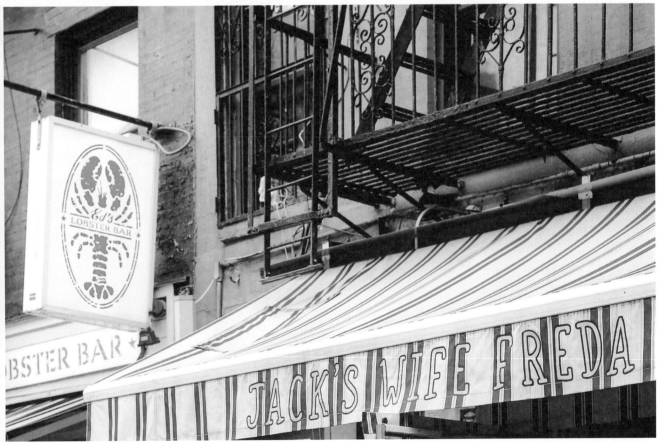

Ed's LOBSTER BAR

OBSTER BAR

JACK'S WIFE FREDA

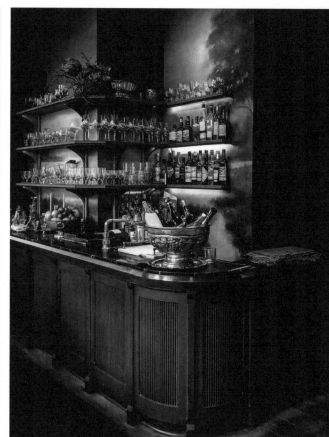

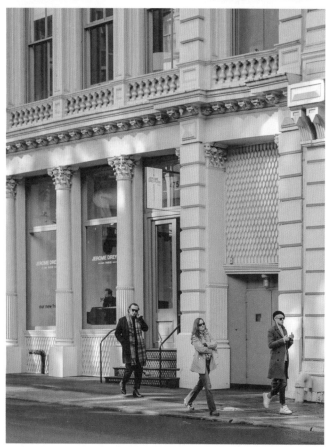

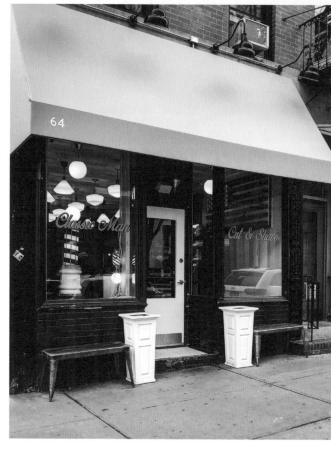

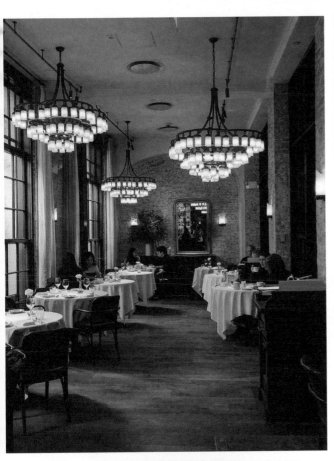

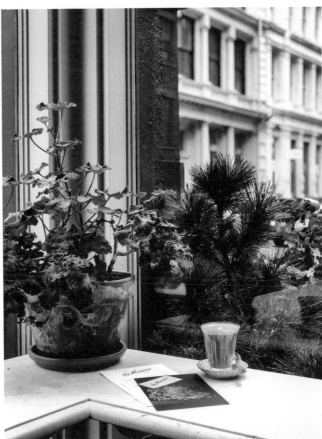

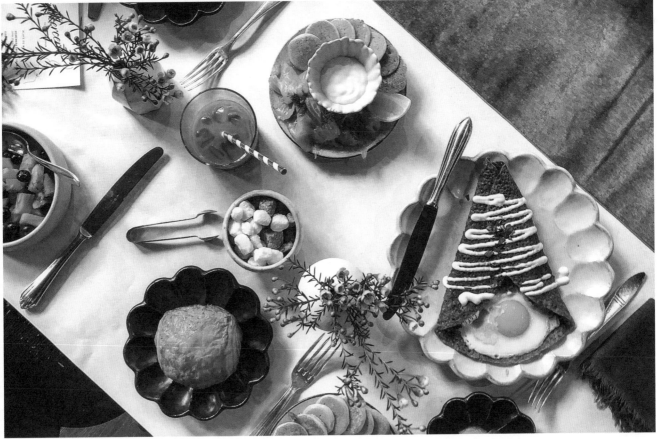

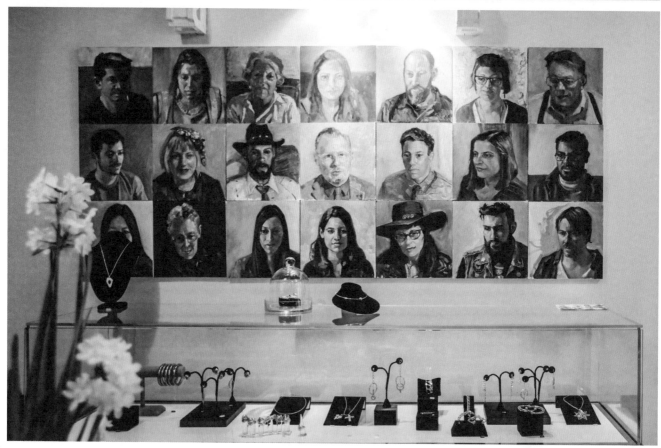

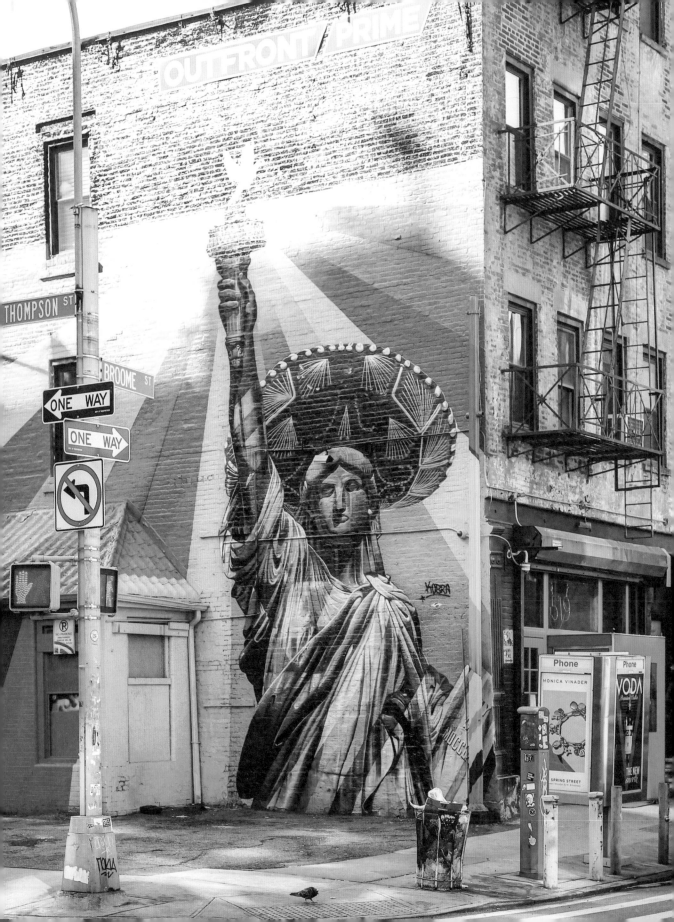

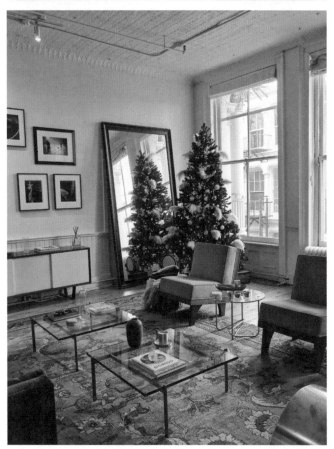

NOLITA

The sudden shift from one neighborhood to the next fascinates me with every visit to New York. This swift change becomes very apparent as you leave behind Soho and enter the much loved area known as Nolita (north of Little Italy), bounded to the north by Houston Street, to the east by Bowery Street, to the west by Lafayette Street, and to the south by Broome Street. This fashionable district emerged in the late 1990s, when independent boutiques, cozy cafes, and restaurants sprung up overnight, largely displacing entire Sicilian communities. This area, home to some of the most charming boutiques like Le Labo, Sézane, and McNally Jackson, and with streets adorned with colorful murals, is one of my favorites to explore. Leaving behind the cast-iron-adorned buildings and fire escapes, you will know you have entered Nolita when you reach the small walk-up buildings, quaint streets, and communal benches full of people sipping espressos alone or with friends. Mott, Mulberry, and Elizabeth Streets, in particular, are lined with charming shops.

NOLITA HOTSPOTS

McNally Jackson – 52 Prince Street: a two-story bookstore with cafe on site. It has floor-to-ceiling and wall-to-wall shelving stocking a large selection of lifestyle books, stationery, and magazines.

Lombardi's – 32 Spring Street: a landmark Italian pizzeria serving coal-fired, thin-crust Neapolitan pizza.

Seamores – 390 Broome Street: a delicious seafood restaurant with beautiful façade on the corner of Mulberry and Broome.

Audrey Hepburn mural – corner of Mulberry and Broome Streets: by Tristan Eaton, a Brooklyn-based street artist.

Urban Back Yard – 180 Mulberry Street: a cozy coffee shop with cute frontage.

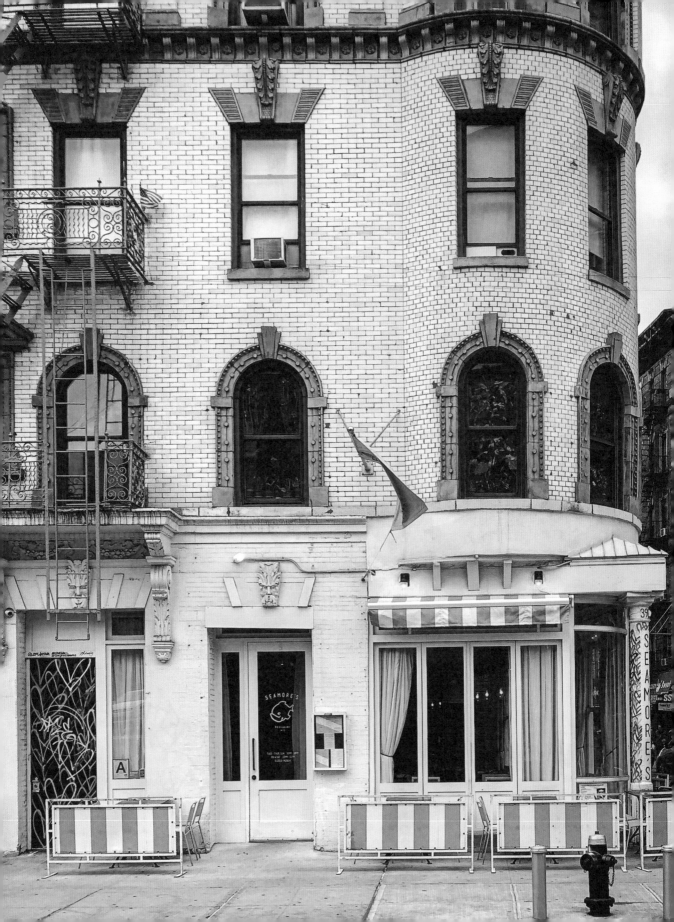

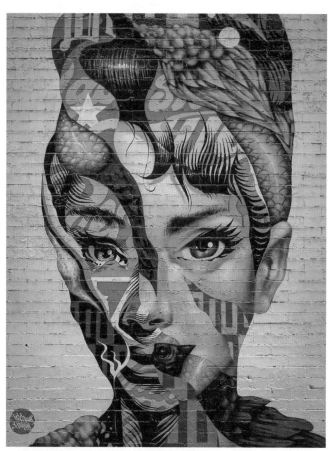

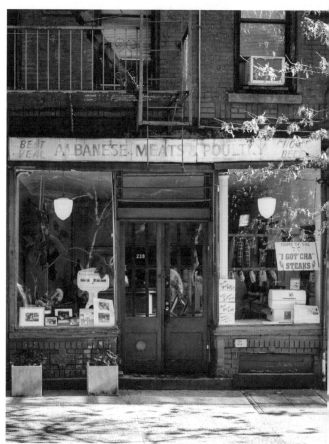

The Butcher's Daughter – 19 Kenmare Street: a bright and airy outpost serving vegan dishes; with seating outside, it is the perfect place to meet friends or sit alone and watch the world go by.

Cafe Gitane – 242 Mott Street: a gem for sure. It's cozy like most of its neighbors, so expect a queue but do stay – it's worth it. A stylish crowd enjoy a French–Moroccan-inspired menu, favorites including avocado on multigrain toast and baked eggs with salmon and capers. If you can't stand the wait, you have Emporio across the street.

Two Hands – 164 Mott Street: best for Australian-style avocado toast or delicious banana bread topped with mascarpone and honey.

ELIZABETH STREET

Many of my favorite little shops are found along the stretch from Kenmare Street to Spring Street. Start with an egg sandwich at the Egg Shop (151 Elizabeth Street), and then walk north to East Houston. Along here you can expect to find:

Le Labo – 233 Elizabeth Street: the original store of this unique fragrance and candle brand. Styled like a vintage apothecary with signature undone interiors, it truly is a beautiful gem.

Aesop – 232 Elizabeth Street: an Australian brand housed in a tiny premises. This store was the original one in New York City and was designed by Jeremy Barbour. The walls are lined with thousands of reclaimed copies of *The New York Times*; a large sink sitting to one side, concrete flooring, and pristine oak shelving add to the charm of this picture-perfect store. Extremely helpful staff are the icing.

Albanese Meats and Poultry – 238 Elizabeth Street: this store resiliently showcases its Sicilian roots, stubborn to the changes of the area, and thankfully so. The charming façade is one of my favorites to photograph all year round.

L'Appartement Sézane – 254 Elizabeth Street: experience a beautiful dose of France inside this store. Sézane, the much-loved French label, has

set up home on Elizabeth Street. Formerly an online-only business, the store sells a selection of womenswear and beautiful lifestyle goods, all affordably priced. Like its Parisian flagship, the Nolita outpost is styled after the apartment of a woman you would like to hang out with. The changing rooms alone are among the most beautiful I have ever seen. With changing shopfront installations and a little seating area inside, it's worth a visit on any day of the year.

Pietro Nolita – 174 Elizabeth Street: go for the 'gram (think bijou pink interiors with a 1950s-inspired vibe), but stay for the delicious Italian food.

Cire Trudon – 248 Elizabeth Street: an acclaimed candle boutique that first opened on Elizabeth Street in 2015. The beautiful boutique was designed by Fabrizio Casiraghi and is a successful fusion of classical and modern elements. Alongside its signature candles, room sprays, and scented matches, it also stocks some cherry-picked vintage treasures.

Love Adorned – 269 Elizabeth Street: a jewelry, home goods, and quirky knick-knacks store, this little, beautifully curated shop is a destination in itself.

Elizabeth Street Garden – between Spring and Prince Streets: a small community sculpture garden.

GREEN SPACE

Elizabeth Street Gardens

HOTEL

Crosby Street Hotel,
11 Howard Street

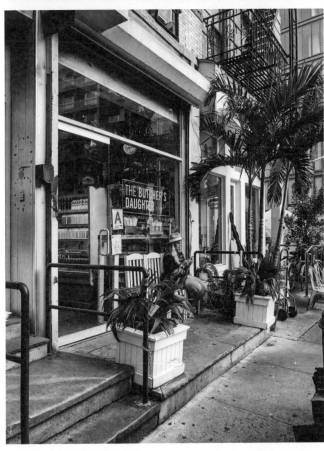

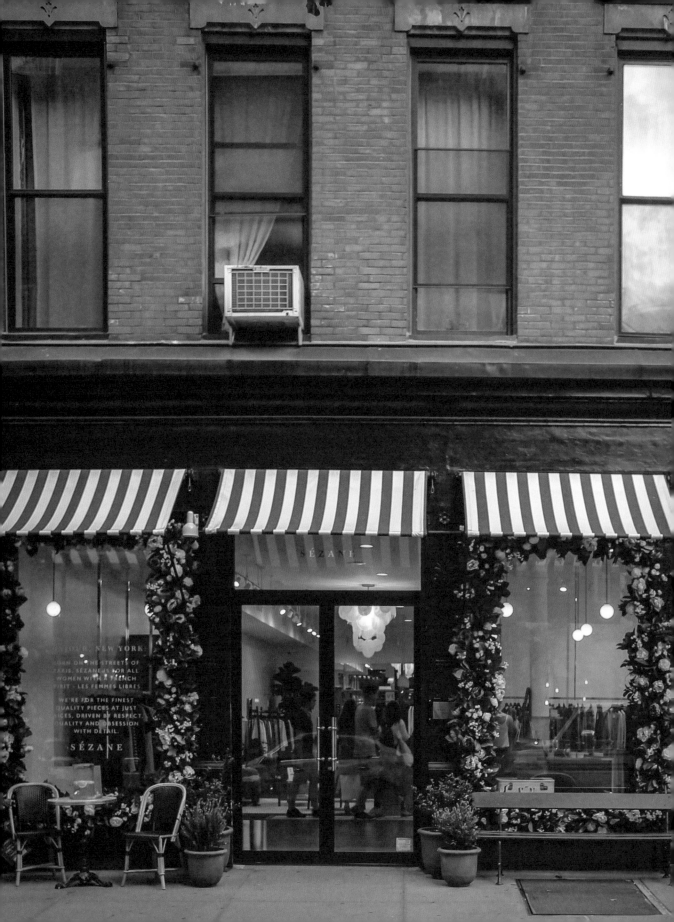

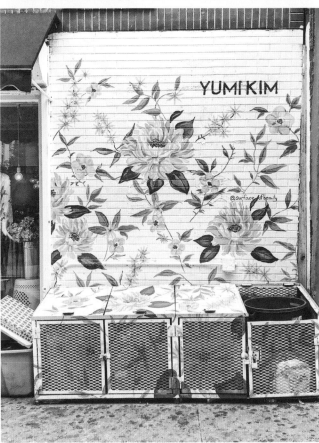

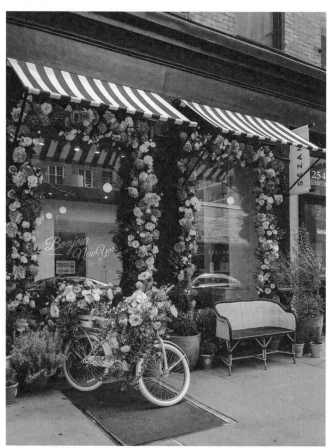

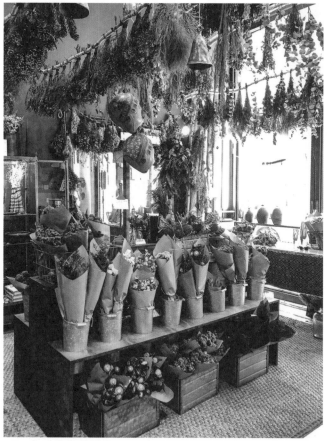
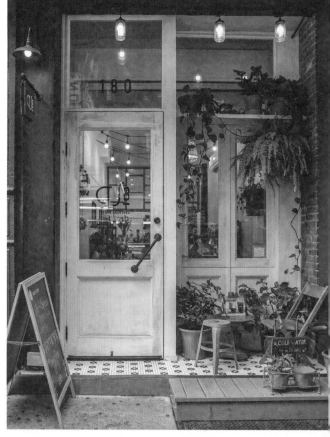

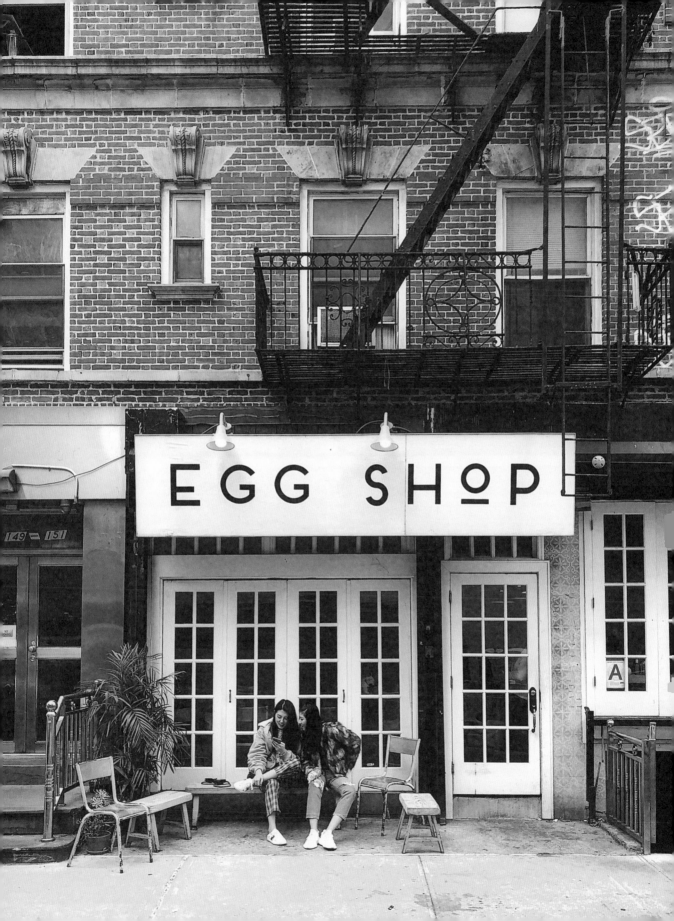

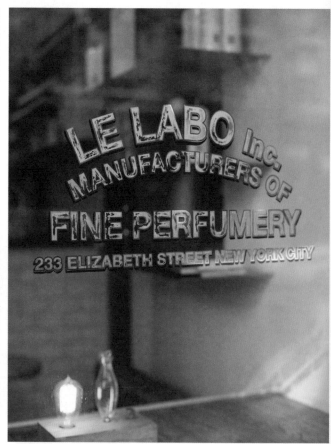

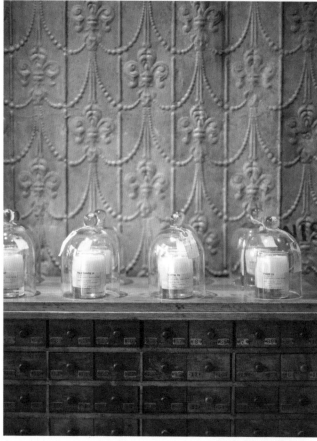

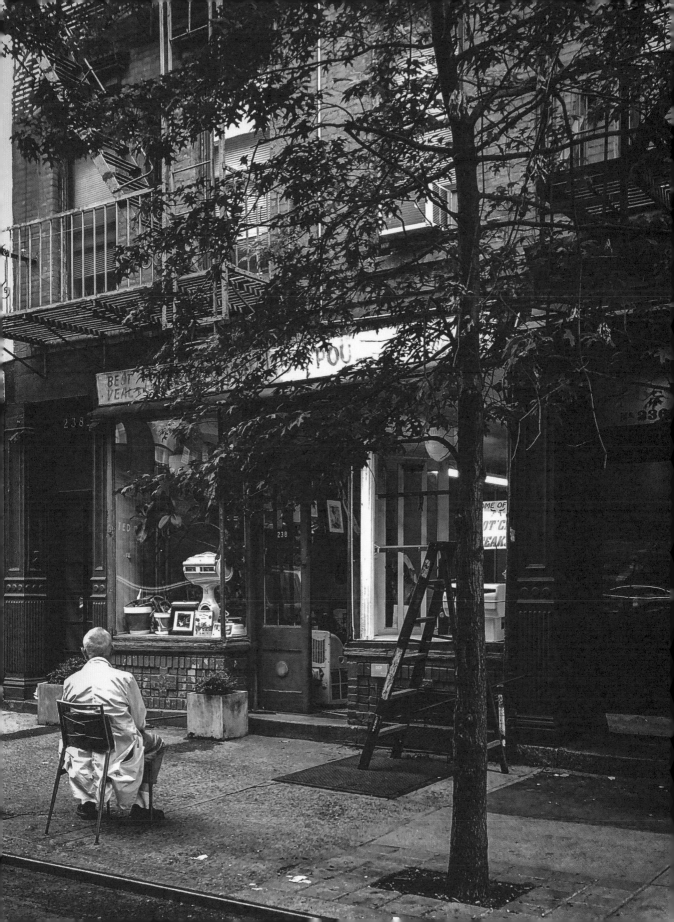

EAST VILLAGE AND THE LOWER EAST SIDE

LAID-BACK CHARM

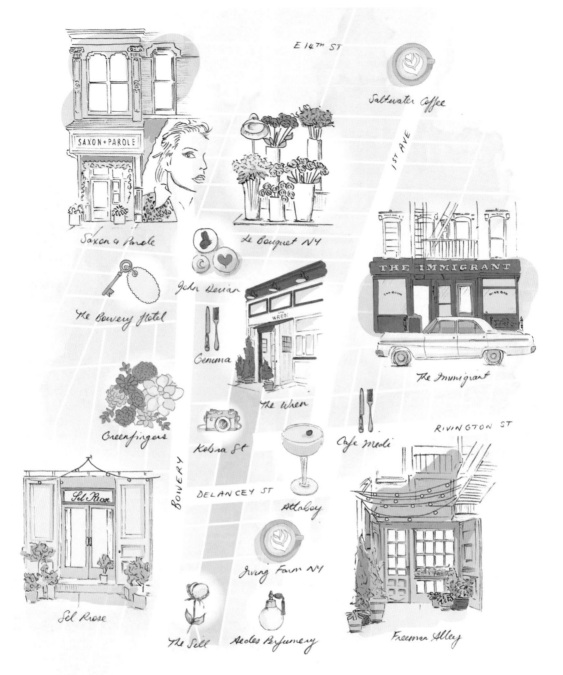

Saxon & Parole

Le Bouquet NY

Saltwater Coffee

E 14TH ST

1ST AVE

John Derian

The Bowery Hotel

THE IMMIGRANT

Gemma

The Wren

The Immigrant

Greenfingers

Kobra St

Café Medi

RIVINGTON ST

BOWERY

Sel Rrose

DELANCEY ST

Attaboy

Irving Farm NY

Freeman Alley

The Sill

Aedes Perfumery

EAST VILLAGE
& LOWER EAST SIDE

#prettycitynewyork

 GEMMA 335 Bowery
SAXON + PAROLE 316 Bowery
THE WREN 344 Bowery
SEL RROSE 1 Delancey St
CAFE MEDI 107 Rivington St

LE BOUQUET NY 116 East 4th St
GREENFINGERS 5 Rivington
THE SILL 84 Hester St

 Kobra Street, Freeman Alley

SALTWATER COFFEE 345 East 12th
IRVING FARM NY 88 Orchard St

AEDES PERFUMERY 164 Orchard St

 ATTABOY 134 Eldridge St
THE IMMIGRANT 341 East 9th

JOHN DERIAN 6 East 2nd St

THE BOWERY 335 Bowery

 PRETTY CITY · NEW YORK
The New York Times

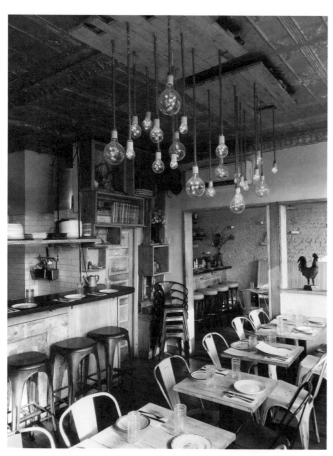

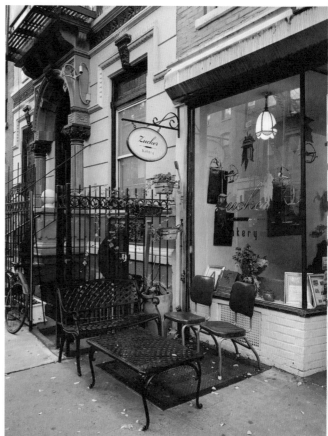

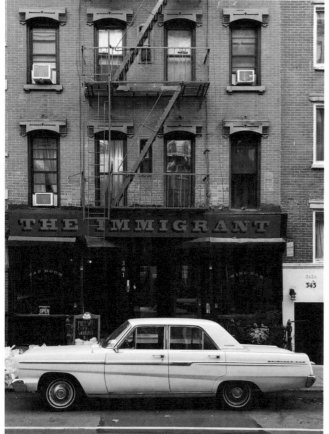

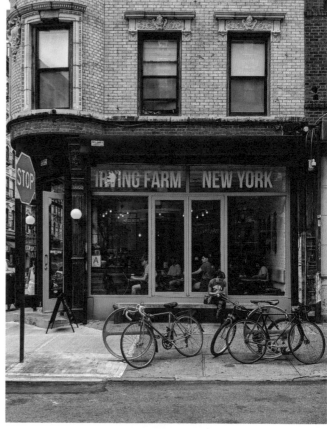

When we think of these areas of Manhattan, pretty and charming don't automatically spring to mind, but I was curious to explore them nonetheless – not least because the East Village is home to not one but three John Derian shops, and I also wanted to see the famous Katz deli in the Lower East Side.

The Lower East Side is roughly located between the Bowery and the East River, and Canal and Houston Streets. Traditionally an immigrant and working-class district, it began extensive gentrification in the mid 2000s. The bulk of immigrants coming to New York City in the mid-nineteenth century settled in the Lower East Side, where tenement buildings emerged. Here strong ethnic groups established distinct neighborhoods and places for them to preserve their cultures, languages, and foods. The East Village's history starts in around the 1960s, when it branched off from the Lower East Side. At this time the area experienced a severe decline, with crime, drugs, and abandoned housing dominating the area.

Today the area has been settled largely by vibrant artists and foodies, drawn to its creative community and melding of cultures. Cool bars, boutiques, and cultural venues play a lead role in this vibrant neighborhood.

EAST VILLAGE AND LOWER EAST SIDE HOTSPOTS:

John Derian – 6 East 2nd Street: browse the furniture, textiles, antique decoupage, and paper products designed by the genius artist John Derian. John opened his first shop on 2nd Street, selling handmade decoupage tabletop pieces, in 1995. He has since added two more next to the first one. Set aside an hour or two to mooch in here. The three stores, which sit side by side, convey an understated elegance, and are full to the brim with his own decoupage, gifts and household objects, dried goods, and animal-friendly 'taxidermy'.

The Immigrant – 341 East 9th Street: housed in an old tenement building, this refurbished pub and wine bar is worth a visit.

Freemans – Freeman Alley: famed on Instagram for its charming façade, but don't forget to step inside to try the hot artichoke dip and see the hanging antlers.

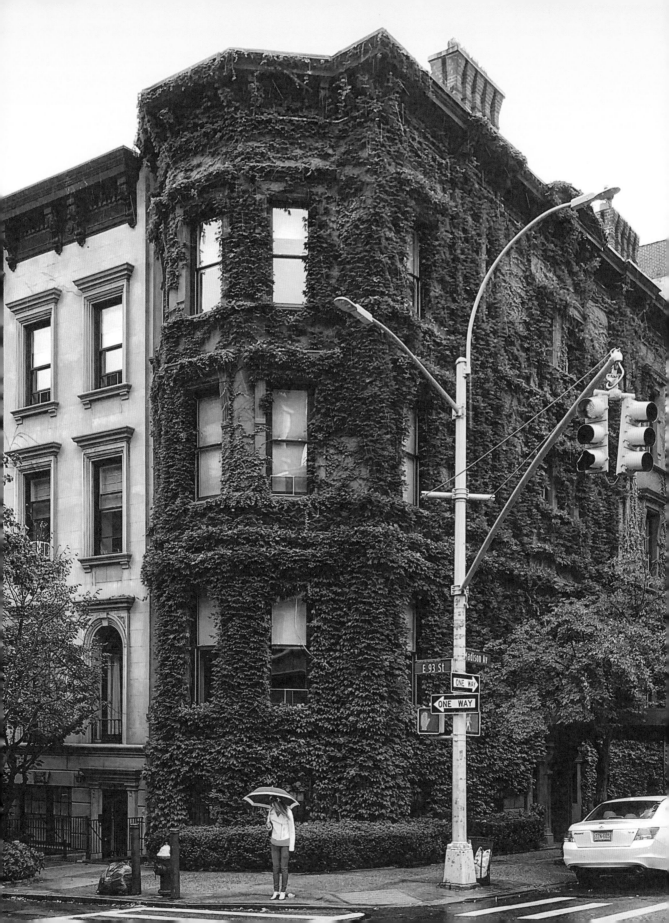

Green Fingers NYC – 5 Rivington Street: a quaint plant emporium that's a dream to photograph inside and out. The beautiful space is owned by cult Japanese plant artist Satoshi Kawamoto and is a sensitive blend of unique plants, typography, and quirky interiors.

Gemma – 335 Bowery: a stunning Italian trattoria inside the Bowery Hotel. A cozy interior is well balanced with a delicious and rustic menu. Go for the pizza.

The Sill – 84 Hester Street: sells an incredible selection of well-kept, easy-to-care-for plants, domestically sourced.

Aedes de Venustas – 16A Orchard Street: a beautiful boudoir specializing in candles and in-house perfumes since 1995. Its original aesthetic allows it to stand out from the crowd, and its new shop in the Lower East Side perfectly showcases its wonderful heritage while blending into the eclectic neighborhood.

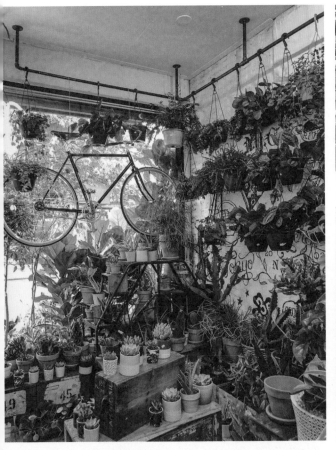

Russ and Daughters – 179 East Houston Street: This fourth-generation, family-owned institution dates back to the 1920s. Their New York brunch was listed as one of Oprah's favorite things of 2018; don't leave the area without a visit. Some might argue it has the best bagels and lox in all of New York.

The Smile – 26 Bond Street: set between Lafayette and the Bowery, locals love this cozy spot for a reason. Located in a landmarked 1830s Federal-style townhouse, it serves delicious Mediterranean-inspired dishes all day.

Goop Lab – 25 Bond Street: Goop bring a bit of West Coast style to their second bricks-and-mortar venture. Taking much inspiration from 1930s Hollywood homes, the 2,100 sq. ft space is very much a dream interior. They sell their own G label alongside a curated selection of items from prestigious brands like Brock and Rochas.

The Wren – 344 Bowery: an inviting bar with an American-meets-Irish vibe (maybe the Barry's tea on the menu adds to its charm). Artisanal cocktails, like the Wren Old Fashioned, work well alongside sophisticated bar bites. Apparently it has a lively crowd in the evenings, but it is an equally nice hangout during the day. I recommend a light bite and a glass of wine in the cozy nook at the front.

Saxone and Parole – 316 Bowery: a meat-centric restaurant with an equestrian-themed interior. The Pond Room, in its basement, has just opened and is seafood and rose focused.

Root and Bone – 200 East 3rd Street: superior classic Southern fare with aesthetically pleasing surrounds.

Sel Rrose – 1 Delancey Street: if you are in the market for oysters and cocktails, this little French-inspired spot with a cute interior and pretty al fresco dining area is the one for you. The menu features daily fresh East and West Coast oysters, and the white marble bar offers botanically infused cocktails. Champagne is on the menu too. Go for the picture-perfect façade, but stay for the elegant atmosphere.

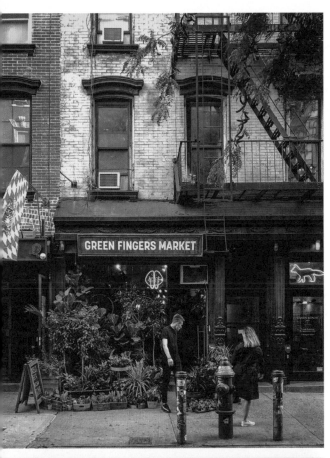

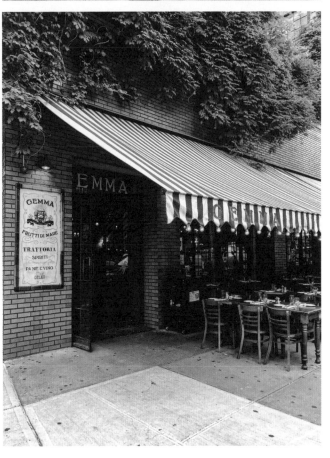

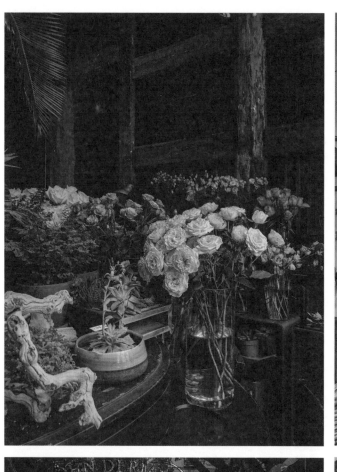
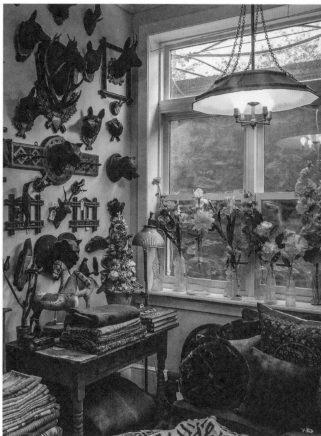

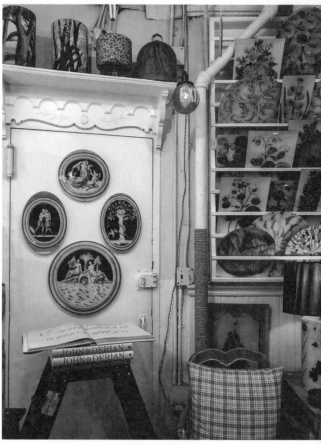

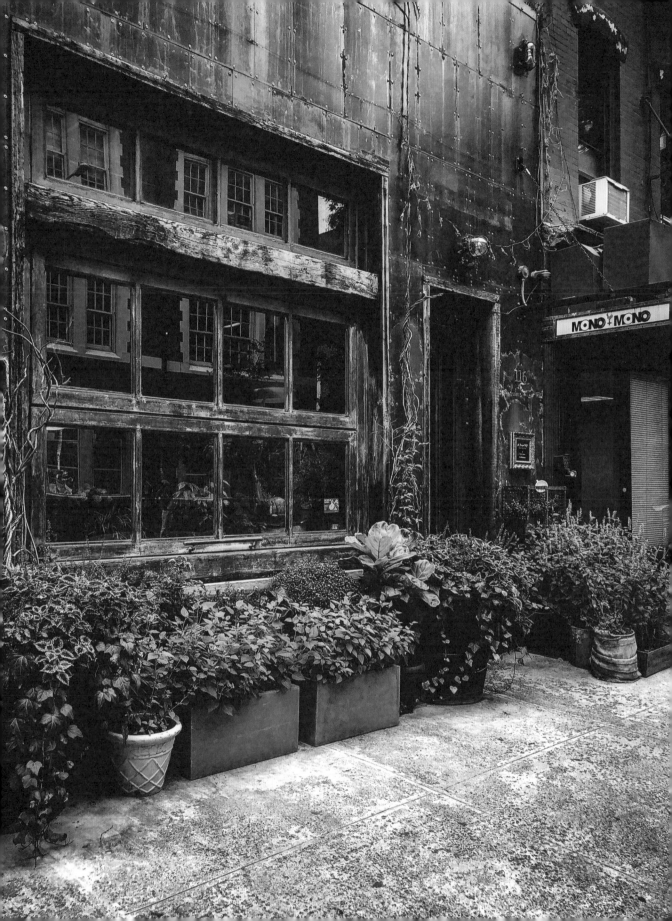

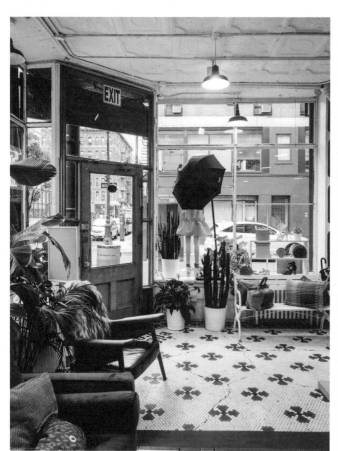

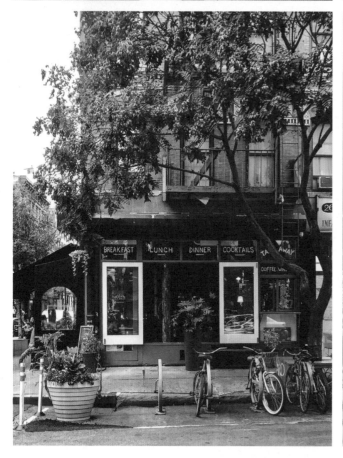

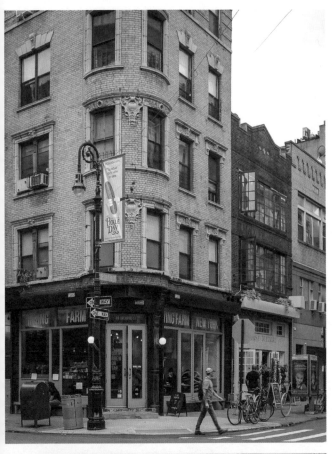

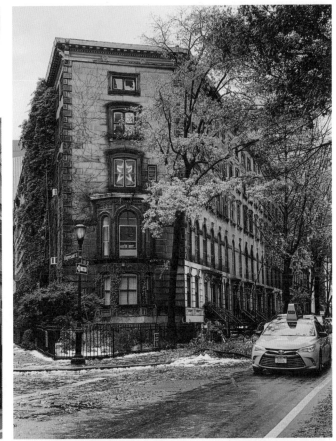

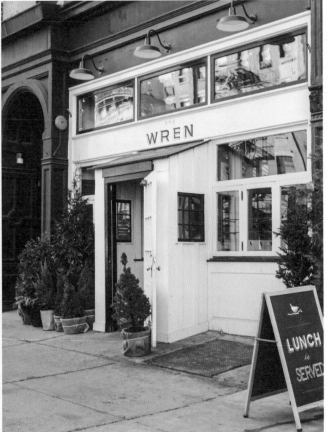

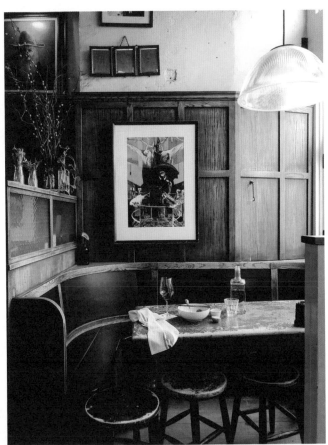

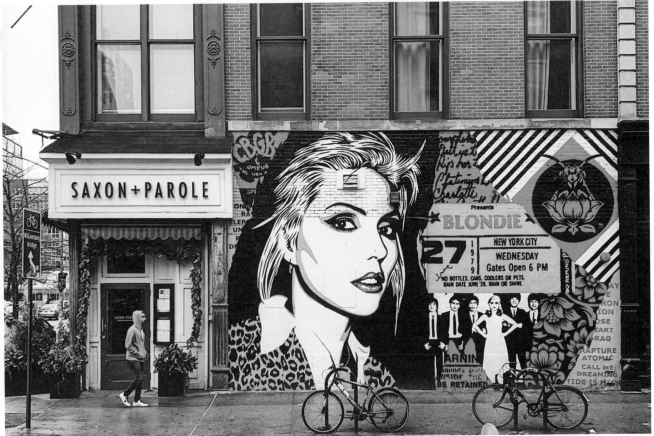

BROOKLYN

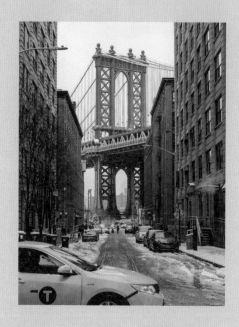

OLD-TIME FASHION,
ARTISTS' MECCA,
AND BEAUTIFUL
BROWNSTONES

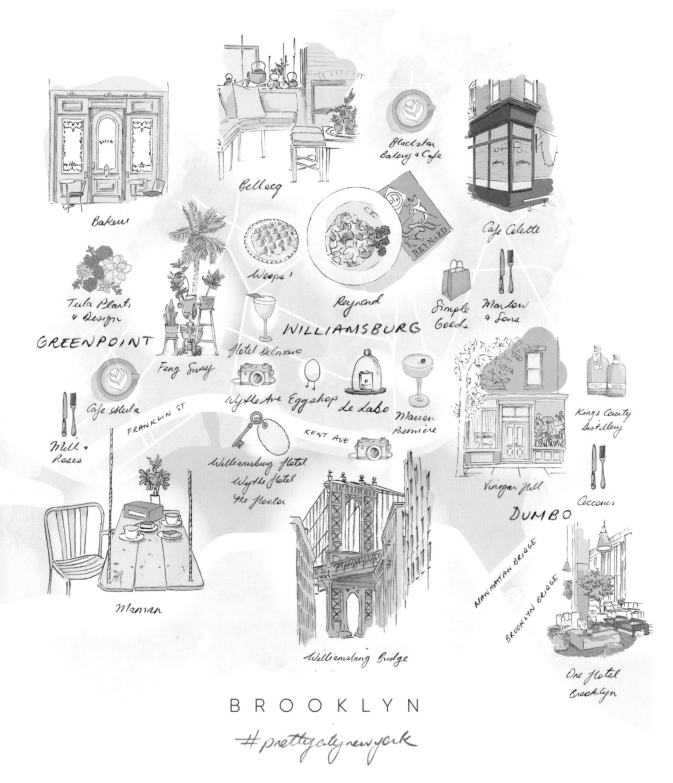

Bakeri

Bellocq

Blackstar Bakery & Cafe

Cafe Colette

Tula Plants & Design

Woops!

Reynard

Simple Goods

Marlow & Sons

GREENPOINT

WILLIAMSBURG

Feng Sway

Hotel Delmano

Wythe Ave Eggshop Le Labo

Maison Premiere

Kings County Distillery

Cafe Alula

FRANKLIN ST

KENT AVE

Milk & Roses

Williamsburg Hotel
Wythe Hotel
The Hoxton

Vinegar Hill

Cecconi's

DUMBO

Maman

Williamsburg Bridge

MANHATTAN BRIDGE

BROOKLYN BRIDGE

One Hotel Brooklyn

B R O O K L Y N

#prettycitynewyork

 MILK & ROSES 1110 Manhattan Ave
CAFE COLETTE 79 Berry St
CECCONIS 55 Water St

 TULA 59 Meserole Ave
FENG SWAY 86 Dobbin St

HOTEL DELMANO 82 Berry St
WILLIAMSBURG HOTEL 96 Wythe Ave
MAISON PREMIERE 298 Bedford Ave

BAKERI 105 Freeman St
CAFE ALULA 252 Franklin St
MAMAN 80 Kent St
WOOPS! 620 5th Ave
REYNARD 80 Wythe Ave
EGGSHOP 138 N West St
BLACKSTAR BAKERY & CAFE
565 Metropolitan Ave

 Wythe Ave, Kent Ave, Vinegar Hill,
Williamsburg Bridge, Brooklyn Bridge

 BELLOCQ 104 West St
LE LABO 120 N 6th St
SIMPLE GOODS 346 Bedford Ave

WYTHE HOTEL 80 Wythe Ave
THE HOXTON 97 Wythe Ave
ONE HOTEL BROOKLYN 60 Furman St

 PRETTY CITY
NEW YORK
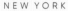

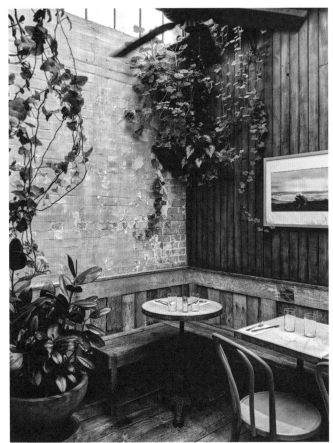
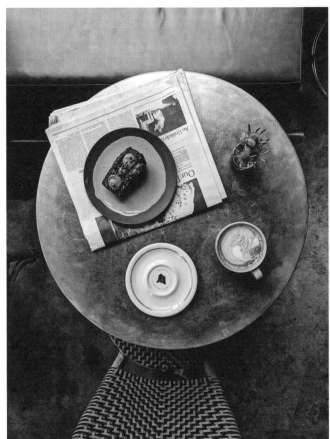

Brooklyn officially became a New York borough in 1898, but for decades after its primary function was to serve as a residential and industrial neighborhood. Today it has transformed into a global capital of creativity and culture. Rapid gentrification here means that areas like Williamsburg, Fort Greene, and Cobble Hill are among the most fashionable in the city, largely thanks to their tree-lined streets, lively art scene, innovative restaurants, fantastic bars, and infamous hipster vibe. Up until recent times there were no hotels in the neighborhood, but these days Williamsburg has three fantastic offerings on Wythe Avenue. The recent arrival of these beautiful hotels means it is now a mecca to rival Manhattan.

Brooklyn has so much to offer. Technically speaking, Brooklyn is in fact larger than Manhattan and is full of bustling neighborhoods. Each of its neighborhoods has its own allure, and it can be a daunting task to think about where to go, especially if time is precious. Most people add a day trip to Brooklyn onto their New York City itinerary, although I predict a shift in this trend with the recent influx of hotels; however, to help you decide where to go I have compiled a list of my favorites – a whistle-stop tour of sorts.

WILLIAMSBURG

Williamsburg, with its reputation as one of the trendiest enclaves in Brooklyn and indeed in all of New York City, is one of my favorite neighborhoods in the area. The trendy Williamsburg scene plays out against a backdrop of old industrial buildings with a mish-mash of cultures; perhaps it is not as beautiful as landmarked brownstone Brooklyn, but it is hugely appealing thanks to its idiosyncratic shops and relaxed village-like atmosphere. This exciting enclave straddles old and new effortlessly. Sleek waterfront properties and new hotels like the Hoxton, the Williamsburg, and the Wythe, along Wythe Avenue, attract the crowds. Bedford Avenue, the main drag, and the streets between North 9th and Broadway that cross it, are dotted with enough boutiques, galleries, artisan cafes, restaurants, and bars to keep you happy for an entire day and well into the night too.

WILLIAMSBURG HOTSPOTS

Bakeri – 150 Wythe Avenue: this tiny old-world cafe and bakery with Norwegian roots is worth a trip to Brooklyn alone. Try to go at off-peak times to snag the little nook at the front; if you do manage to get it, it will be hard to leave. Rosemary chocolate chip cookies, skolebrød (classic Norwegian custard-stuffed cardamom buns topped with coconut), and other delights are all baked in house. The space itself is vintage and eclectic and welcoming overall, making it my very favorite gem.

Le Labo – 120 North 6th Street: the Brooklyn outpost is perhaps my favorite of all the city's Le Labos. The building is flooded with natural light, while its industrial undone interiors, fitted with trademark black steel shelving, distressed wall finishes, credenza desk, and distressed vintage armchair are simply beautiful. For me, Le Labo's appeal lies in its perfectly imperfect vibe – though, of course, everything is carefully considered in that Japanese *wabi-sabi* way. Step inside this store to find aesthetically beautiful interiors and lingering scents of sweet and spicy notes. The friendly staff are well informed and at hand to freshly compound each bottle while you wait.

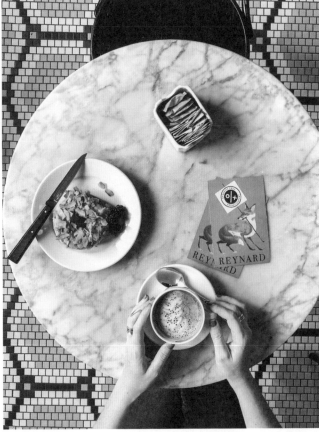

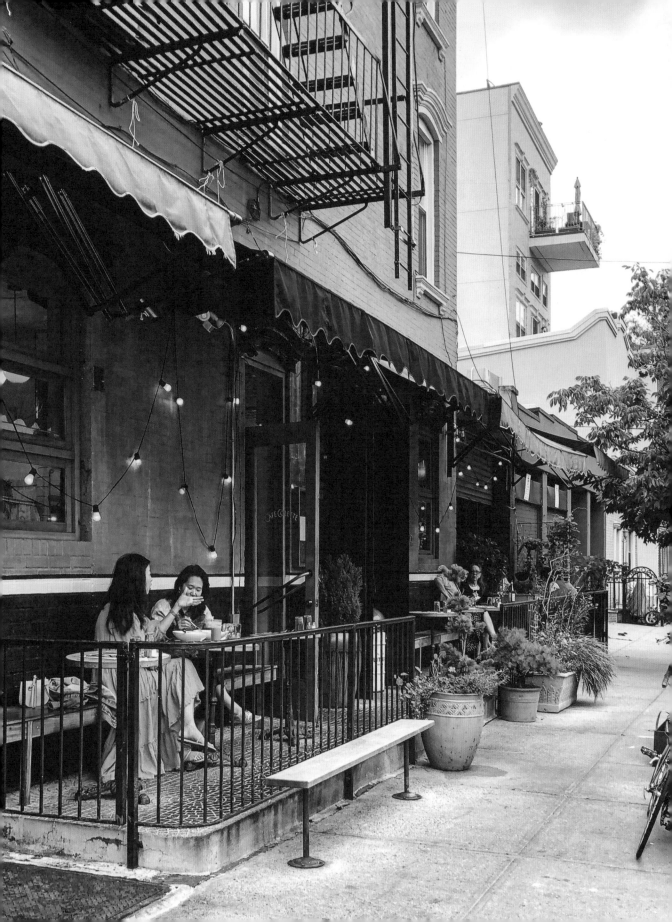

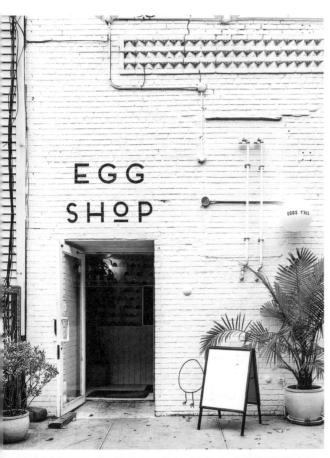

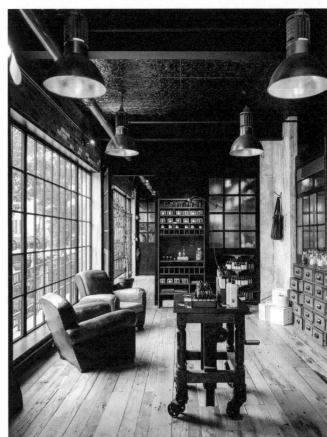

While they don't create bespoke scents, they do personalize your chosen perfume's label with a message of your choice. The Le Labo range includes candles, body, face, and hair products, as well as detergents, as a result of collaboration with eco-friendly NYC label The Laundress.

Partners Coffee Roasters (formerly Toby's) – 125 North 6th Street: the original and spacious flagship cafe and brew school with a roaster on site. The tiny kitchen serves breakfast and lunch daily. Try the award-winning sandwiches or baked goods from local artisans.

Bedford Cheese Shop – 265 Bedford Avenue: a treasure trove of meticulously kept imported and local handmade gourmet treats, with a rather amazing selection of high-grade international cheeses. The establishment is old-fashioned, but the staff don't mind you sampling.

Cafe Colette – 79 Berry Street: designed and built by Zen Sewart of Hotel Delmano. Go for the rustic surrounds, soft color palette, and garden greenhouse, but stay for the delicious food. The perfect spot for an early morning coffee, brunch with friends, or a romantic dinner date.

Marlow and Sons – 81 Broadway: sister restaurant to Andrew Tarlow's Diner. The simple façade is part of the appeal: this cozy, friendly spot is much loved and gets all sorts of accolades for good reason. Try the brick chicken or opt for some takeaway sandwiches from the deli at the front.

Pink Olive – 370 Bedford Avenue: sister to Pink Olive in the West Village and East Village. A whimsical boutique full of books, stationery, and special gifts, with beautifully curated windows to boot.

Reynard – 80 Wythe Avenue: a handsome restaurant attached to the Wythe Hotel with art deco-styled lamps, wood-beamed ceilings, exposed brick walls, and stunning tiled floors. The American menu with a wood-fired cooking focus includes classics such as poached eggs and frittatas, but it would be a sin not to order the sourdough pancakes. If you are there for something heartier, you can't go wrong with their decadent take on a burger, which comes with raclette and horseradish mayonnaise.

Kleins – 97 Wythe Avenue: the all-day restaurant attached to the new Hoxton Hotel on Wythe Avenue is sure to become a local staple, serving American comfort food in an elevated fashion (think meatballs and roast chicken with potato puree). The menu was created by Zeb Stewart of Cafe Colette and Bud Mongell of Five Leaves. If you can, dine at the square-shaped bar in front of the open kitchen.

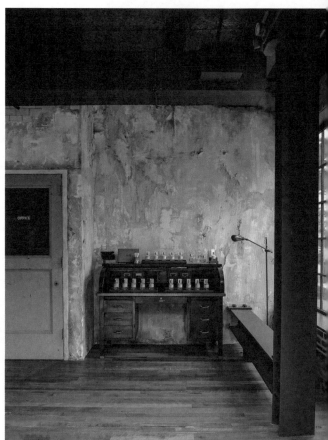

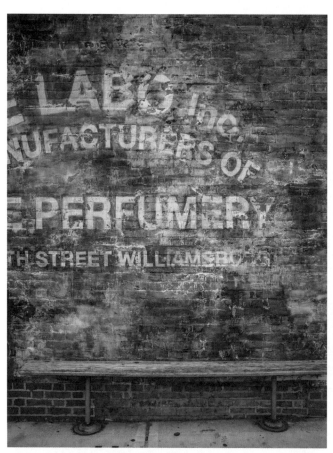

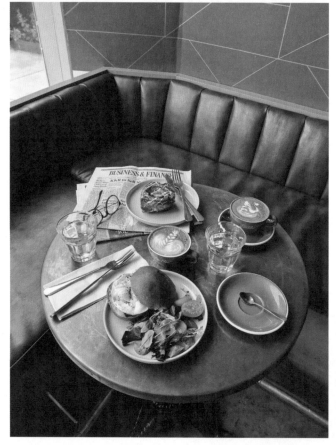

Egg – 109 North 3rd Street: a cozy and friendly breakfast-only spot. Expect a queue, but it's worth the wait. Try the egg in a hole topped with cheddar cheese or the country ham biscuit served with a side of grits.

Diner – 85 Broadway: located in an old dining car and with an ever-changing menu written out daily on your paper table covering; if the buckwheat pancakes happen to be on, be sure to order them.

Maison Premiere – 298 Bedford Avenue: a charmingly old-world backdrop complements the exquisite oysters and champagne menu. This New Orleans-inspired bar is best known for its lobster roll and absinthe, and for its shellfish happy hour.

The Hoxton Hotel – 97 Wythe Avenue: a British hotel brand taking the world by storm, and this venue has it all: a rooftop restaurant with unrivaled views of the Manhattan skyline, gorgeous interiors inspired by the surrounds of Williamsburg, welcoming lobby, and fantastic restaurants. You would be forgiven for staying in and skipping sightseeing altogether.

Hotel Delmano – 82 Berry Street: an old-world New York aesthetic acts as the perfect backdrop for delicious cocktails.

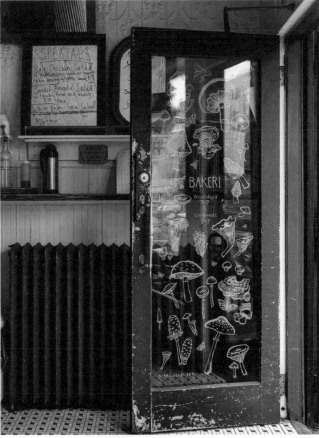

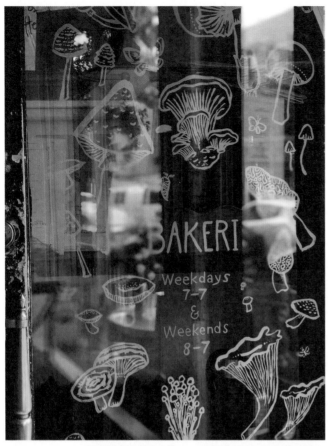

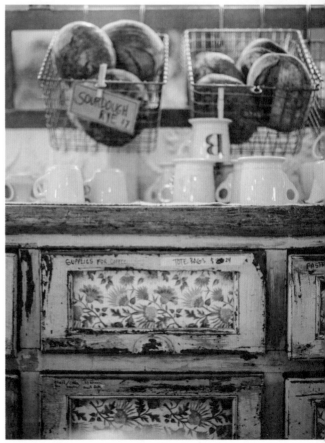

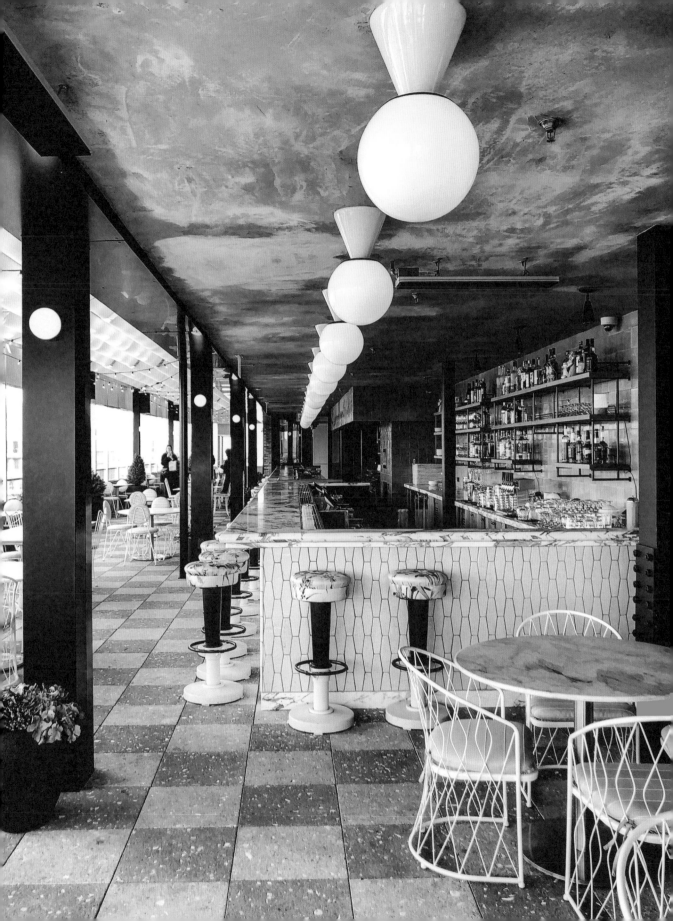

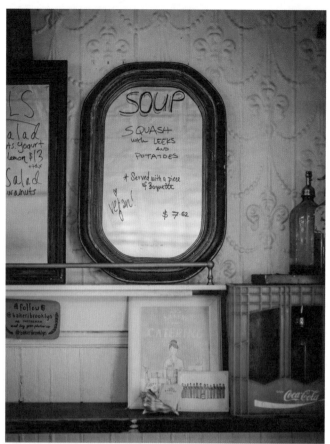

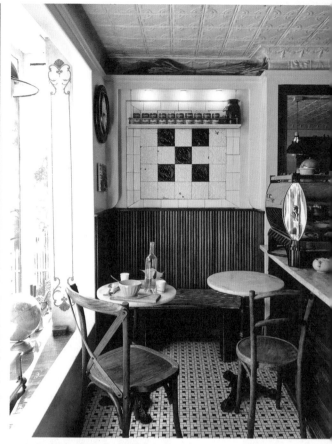

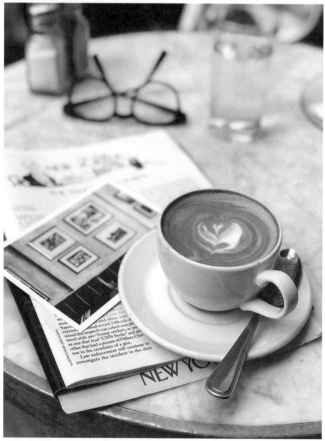

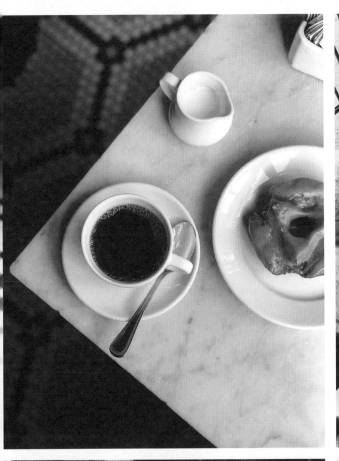
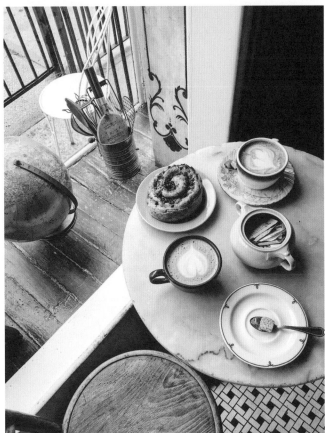
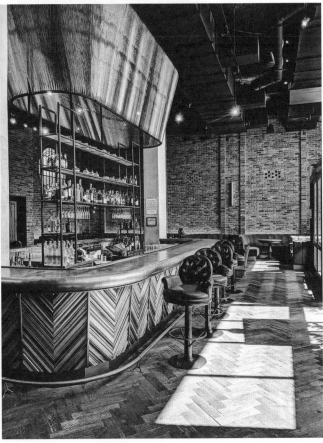
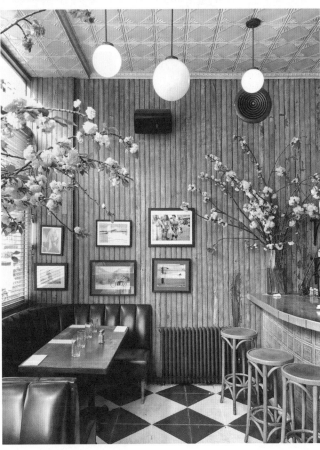

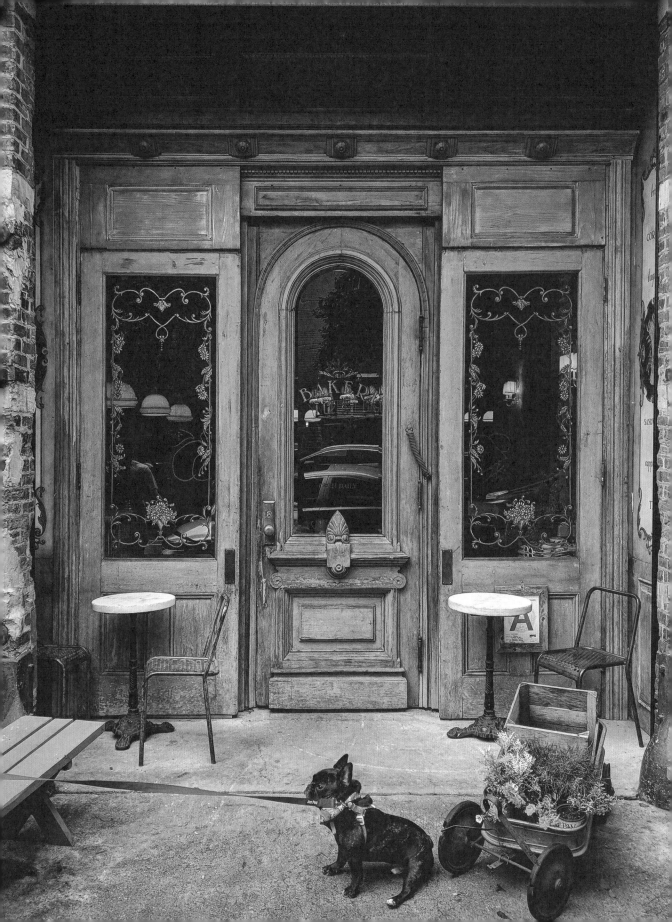

GREENPOINT

Just north of Williamsburg is the more low-key Greenpoint. This area is quieter and no less charming; admittedly, finding the second Bakeri and Maman were my main draws, but I soon discovered this old-world multicultural enclave has so much more besides.

Homecoming – 107 Franklin Street: this quaint store is a florist, home boutique, and cafe combined, and carries a mix of mostly locally made ceramics, books, and small design goods. It serves local favorite Bellocq tea and Blue Bottle coffee. Not in the market for some indoor plants? Don't worry, you can walk out with a beeswax totem candle or Postalco notebook.

Bellocq Tea Atelier – 104 West Street: a simply beautiful tea atelier. On first impression you could be forgiven for turning on your heels and running down the humble street, but the large industrial frontage couldn't be more of a contrast to the setting inside. Behind those industrial black doors, a magical tea emporium awaits. Originating in London but now headquartered in Brooklyn, a visit here is an absolute must. You have to ring the bell to enter but once inside you will find a calm oasis and a haven of curiosities – rows of yellow caddies filled with organic teas are set against a stunning backdrop. The highlight of the space is the sitting room, with dusty pinky seats and hints of gold. You can sit here for a while and sample some of the atelier's fine collection. Friendly and well-informed staff make the entire experience a delight.

Maman – 80 Kent Street: the perfect cafe to work, meet friends, or read a book. In keeping with the company's rustic approach to interiors and atmosphere, this Maman is simply stunning. Go to see the swing-inspired tables and upstairs space, but stay for the quiche and chocolate chip cookie. The cute coffee cups are to die for, too. Try to leave room for the famous lavender hot chocolate.

Bakeri – 105 Freeman Street: it's love at first sight for this sister to Bakeri in Greenpoint. The tall, decorative, wooden doors are simply beautiful. The outside seating space is too. Bakeri Greenpoint was born out of a need

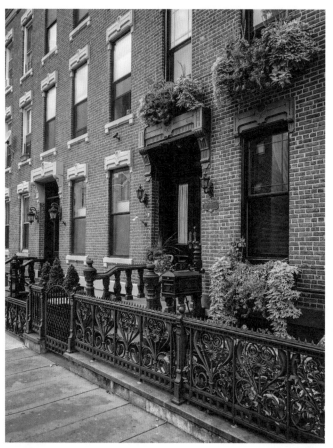

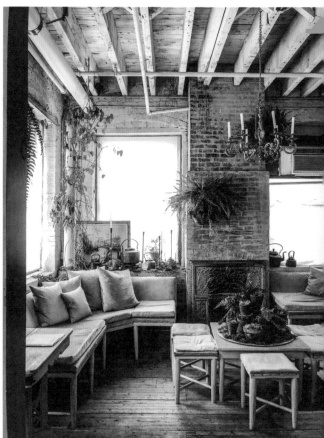

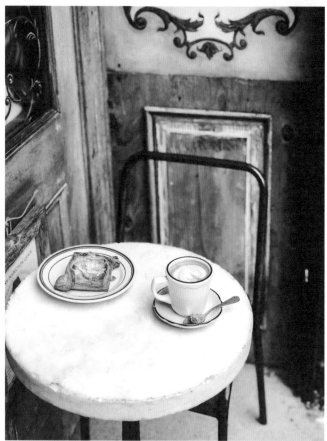

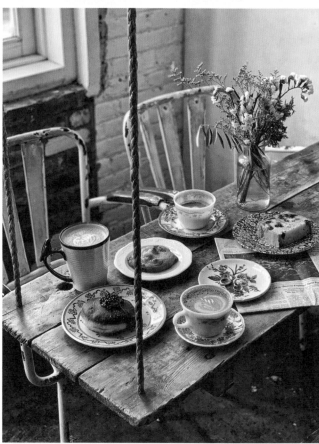

to create more room for baking. The space is decorated with handmade crafts picked up by owner Nina Brondmo on her travels; the quirky and individual interiors complement the delicious food. The highlight of the inspiring space is the beautiful French-designed wallpaper by Nathalie Lété – that and the gorgeous communal table. It's the perfect spot for lunch or a takeaway snack.

Five Leaves – 18 Bedford Avenue: a relaxed restaurant with an Australian vibe, opened in honor of the late Heath Ledger. Its no reservations policy might mean a little wait at the bar … the perfect excuse to try the Turmeric Bees Knees cocktail.

Feng Sway – 86 Dobbin Street: located on an industrial strip in Greenpoint, with an eye-catching storefront, this is worth a trip for sure. There is a mish-mash of tropical plants and vintage goods sourced by shop owner Kate Lauter.

Milk and Roses – 110 Manhattan Avenue: serves southern Italian fare with heavy American influences and features two very different yet equally beautiful spaces. Inside you will find the library wall, complete with red leather couches, and out the back, a lush and glorious indoor garden.

FRANKLIN STREET

Don't leave Greenpoint without a walk down Franklin Street, with its high concentration of indie boutiques offering homewares, books, and fashion, mostly sourced locally. Wolves Within, Home of the Brave, and Alter are among the best.

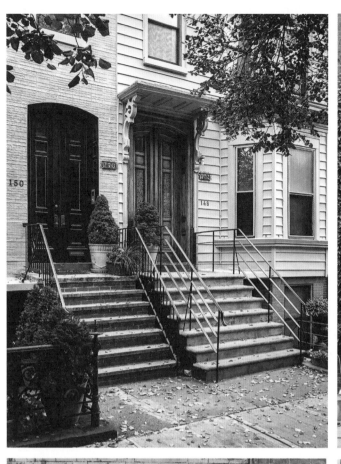

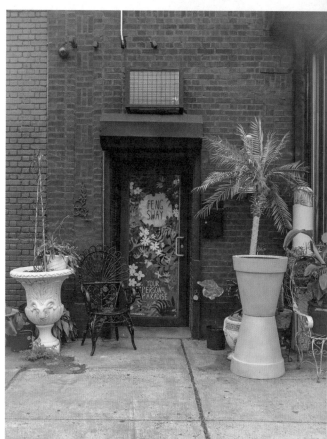

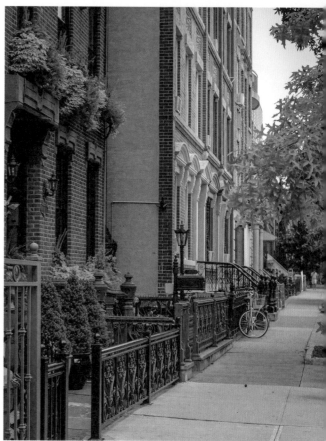

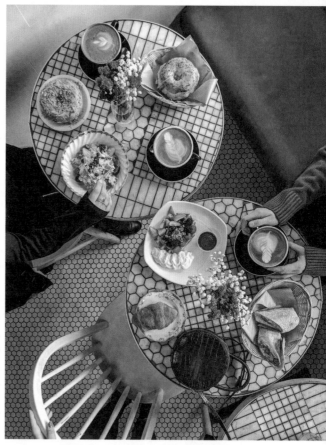

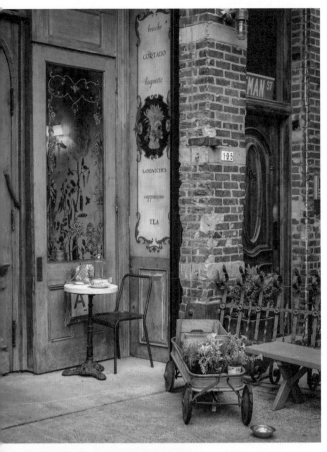

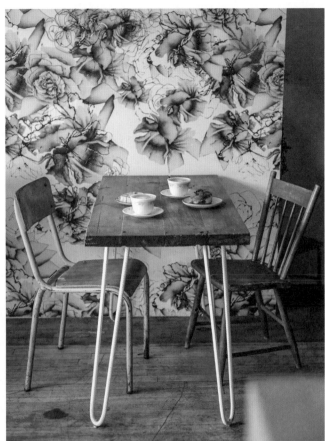

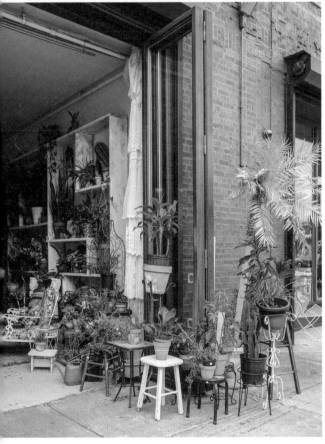

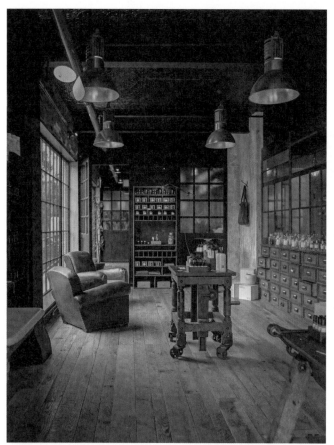

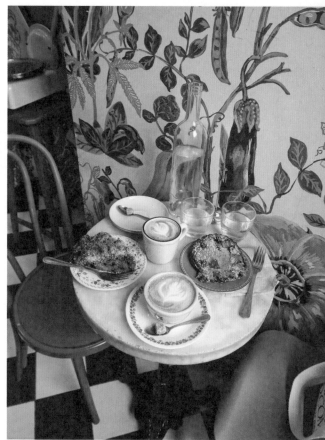

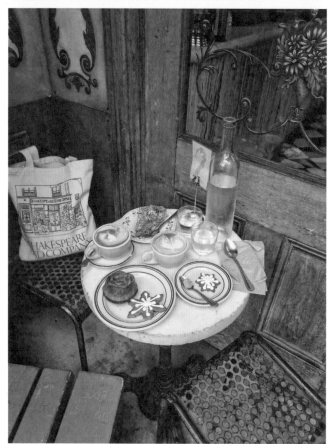

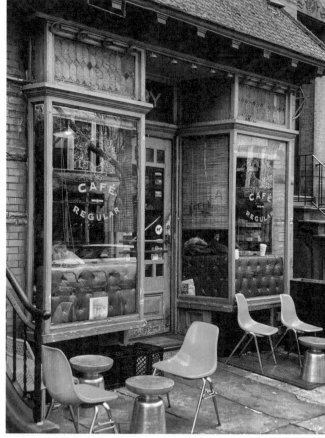

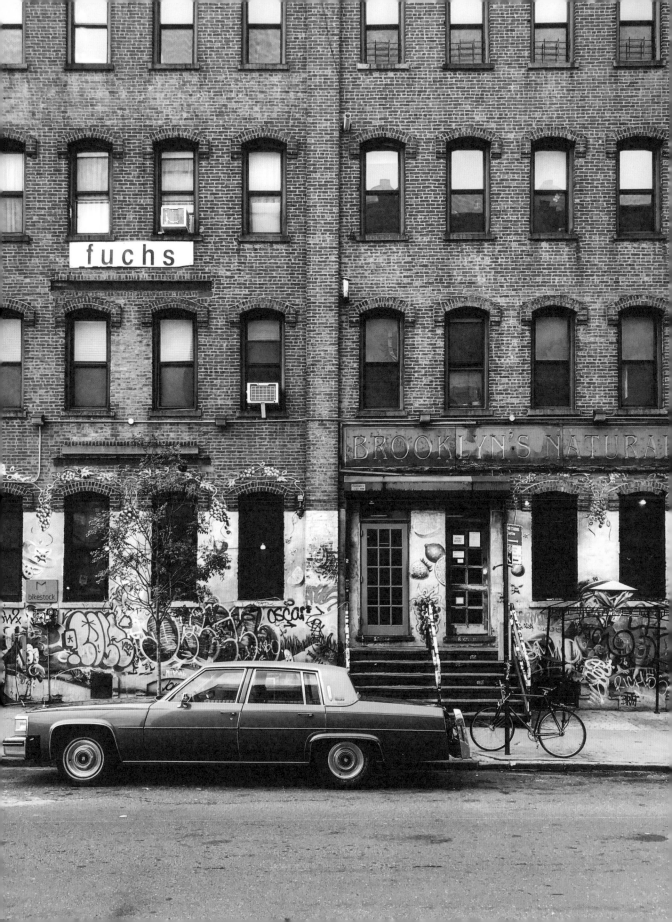

DUMBO, VINEGAR HILL, AND OLD NAVY YARD

DUMBO

For many years people headed to Dumbo (Down Under Manhattan's Bridge Overpass) simply to begin their walk across the Brooklyn Bridge, but today this often ignored district has become a popular destination in its own right. The best view of the Manhattan Bridge is on Washington and Main Street – with the Brooklyn Bridge towering at the end of the street and framing the Empire State Building and beyond. Also in the area and worth seeing is Jane's Carousel, which dates back to the 1920s. The Carousel was built for an amusement park in Ohio and donated to Brooklyn when the park closed in the 1980s. It can be accessed via entrances at Dock Street and Main Street.

DUMBO HOTSPOTS

Jacques Torres Chocolate – 66 Water Street: a chocolate emporium with a Willy Wonka vibe.

Cecconi's – 55 Water Street: features a terrace with waterfront views of the Manhattan skyline and a pretty handsome interior, complete with marbled flooring, exposed brick, and large bar with seating. Food is classic Italian: think veal Milanese and crisp-edged pizzas.

Grimaldis – 1 Front Street: firing up some of the best pizza in New York City.

1 Hotel Brooklyn Bridge – 60 Furman Street: eco-friendly and recently opened with one of the best rooftop bars in all of New York City.

Empire Stores – 55 Water Street: head to the landscaped public amenity atop the newly renovated Empire Stores for amazing waterfront views, or explore the many wonderful shops that occupy the building, including Shinola, West Elm, Feed, and J. Crew.

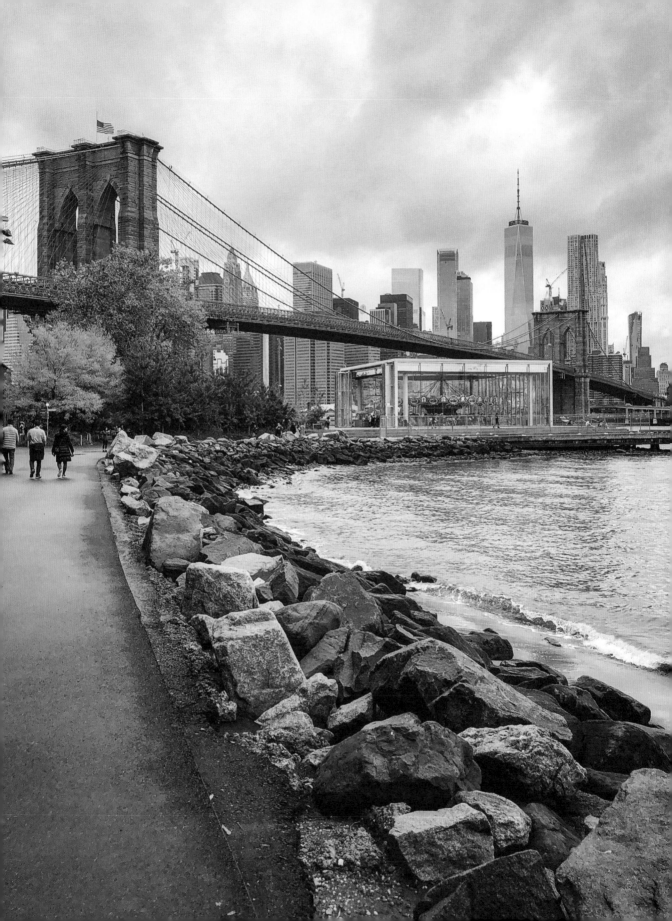

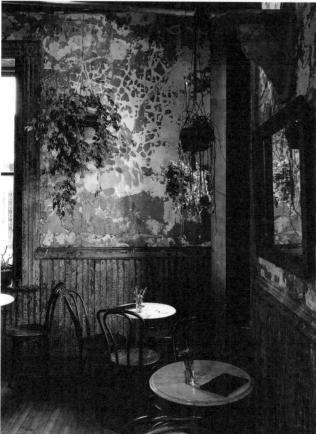
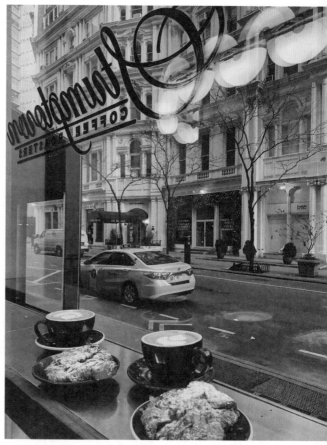

VINEGAR HILL AND OLD NAVY YARD HOTSPOTS

Vinegar Hill House – 72 Hudson Avenue: a pocket-sized enclave (just four or five blocks) located east of Manhattan Bridge, and a charming little area that time seems to have forgotten. The main drag, Hudson Avenue, is dotted with quaint historic brick-and-frame houses and lacks any commercial activity, giving it an unassuming sleepy vibe. Marry a walk through with a visit to Dumbo, and pop into Vinegar Hill House for the sourdough pear pancakes.

Brooklyn Navy Yard – 141 Flushing Avenue: Kings County Distillery is New York City's first legal distillery since prohibition. Founded in 2010, the distillery produces handmade moonshine, bourbon, and other whiskeys in the grand old Paymaster Building. Visit the beautiful buildings and see why this special distillery was voted Distiller of the Year by the American Distilling Institute in 2016.

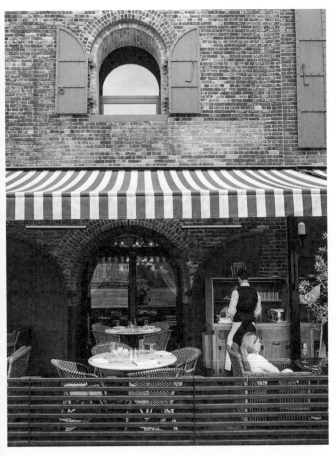

UPPER EAST SIDE AND CENTRAL PARK

GREEN SPACES,
GRAND MUSEUMS,
AND HIGH-STYLE
FAVORITES

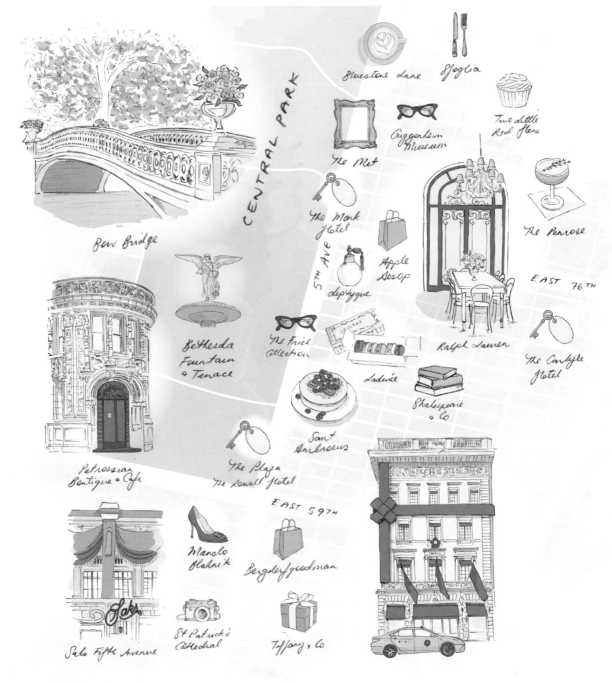

Bluestone Lane · Sfoglia · Two Little Red Hens · Guggenheim Museum · The Met · The Mark Hotel · Apple · Aesop · Diptyque · The Penrose · EAST 76TH · Ralph Lauren · The Carlyle Hotel · CENTRAL PARK · 5TH AVE · Bow Bridge · Bethesda Fountain & Terrace · The Frick Collection · Ladurée · Shakespeare & Co · Sant Ambroeus · Petrossian Boutique & Cafe · The Plaza · The Lowell Hotel · EAST 59TH · Saks Fifth Avenue · Manolo Blahnik · St Patrick's Cathedral · Bergdorf Goodman · Tiffany & Co

UPPER EAST SIDE
& CENTRAL PARK

#prettycitynewyork

 SFOGLIA 1402 Lexington St

 PETROSSIAN 911 7th Ave,
CENTRAL PARK Bethesda
Foundation, Bethesda Terrace
& Bow Bridge, 5TH AVE
St Patrick's Cathedral,
Luxury Stores

 THE CARLYLE HOTEL E 76th St
THE PLAZA 5th Ave
THE LOWELL HOTEL 28 E 63rd St
THE MARK HOTEL 25 E 77th St

 BLUESTONE LANE 1085 5th Ave
RALPH LAUREN 888 Madison Ave
TWO LITTLE RED HENS 1652 2nd Ave
LADURÉE 864 Madison Ave
SANT AMBROEUS 1000 Madison Ave

 GUGGENHEIM MUSEUM
1071 5th Ave
MET MUSEUM 5th Ave
FRICK COLLECTION 5th Ave

 AESOP Madison Ave
DIPTYQUE 971 Madison Ave
APPLE 940 Madison Ave
SHAKESPEARE & CO
939 Lexington Ave

PRETTY CITY
NEW YORK

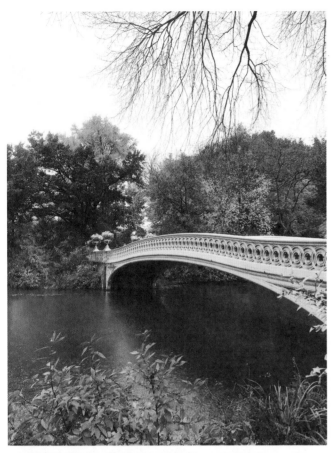

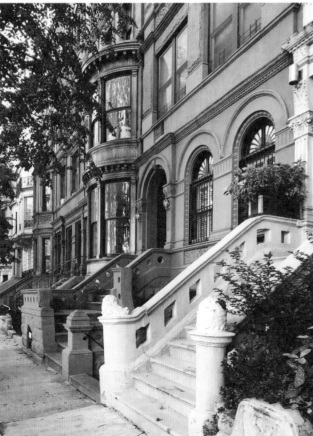
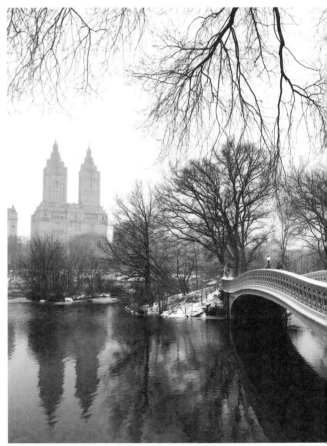

The Upper East Side is one of the city's most prestigious neighborhoods, most famous for its historic townhouses, prep schools, and of course the wonderful Museum Mile. While most other neighborhoods have been penetrated by immigrations and artistic trends, this one has for the most part remained unchanged. The area was once home to dynasties such as the Rockefellers, the Whitneys, and the Astors. Many of their Beaux-Arts grand mansions are now beautiful museums, including the Met, the Guggenheim, and the Frick.

The wealthy residents attract chic boutiques, stylish cocktail lounges, and high-end restaurants. It is the epicenter of luxe thanks to its famous boulevards; Fifth, Park, and Madison. Madison and Fifth are lined with designer clothes stores, while Park – a primarily residential strip – has sweeping views down south. As Fifth Avenue progresses north alongside Central Park, it becomes Museum Mile. My favorite time to explore this area is at Christmas, in order to get a glance at the notable window displays at Bergdorg Goodman, Cartier, and other gorgeous shops.

Central Park is on its western border and offers a tranquil retreat from big-city living. Set smack in the heart of Manhattan, it extends from 59th to 110th Street. It is a beautiful oasis comprising 843 acres of elm-lined walkways, manicured gardens, lake and a reservoir, a zoo, and an outdoor theatre. The Loeb Boathouse and the Bethesda Terrace are two beautiful marvels inside its gates.

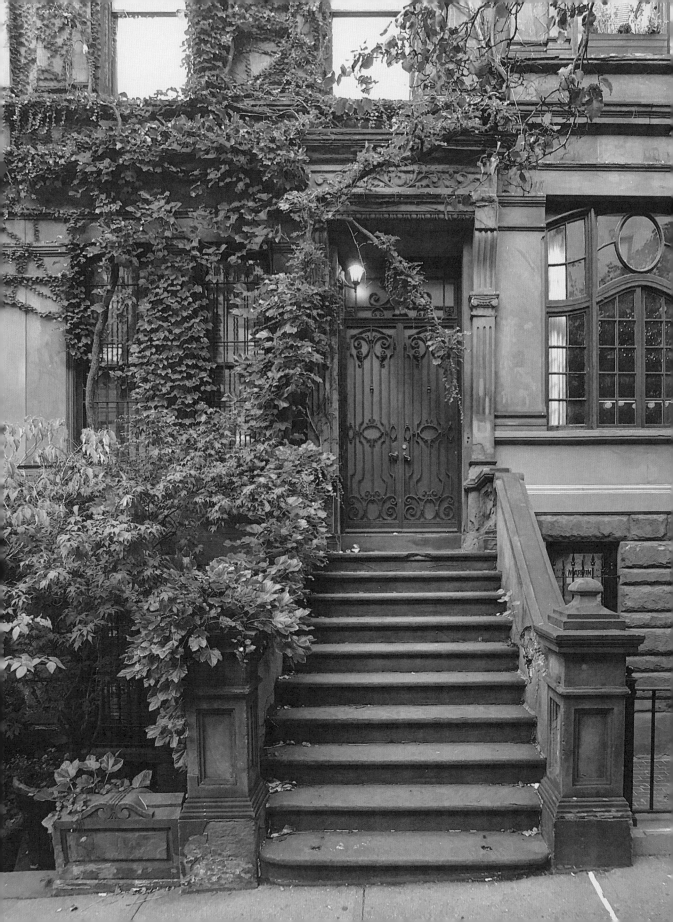

Suggested route:

Grab a coffee or sit and have breakfast at Bluestone Lane, located on East 90th Street, across from Central Park and adjacent to the beautiful historic Church of Heavenly Rest. It offers a seasonal menu of healthy breakfasts and lunches that perfectly complement the delicious coffee. In the warmer months you can opt to sit outside, but in the colder ones arrive early to snag a table – it is cozy!

Pop into Cooper Hewitt on East 91st Street, housed in Andrew Carnegie's former Georgian mansion; it still maintains the beautiful original dark wood-lined interiors and imposing staircase. It reopened in 2014 after extensive refurbishment and is well worth seeing, as is the stunning museum shop.

After visiting Cooper Hewitt, stroll down Madison and take in the stunning views down south – be sure to meander around here – before veering off to see the stunning houses along East 78th Street between Park and Lexington. I also like the stretch of shops alongside Aesop on 1070 Madison between East 81st and East 80th Street. If you are getting peckish, you could head to Jones Wood Foundry for a mellow atmosphere and pub grub, or to Cafe Sabarsky or Sfoglia for something more refined. Le Moulin, a cafe over on York Avenue, is also noteworthy, serving comfort food and small plates.

The stretch between East 79th and East 72nd Street is also beautiful, and I highly recommend a visit to Ralph's, the aesthetically pleasing cafe inside Ralph Lauren Women's on Madison Avenue between East 72nd and 71st Street, or Sant Ambroeus, a gorgeous Milanese restaurant between 78th and 77th Street.

Head to East 70th Street to find the Frick Collection Museum. The lavish mansion and former home of the steel and railway tycoon Henry Clay Frick houses a breathtaking collection of paintings by many of the European masters, such as Rembrandt, Goya, and Bellini. There is a fee to enter and photos are forbidden save for inside the interior courtyard, which is planted with beautiful ferns and centered on a stunning fountain. The intimate little shop is also worth a visit. If you only have time for a visit to one museum on your trip to New York City, make it this one.

After the cultural stop, head along East 70th Street to see the elegant houses that line this street, each more beautiful than the next. They range

from an 1863 white-painted brownstone at number 129 to an international-style edifice at number 124, designed in 1940 by William Lescaze. Number 125, a post-World War II mansion, was built for Paul Mellon in a French provincial style.

Is it time for some shopping? It must be. Then stay on Madison or stroll down Fifth Avenue.

UPPER EAST SIDE HIGHLIGHTS

Tiffany and Co. – 727 5th Avenue: a synonym for style and taste. Inside the grand 5th Avenue address you will find the luxurious collection of jewelry in art deco surrounds.

The Mark – 25 East 77th Street: a boldly lavish hotel housed in a 1927 building overlooking Madison Avenue.

The Carlyle – 35 East 76th Street: an art deco landmark named after Thomas Carlyle (British literary figure). An elegant atmosphere and a favorite with the well heeled. Worth a visit to see the lavish black-and-gold-hued marble lobby, hung with oil paintings resembling a Renaissance museum. Try the extensive drinks menu at the Bemelmans Bar.

The Plaza – 768 5th Avenue: on the brink of the Upper East Side, you will find one of New York's best-loved icons. The Beaux-Arts architecture is worth seeing, but I really love the Todd English Food Hall on the lower ground floor, housing a cute little Ladurée outpost. Upstairs you will find Assouline.

Shakespeare and Company – 939 Lexington Avenue: although part of a small chain, this bookstore is lovely, and has a cafe at the front and neighborhood local vibe.

Le Labo – 22 East 65th Street: a small outpost of this gorgeous candle and fragrance brand.

Bergdorf Goodman – 754 5th Avenue: enjoy a luxurious mooch inside one of the most famous department stores.

The Penrose – 1590 2nd Avenue: I recommend a visit for an old-fashioned cocktail with a side of jazz (on selected nights).

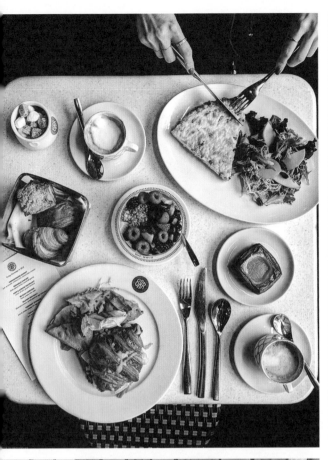
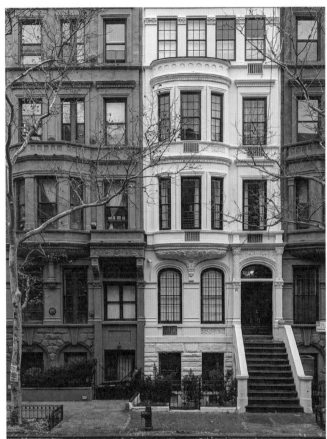
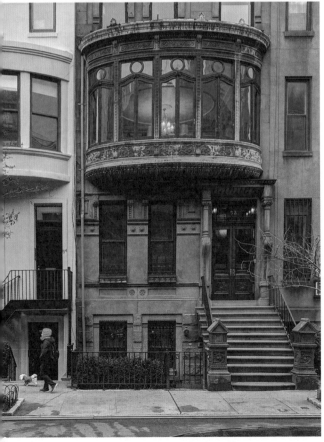
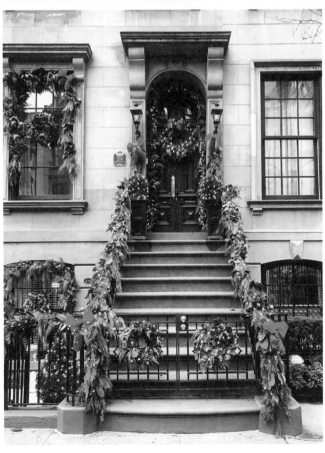

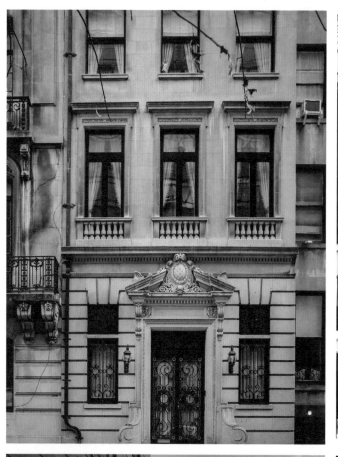

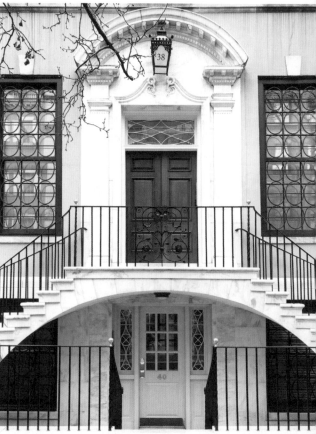

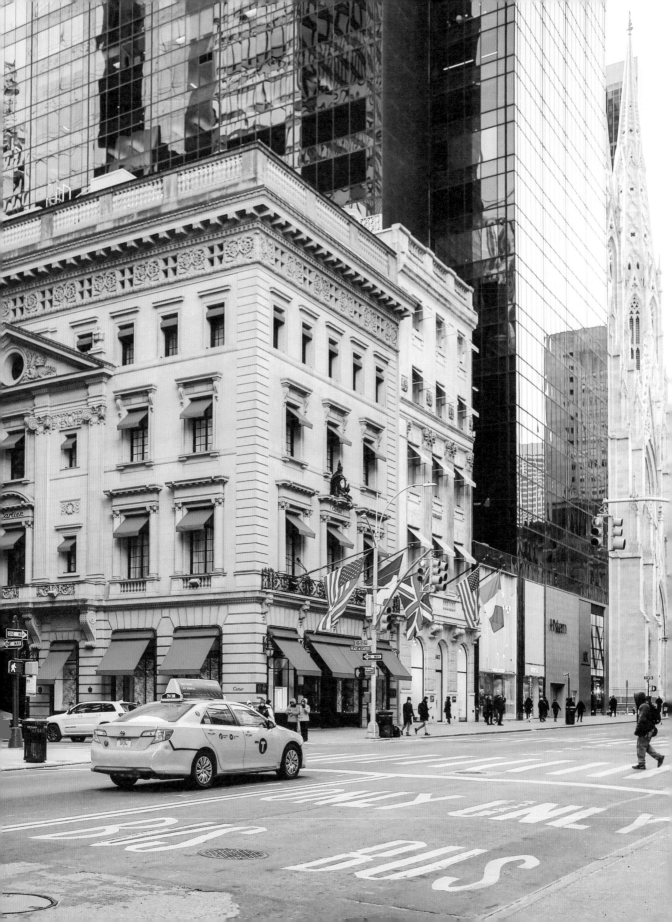

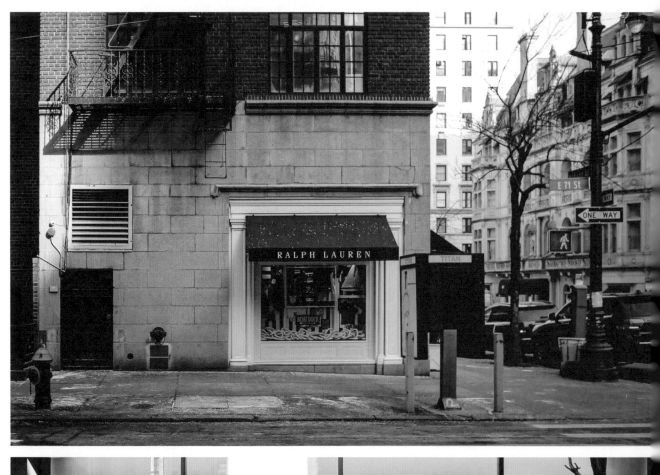

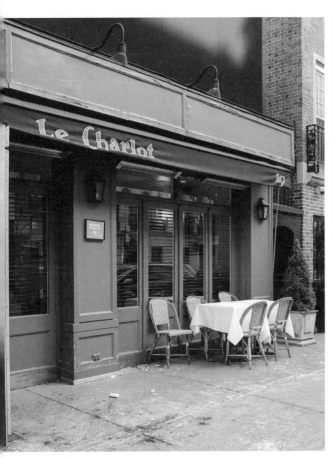

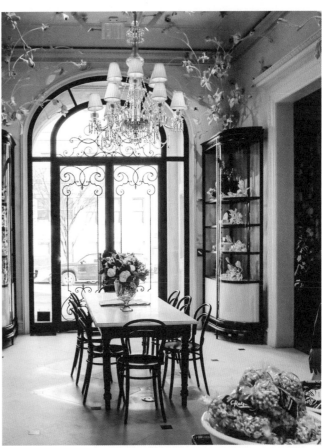

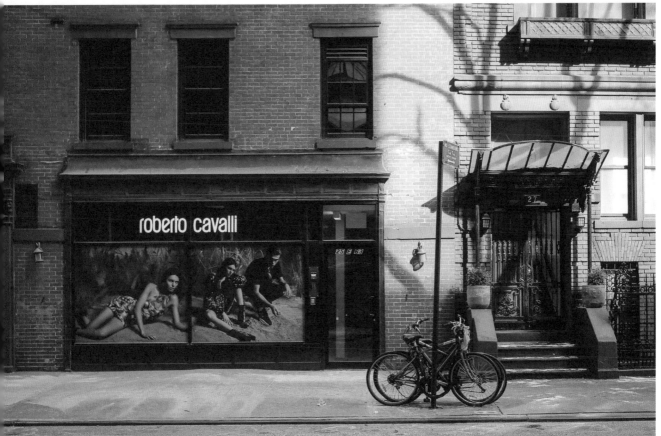

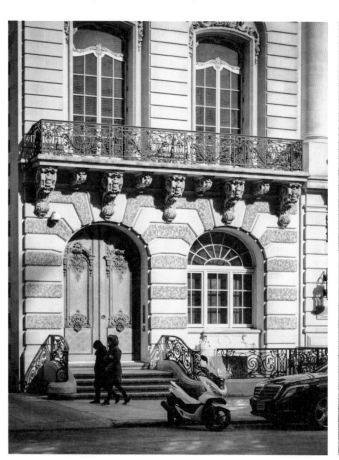

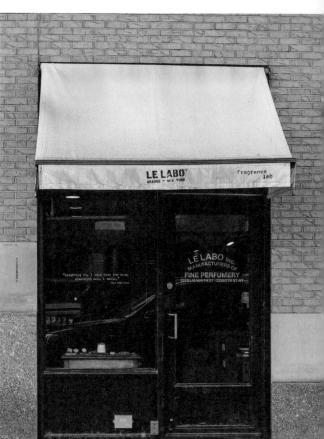

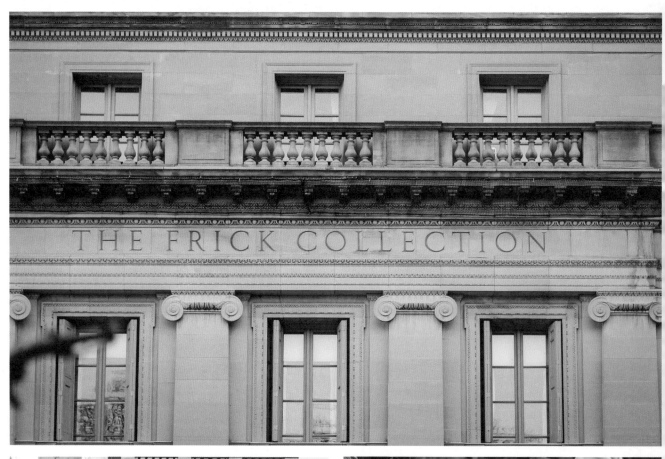

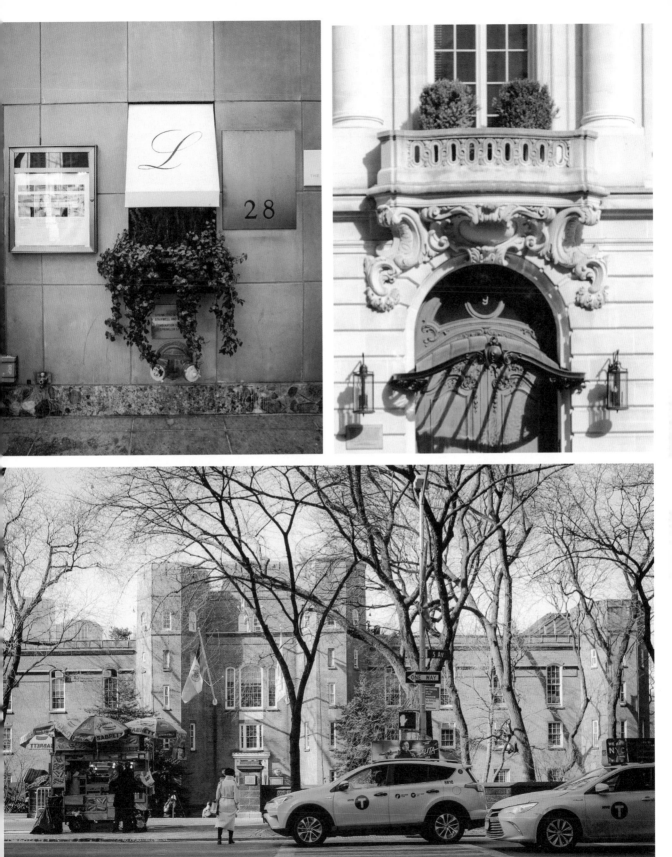

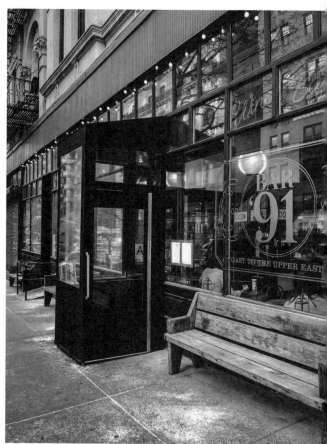

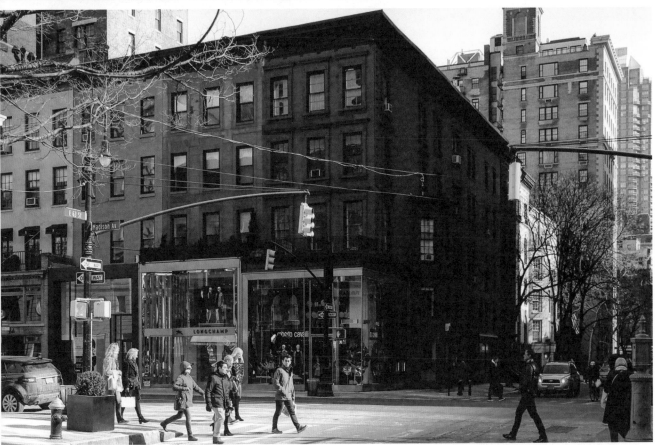

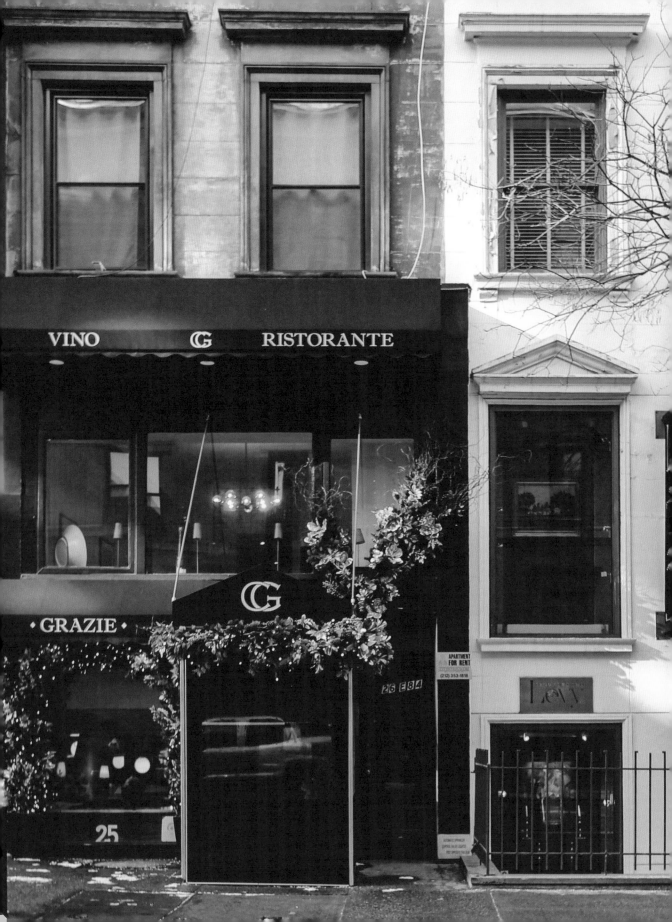

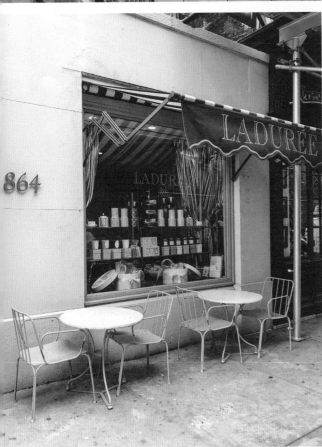
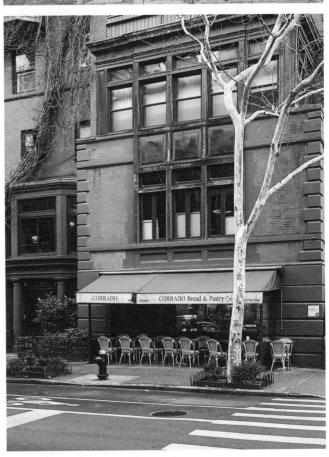

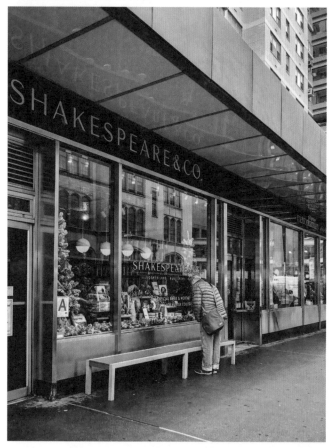

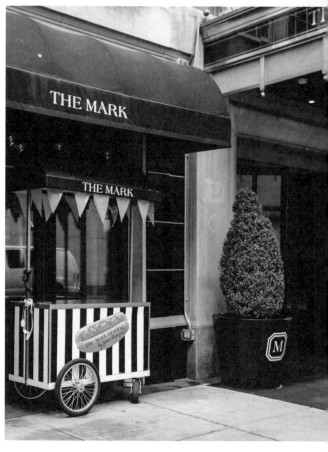

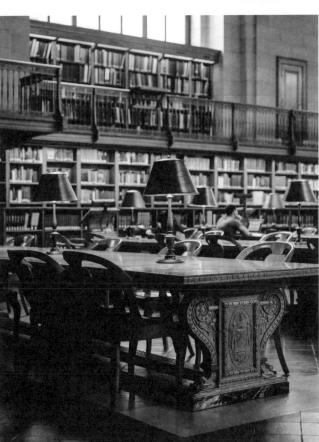

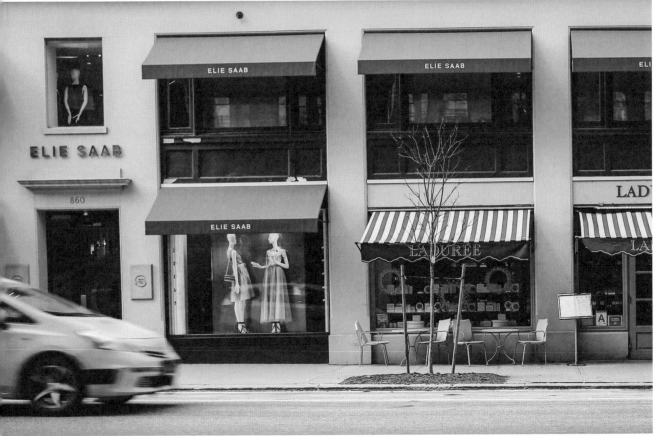

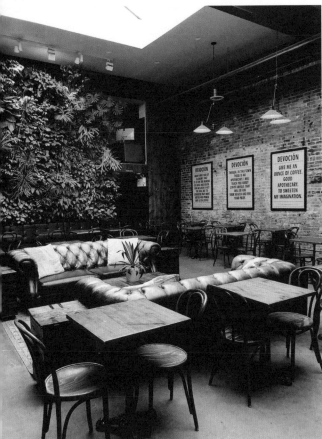

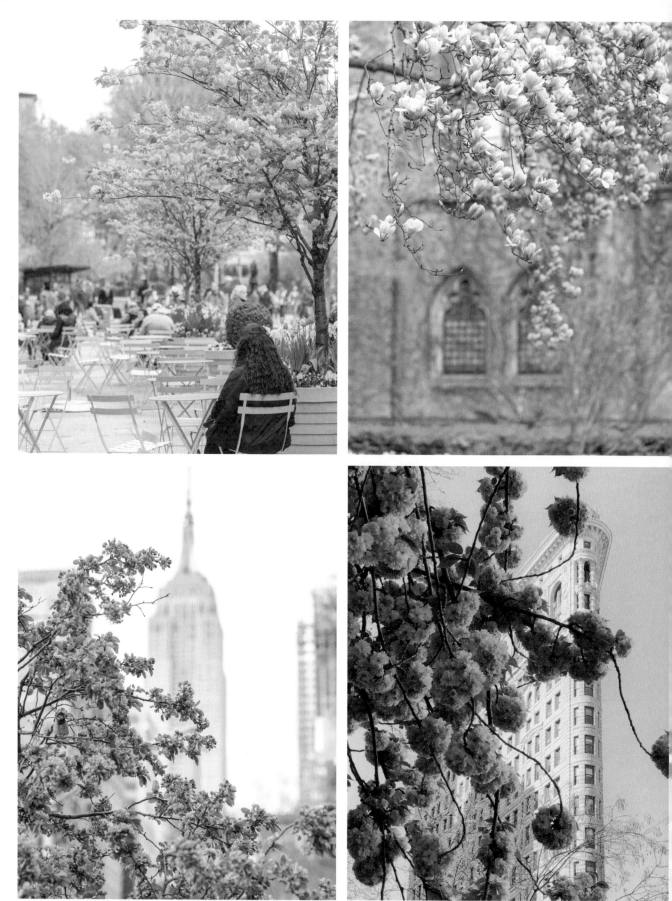

PRETTY CITY NEW YORK THROUGH THE SEASONS

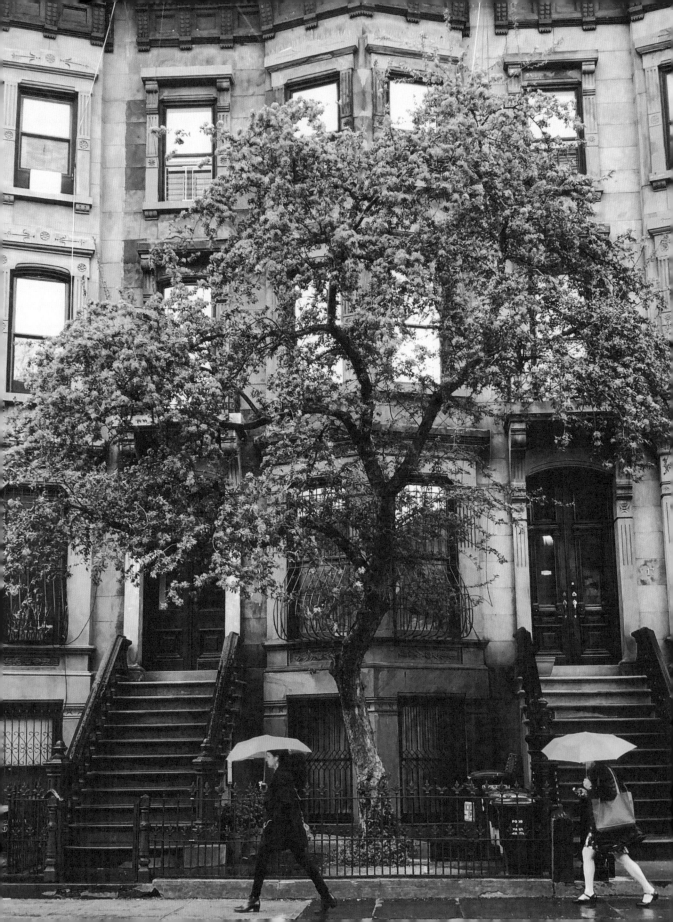

SPRING

It is spring. Thank heavens. As the weather warms, New York City becomes a more vibrant, fun place to visit. It may not be as blossom-filled as, say, Paris or London, but it does still bloom. With the cherry blossom and sparkling river as a backdrop, spring is the time to take advantage of rooftop bars, al fresco dining, and Central Park walks. Magnolia, cherry blossom, and lilacs dot the city in early spring. **Bryant Park**, **Central Park**, and **Brooklyn Botanical Gardens** are some of the best places to experience in the city during this season.

EMBRACE SPRING IN PRETTY CITY NEW YORK

Stroll though one of New York's many beautiful parks and gardens. **Central Park**, **Bryant Park** (adjacent to the New York Public Library), and **Brooklyn's botanical gardens** are all extra beautiful in spring.

Join the **Easter Parade and Bonnet Festival**, held annually on Easter Sunday. It takes place on 5th Avenue, around 49th to 57th Street.

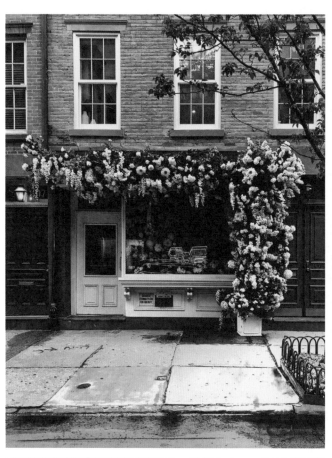
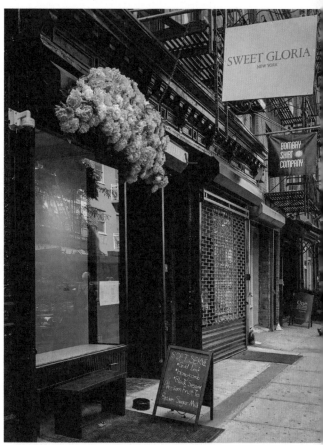
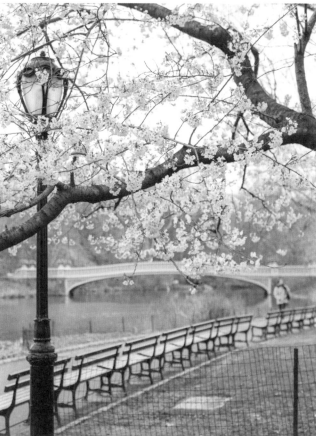
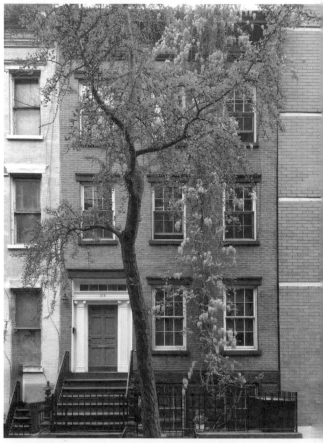

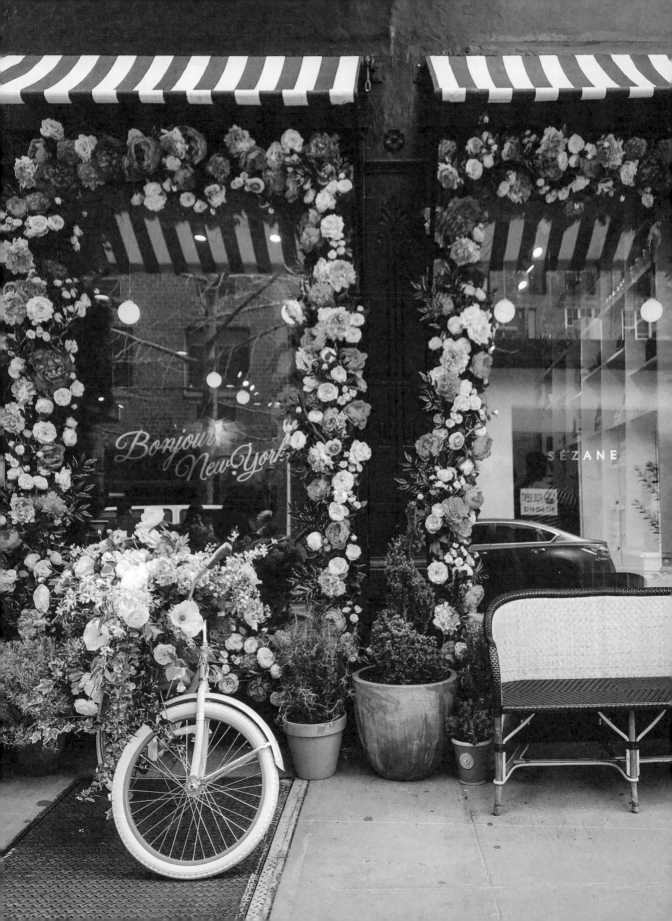

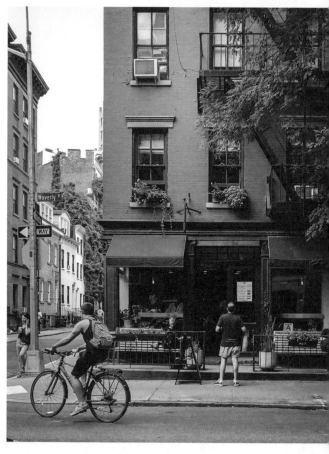

SUMMER

June, July, and August are the months to look forward to the most. Sun, warmth, al fresco dining, and rooftop-drinking during long summer evenings becomes the city's favorite pastimes. Many avoid the city in July and August, when sweltering temperatures and high humidity can make it unbearable, but early and late summer here is lovely.

EMBRACE SUMMER IN PRETTY CITY NEW YORK

Explore **Central Park**: the 843-acre oasis in the heart of the city has a zoo, miles of paths, acres of picnic-ready grassland, and the romantic **Boathouse** restaurant.

Washington Square Park with its water sprinklers.

Walk the **High Line**: take a walk along the gorgeous landscaped elevated park that stretches twenty-two blocks from Gansevoort Street to 34th Street. Watch the sun set over the river.

Visit **New York Botanical Garden**: set in 250 acres of Bronx Park and inspired by London Royal Botanic Gardens.

Visit the open-air theatre in Central Park: Shakespeare in the Park is a long-running, free, open-air play.

Attend the Summer Movies: watch one of the free open-air movies. Screenings takes place across the city: **Bryant Park** under the skyscrapers of Midtown, or **Brooklyn Bridge Park** on the banks of the East River.

Take a cruise around **Manhattan Island**.

Hire a bike and explore Central Park and the city.

Head for one of the many amazing rooftop bars and watch the sun go down. **1 Hotel Brooklyn Bridge** and the **Hoxton Hotel** have stunning views.

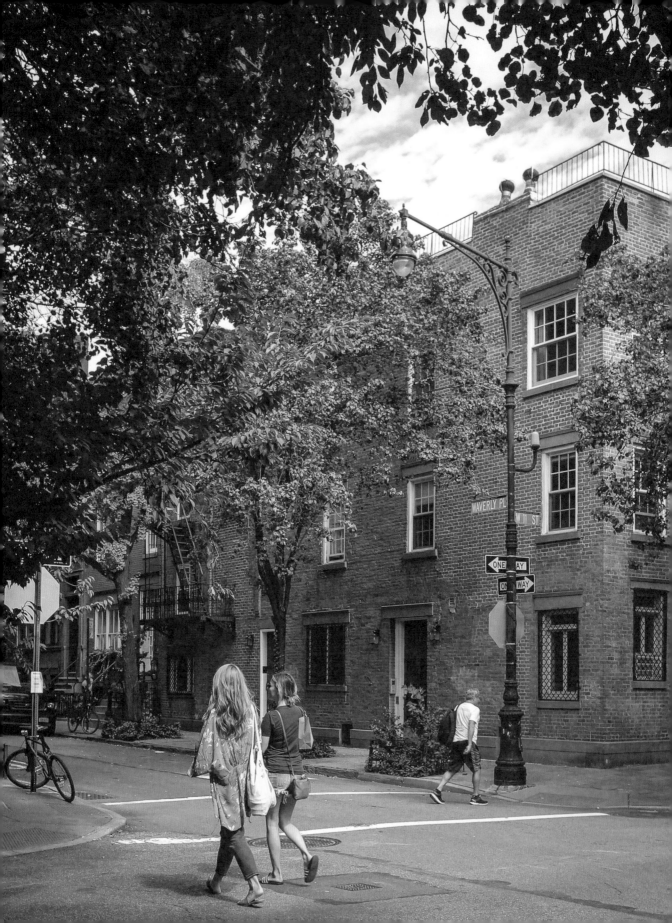

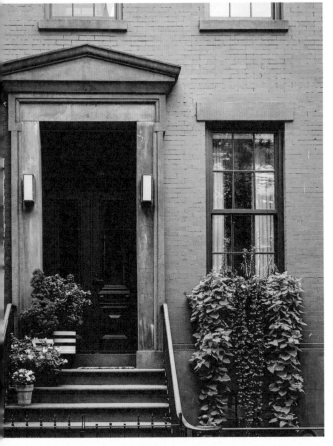

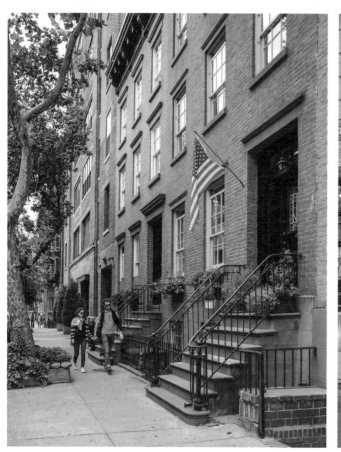

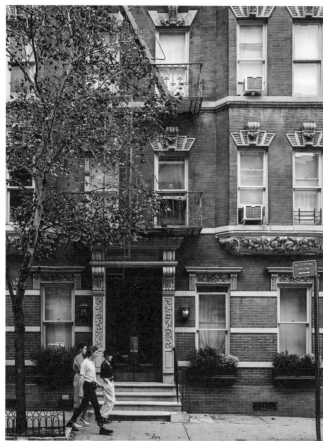
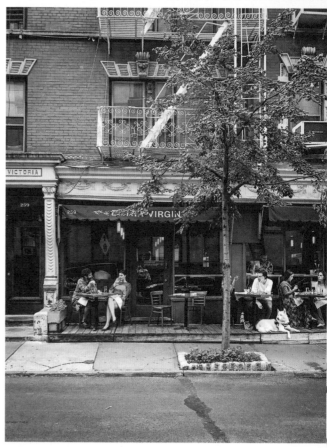

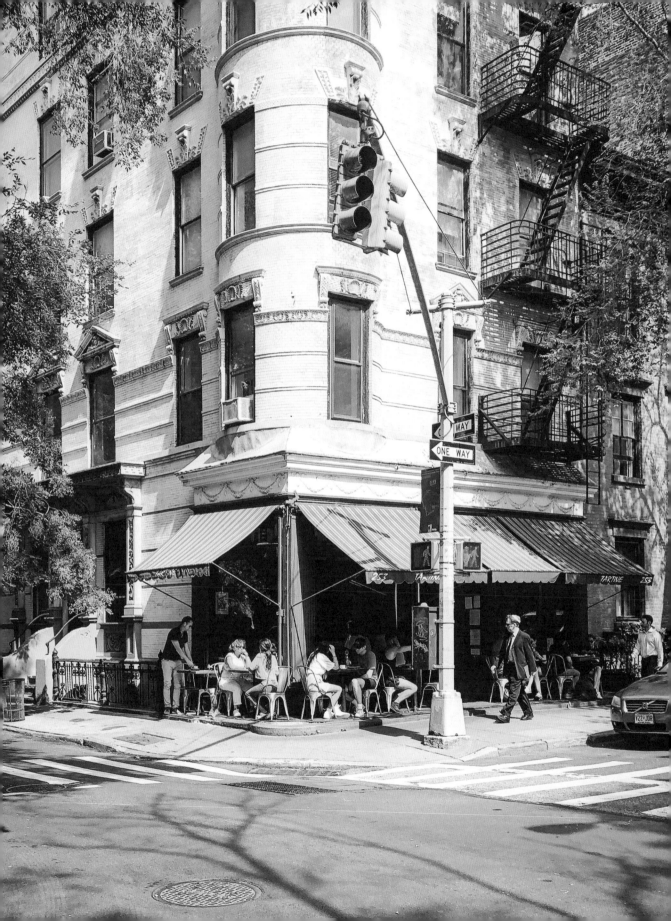

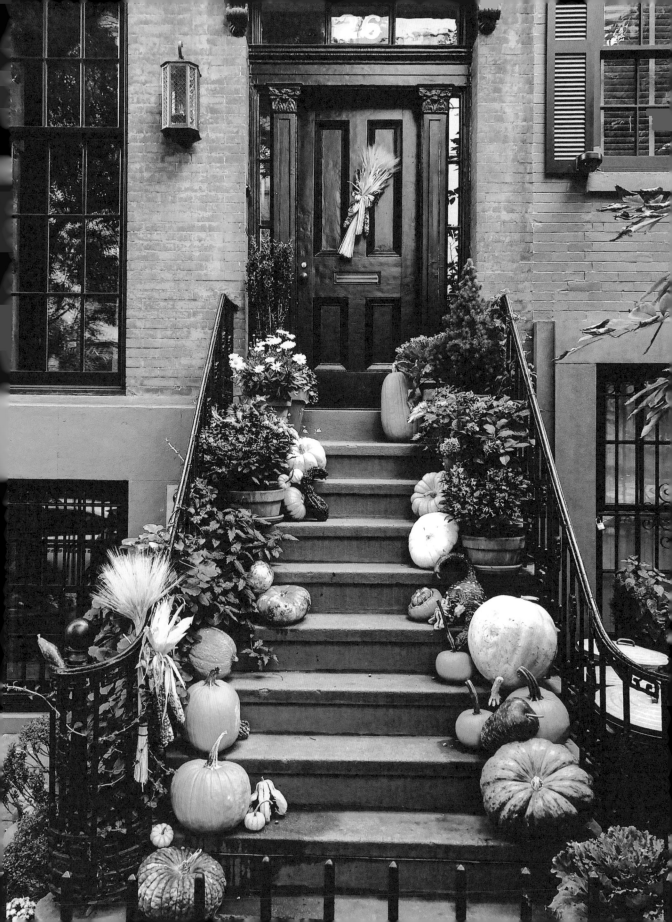

FALL

'Autumn … the year's last, loveliest smile' – William Cullen Bryant.

Take out your favorite sweater: this is New York's finest season.

EMBRACE FALL IN PRETTY CITY NEW YORK

Head to the parks, where the crunchy fallen leaves transform the ground to a golden carpet and the woodlands glow.

Celebrate Halloween and take a neighborhood walk to see some of the finest houses transformed for the spooky festival. **West Village** and the **Upper East and West Sides** are the best places to witness the crème de la crème of Halloween decorations.

Find a cozy pub or wine bar – think the **Wren** on the Bowery – and read a book by the fire.

Visit a stunning fall art show in one of the museums along the **Museum Mile** in the Upper East Side.

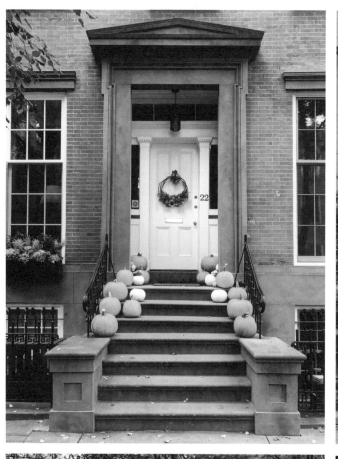

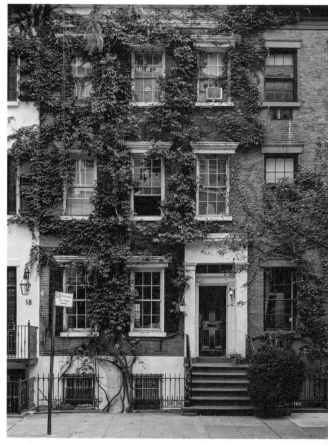

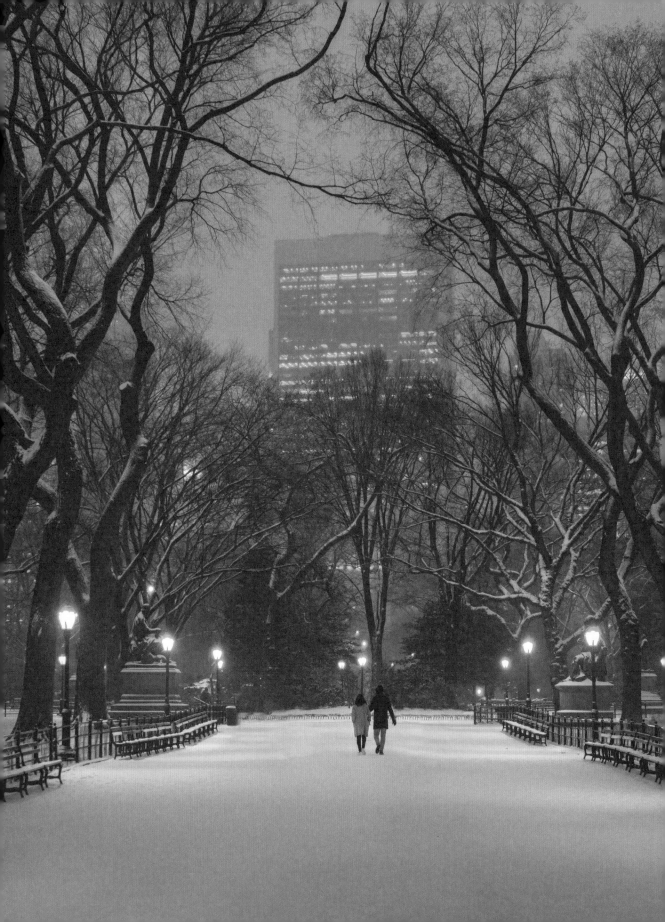

WINTER

With summer crowds and fall behind us, like so many other cities, New York begins to exude a slightly different charm in winter, and in particular at Christmas. Winter here can be bitingly cold, but with ice-skating at **Central Park**, the Christmas tree at **Lotte New York Palace**, **Cartier's** grand decorations, and **5th Avenue**'s magical windows, there is no better place to celebrate the holiday season.

EMBRACE WINTER IN PRETTY CITY NEW YORK

Like Mayfair in London, the Upper East Side is the best place to celebrate Christmas in the Big Apple. Here, Jackie Clair of @yorkavenue_ shares her tips for celebrating the holiday season in New York.

HEAD FOR THE UPPER EAST SIDE

The **Park Avenue** tree lighting: the Christmas trees that line the Park Avenue Mall from 54th to 97th Streets are lit at the beginning of December each year, and it's a festive way to kick off the holiday season.

Drinks at the **Carlyle**: the Carlyle is a New York institution and the perfect cozy spot to grab a drink during the holidays.

Check out the department store windows on **5th Avenue**: the department stores lining 5th Avenue on the Upper East Side go all out for the holidays. Particularly not to miss are the stunning creations in the windows of **Bergdorf Goodman**.

Holiday tea at the **Plaza**: it's always fun to sit down for afternoon tea at the Plaza Hotel, and even better during the holiday season when the lobby is dressed to the nines in festive fashion.

Ice skating in **Central Park**: ice skating at **Wollman Rink** is a perfect activity to capture that New York at Christmas feeling.

Hot chocolate at **Two Little Red Hens**: Two Little Red Hens is a charming Upper East Side bakery with the most delicious cupcakes, and it's a great place to warm up with hot cocoa after skating in Central Park.

Walk around and see the decorated townhouses: no one decorates for Christmas like the **Upper East Side**! The architecture in the area is already stunning, and when decked out in garlands, wreaths, and lights, it's an absolute delight to explore.

Explore the stores on **Madison Avenue**: last but not least, take a stroll along Madison Avenue and check out all the stores dressed up for the holidays. **Ladurée** and **Ralph Lauren** are right near each other, and both do spectacular decorations.

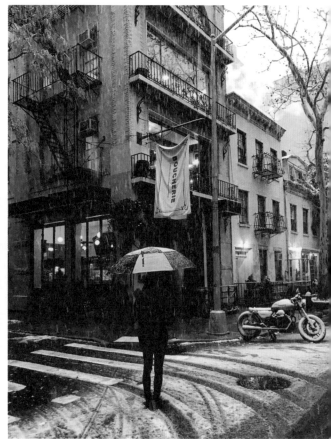

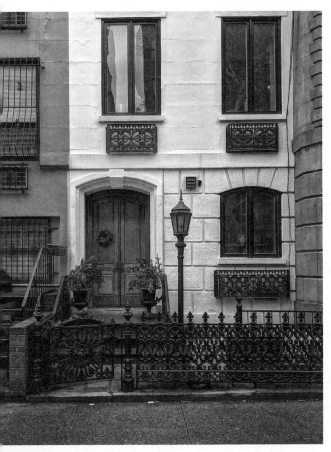

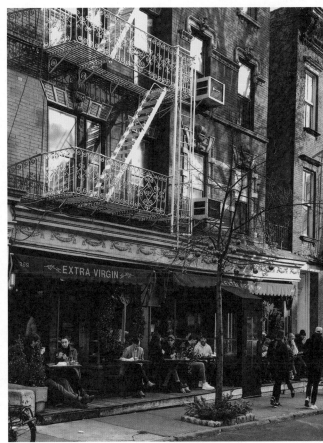

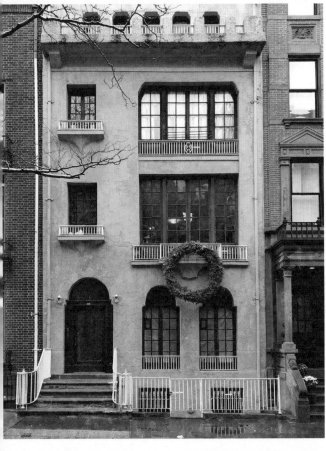

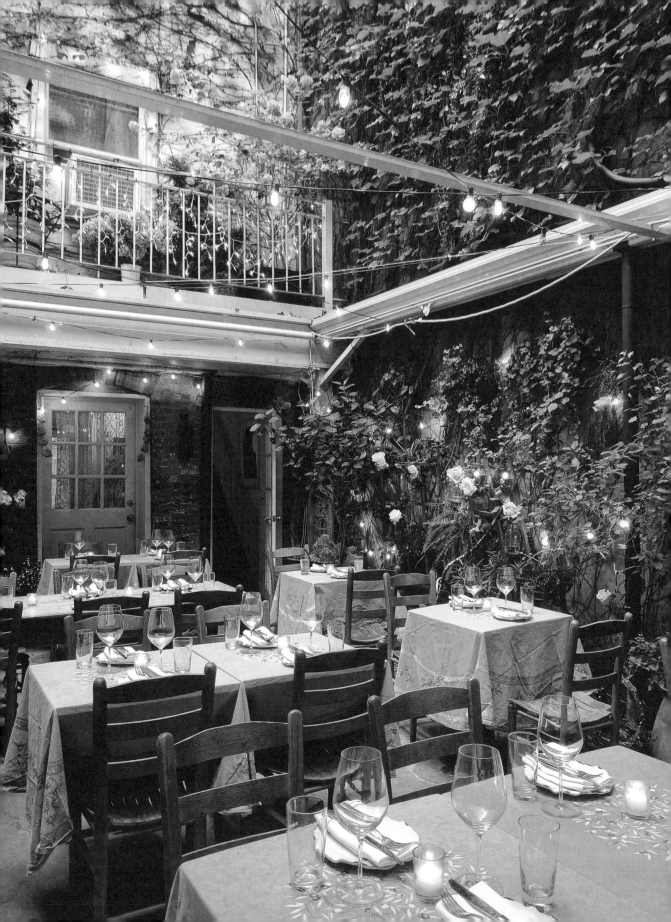

BUCKET LIST OF THINGS TO DO IN PRETTY CITY NEW YORK

A PERFECT FEW DAYS
IN NEW YORK CITY

New York is full to the brim with things to do, shops to visit, museums to explore, and new restaurants to try. It would be impossible to cover all of it on any one trip but to help you plan your trip I'll attempt to share an ideal itinerary.

DAY ONE

A Pretty City New York day should start with breakfast at **Buvette**, but although you will want to sip the day away in here, there are just far too many other places to go. Follow breakfast with a stroll down Christopher to **John Derian**'s cute West Village store, housed in a pre-war building. Go for the decoupage and prints, but stay to admire the carefully curated selection of Astier de Villatte ceramics on display. Back on Christopher Street, take a right turn down Gay Street and spend some time admiring the architecture and photographing the charming street scenes that emerge. Then make your way down Waverly Place to the bookstore **Three Lives and Co.**, and follow that with a browse in **Upper Rust** or **Pink Olive**. Reward your walking with lunch at either close-by **Cafe Cluny**, the **Spotted Pig**, or **Petite Boucherie**, or if you simply want a light bite then opt for a coffee and sandwich from **Partners Coffee Roasters**.

From here head for Soho, kicking off any exploring with a stop at **Laundress**, on Prince; opt to photograph its pretty façade, complete with black-and-white awning, or step inside to browse the unique selection of products exquisitely displayed. Then begin a slow wander along Prince and Sullivan Street followed by a meander along West Broadway to **Roman and Williams Guild**, a one-stop shop for food, flowers, shopping, and design. Follow your browse with a walk up Mulberry for a glimpse of Tristan Eaton's marvelous street art mural of Audrey Hepburn. From here head to Elizabeth Street for a slow browse through the many artisan shops; **Le Labo**, **Aesop**, and **Love Adorned** are some of its highlights, but don't forget to step inside **Sézane**. The marvelous take on a French apartment is the perfect place to lose an hour or so.

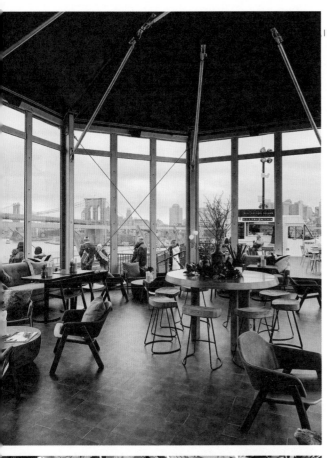
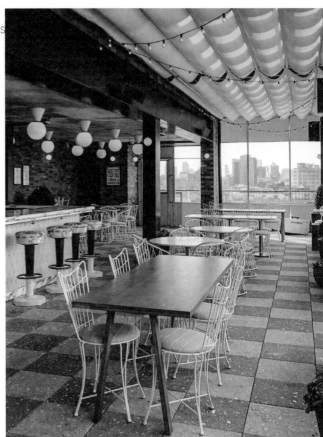
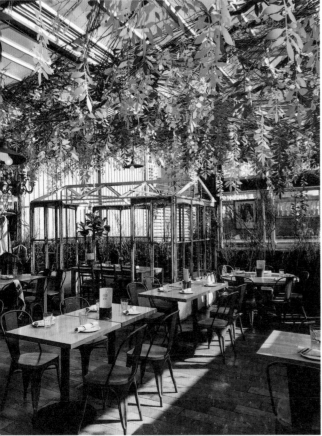

After a lovely afternoon spent in Soho and Nolita, I suggest you hop in a cab and head for the **High Line** – the most beautiful spot to take in the sunset – or if you feel like adding a side of glamour, pop up to the **Top of the Standard**. Then make your way to your hotel, ideally the **High Line** or the **Standard**, and try to get some sleep.

DAY TWO

Kick your day off with a coffee at **Intelligentsia** at the High Line, followed by a walk over to the **Whitney Museum** or one of the many other wonderful galleries in the area. I would then opt to hop in a cab or stroll over to **Frenchette** in Tribeca for lunch, but skip dessert and go for the chocolate chip cookie from nearby **Maman** (either Maman Tribeca or Hudson are well placed).

Take a walk around Tribeca; if there is time you can even treat yourself to a spa break at **Aire Baths** or a cocktail at **Tiny's Bar**.

When you have seen enough of Tribeca, hail a cab and head for the historic Financial District for a visit to the Oculus, a walk down Stone Street, or a cocktail at the stunning **Beekman Hotel**. Opt to check in, if budget allows, or head to my ideal hotel for the night: the **Hoxton** in Williamsburg. With its stunning Manhattan or Brooklyn views, it is extremely well placed to explore Brooklyn's best spots. Watch the sun go down from your room with a view, or the hotel rooftop, and then head out to **Cafe Collette** for a light dinner or snag a seat at the open kitchen bar in **Klein's**. Drift off to sleep with the curtains open, but be sure to wake early the next morning.

DAY THREE

Head downstairs but be in no rush to leave, instead soak up some of the lobby atmosphere. It is decorated in understated neutrals and hints of blush, enticing you to linger, and the little 'best of Brooklyn' shopping space

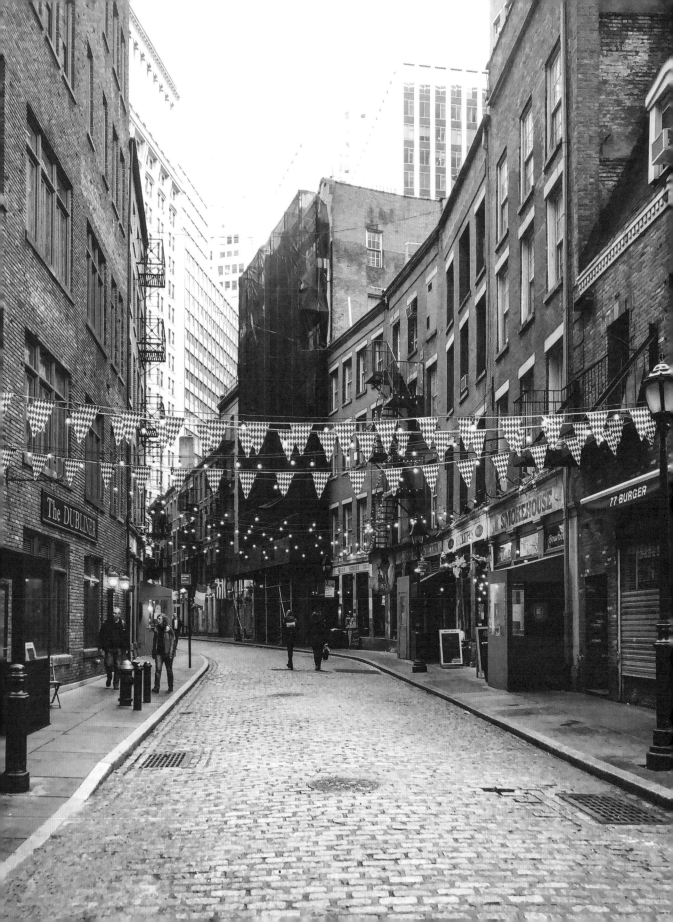

invites you to mooch. After a while, head over to **Reynard** for their sourdough pancakes and Insta-gold interiors. Then opt to explore Williamsburg, filled to the brim with farm-to-table restaurants, specialist shops outside beer gardens, and a down-to-earth vibe.

If time is against you, you can't go wrong with heading for Bedford Avenue – the main drag. There are plenty of options for food on or around Bedford Avenue, but I would recommend heading for lunch at **Bakeri** in Greenpoint. Follow lunch with a browse around the many wonderful shops on Franklin Street, sample tea at the tea emporium **Bellocq**, or admire the lush foliage, tiny succulents, and vintage pieces at **Feng Sway**. I would then head back to Wythe Avenue and stroll down to **Williamsburg Bridge** to catch the ferry to Dumbo.

Check in to **Hotel 1 Brooklyn Bridge**, and watch the sun set and enjoy the stunning Manhattan views from their plunge pool.

DAY FOUR

Wake up early and walk over to **Brooklyn Bridge** to see the bridge itself, enjoy a spin on **Jane's Carousel**, or brunch at **Cecconi's**. Take a moment to enjoy the view before walking over to **Jacques Torres Chocolate** for its Willy Wonka vibe. Follow a hot chocolate with a stroll through **Brooklyn Bridge Park** to Vinegar Hill.

Enjoy a stroll around this pocket-sized enclave before having lunch at either **Vinegar Hill House** or **Cafe Gitane**. Follow lunch with a walk over to **Kings County Distillery**. Located in the Paymaster Building, you will find New York's oldest operating whiskey distillery – the first opened since prohibition. Pop into the **Gatehouse** – the perfect place to sample the whiskeys or an afternoon cocktail or two.

After tasting, book a cab to take you to the East Village and Lower East Side. Spend an hour or so exploring this charming enclave. Mooch in one of **John Derian**'s stores, smell the roses in **Le Bouquet**, or visit the bijou perfumery **Aedes de Venustas**.

After an action-packed day, check in to the **Bowery Hotel**. Linger a while in the art deco-inspired lobby or, if food beckons, you won't go wrong with nearby **Saxone and Parole**, **Gemma**, or the **Wren**.

DAY FIVE

It has to be said that no New York itinerary is complete without a visit to the **Upper East Side**. Check out of the hotel early and head for **Central Park** (save your walking shoes for a stroll through, taking in its many highlights); if your feet can take no more walking then why not opt for a horse-drawn carriage – a wonderful way to experience the beauty of the park.

After your time in the park, head for the **Frick Collection** on Museum Mile. Its small but beautiful collection will take your breath away, so be sure to leave time for a sit inside the stunning courtyard.

Follow your visit with a walk down Madison Avenue for a lovely spot of window-shopping, and treat yourself to a delicious coffee in the cafe at **Ralph Lauren**, or ice cream from **Sant Ambroeus**. Meander down Madison, head over to 5th Avenue, and linger in **Bergdorf's**, then refuel at the **Plaza Food Hall**, or wander back to **Sfoglia** for its Italian menu.

After a mesmerizing short visit, head for the airport.

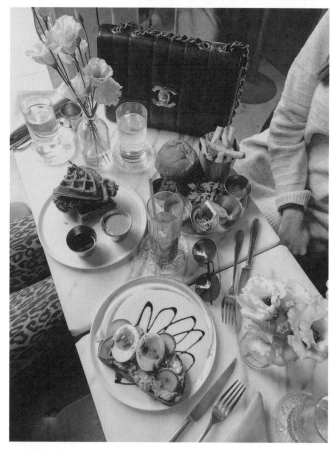

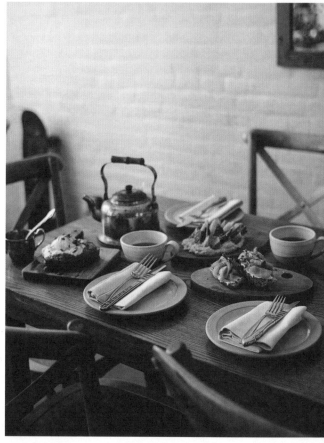

THE BUCKET LIST

If you haven't the luxury of a full five days in the city that never sleeps, or if you wish to add some Pretty City bucket list items to your own itinerary, then here are some more ideas of things to do in this Pretty City (some items have been added by local Instagrammers in the know).

CAFES AND COCKTAILS

For me there is nothing quite as nice as finding a cute and cozy New York cafe to steal away from the bustle for a while. There is no shortage of amazing independent coffee shops in New York City, but to navigate through the endless list can be daunting – these are my favorites:

Maman: locations throughout New York, but my favorites are in Soho, Tribeca, and Greenpoint.
Bakeri: Greenpoint and Williamsburg.
Woops: Greenpoint and Williamsburg.
Intelligentsia: at The High Line Hotel, Chelsea.
Partners Coffee Roasters: in Brooklyn and the Village.
Saltwater Coffee: Lower East Side.
Cafe Alula: Brooklyn.
Remi Flower and Coffee: Midtown.

Alternatively, sip on champagne or a signature cocktail – no trip to New York would be complete without doing so. Try the **Hoxton** in Williamsburg, **Maison Premiere** in Brooklyn, or **While We Were Young** in the Village.

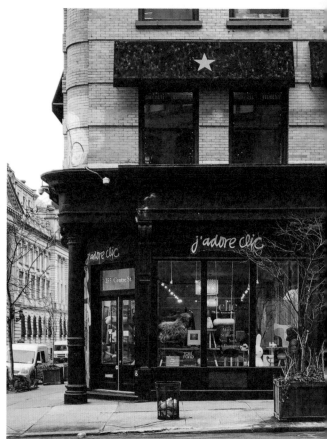

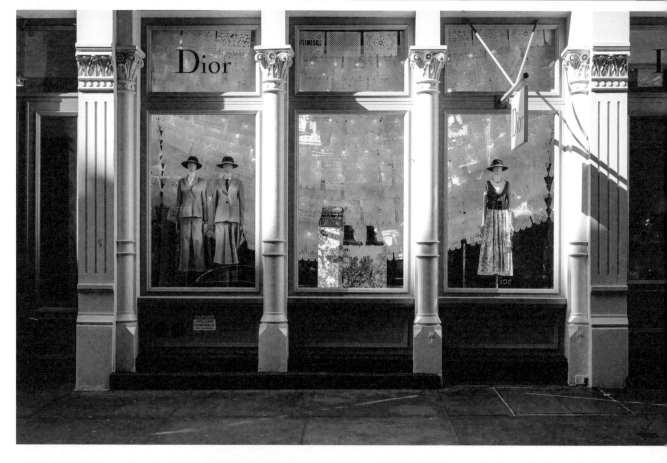

SHOPPING

Go shopping: no trip to New York is complete without some proper shopping. With so many shops to chose from, I needed some local insight, so I spoke with Paula Flynn, founder and editor of @the_shopkeepers, for her favorites in the city:

BDDW – 5 Crosby; **M. Crow** – 16 Howard Street
The interconnecting shops of BDDW and M. Crow take us through the inspiring world of designer Tyler Hayes. The spaces have soaring ceilings and a series of interesting pass-throughs to showcase a lifestyle collection including heirloom-quality furniture, whimsical jigsaw artwork, creative ceramics, and clothing.

Goods for the Study – 50 West 8th Street and 234 Mulberry Street
A shop devoted to the tools involved in creating a perfect workspace, whether it be a dedicated room or a simple work surface. They are famous for their extensive pen assortment, a wide selection of stationery, office furnishings, and art.

Green Fingers Market – 5 Rivington Street
Potted plants in vintage crates frame hand-painted signage on white-brick walls, making Green Fingers Market a unique, must-visit plant shop.

John Derian Company – 6–10 East 2nd Street, between 2nd Avenue and the Bowery, and 18 Christopher Street
John Derian Company has shops in Manhattan's East and West Village neighborhoods. They feature the designer's unique decoupage plates, platters, paperweights, and coasters, which are all handmade in his New York studio. Alongside Derian's designs is a veritable treasure trove of decorative home objects, textiles, and furniture.

Le Bouquet: 116 East 4th Street
A flower shop in the East Village with a rustic shopfront and giant folding window, opening to a baby grand piano that does double duty as a bar and flower display.

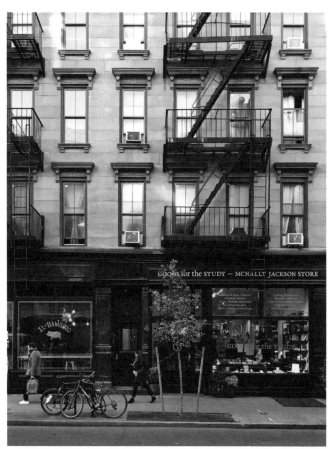

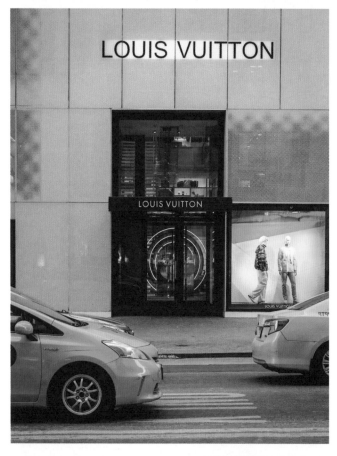

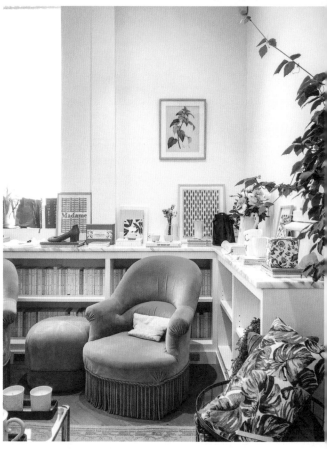

Marche Maman – 237 Center Street
A beautifully displayed assortment of home goods, beauty and lifestyle products, children's wear, jewelry, flowers, and vintage goods. Brands rotate on a regular basis, ensuring there is always something new to delight and discover.

Roman and Williams Guild – 53 Howard Street
Part home interior and home shop, part cafe and flower shop, this beautiful store is the modern luxury lifestyle vision of New York design studio Roman and Williams. RW Guild is a modern and innovative retail concept store.

Salter House – 119 Atlantic Avenue; **Picture Room** – 117 Atlantic Avenue
Family-run sister shops. Salter House is a cafe and sustainable home goods shop, selling everything from linens and china to baby supplies and toys. Next door, the Picture Room features art by emerging and established contemporary artists, as well as rare prints, posters, artists' books, and art publications.

Tender Buttons – 143 East 62nd Street
A New York institution, the walls of Tender Buttons are lined with boxes of everyday buttons carefully organized by color and type, above which are framed collections of rare and antique buttons.

Wooden Sleepers – 395 Van Brunt Street
A compelling collection of stylishly presented classic American vintage clothing, from traditional Ivy League to workwear and military.

Rizolli – Nomad; **Shakepeare and Co.** – Upper East Side; **Three Lives** – West Village; **Assouline** – in the Plaza; **McNally Jackson** – Nolita
Visiting a beautiful bookstore is a must, and these were some of my favorite finds. In a bustling city there is nothing better than finding a cool and quiet bookstore to get lost in.

QUIET TIME

Find some quiet time away from the bustle. The Rose Main Reading Room of the **New York Public Library** is a sight to behold, hidden in plain sight. Join the silence seekers and bibliophiles inside, or browse in the gorgeous gift shop.

THE HIGH LINE

Stroll the beautiful High Line. Once a railroad track carrying freight trains, this elevated space has been transformed into a beautiful walking park.

UPSTATE

Take a day (and night) trip upstate. One of my favorite New York-based Instagrammers, Melissa Male (@melissamale), gives some tips here on making the most of a trip upstate to Hudson:

Nestled in upstate New York is the small city of Hudson. Named after the Hudson River and its namesake, explorer Henry Hudson, it has become a popular escape from the hustle and bustle of NYC and, with its growing food and shopping culture, is a weekend destination for many in the area.

Where to stay:

This Old Hudson – 930 Columbia Street
This gorgeous rental property is located close to Warren Street (the main street in Hudson). The property is over 100 years old and was designed and launched by Zio and Sons in the summer of 2016. It now serves as a weekend retreat, creative space, and photo/video-shooting location. You can find it on Airbnb.

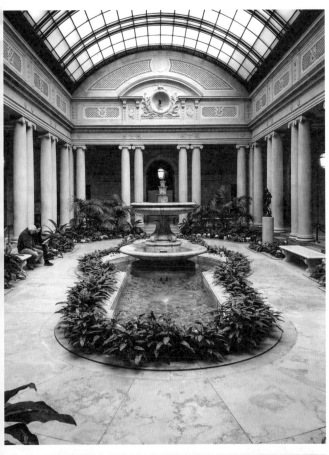

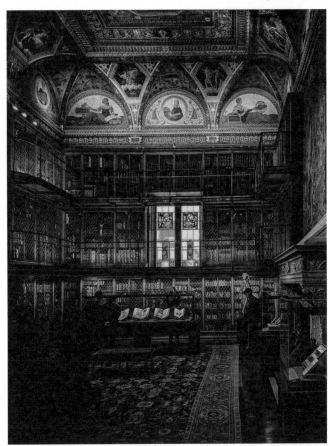

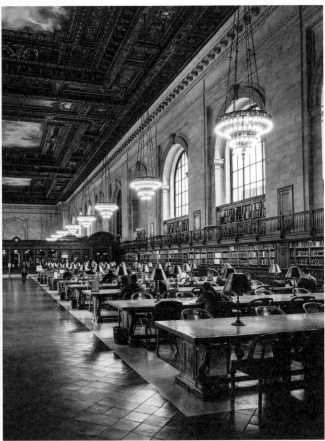

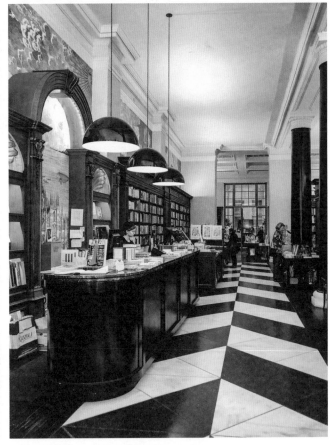

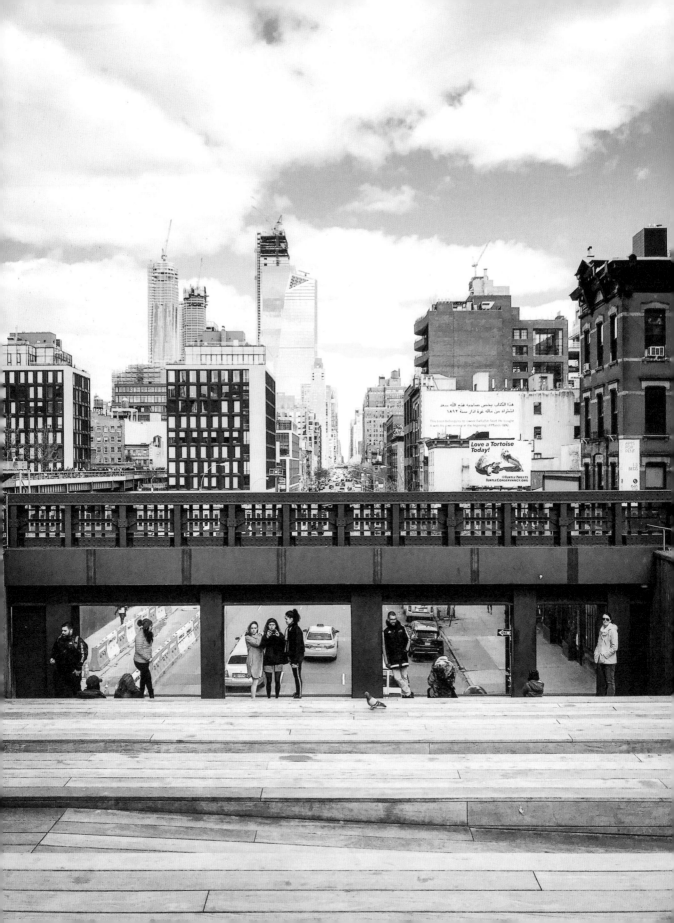

Where to shop:

MINNA – 421 Warren Street
MINNA uses traditional craft techniques to produce ethically made homeware with a contemporary edge. Its mission is to give people access to contemporary design without sacrificing quality, while keeping in line with people's values. The shop itself is adorable and features beautiful blankets, pillows, and tapestries with different textures and patterns that are meant to be mixed and matched.

Flowerkraut – 722 Warren Street
This sister-owned shop offers a selection of local, seasonal fresh flowers, an array of plants, cute cards, and sauerkraut (hence the name). The shop itself is adorned with beautiful hanging planters, with shelves full of gorgeous ceramics and assorted apothecary items. Everything is locally grown and sourced depending on the season, as sustainability is heavily considered. It's a slippery slope for plant and flower lovers, who will want to purchase everything in the store!

Where to eat and drink:

Supernatural Coffee – 527 Warren Street
One of Hudson's newest coffee shops, you'll regularly find people enjoying their coffee with human and canine friends alike. The space is minimal, but perfect for enjoying a coffee and pastry with a friend.

Olde Hudson Market – 449 Warren Street
This market specializes in cheese boards and charcuterie, but there are a few tables in the front where you can grab coffee and a bite to eat. Everything in the market is stocked thoughtfully with only the best ingredients and products, ranging from artisanal cheeses to all-natural meats.

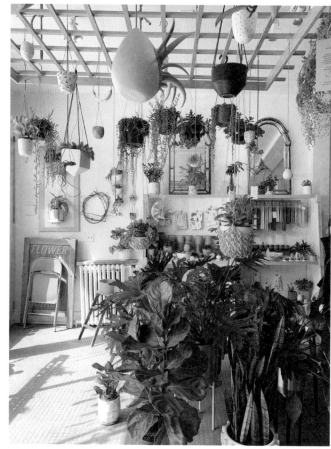

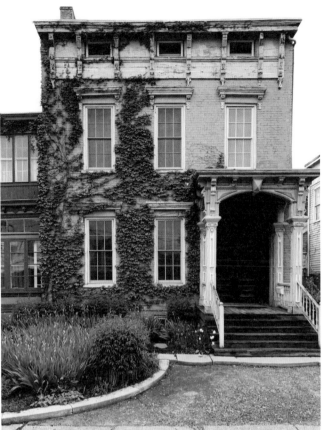

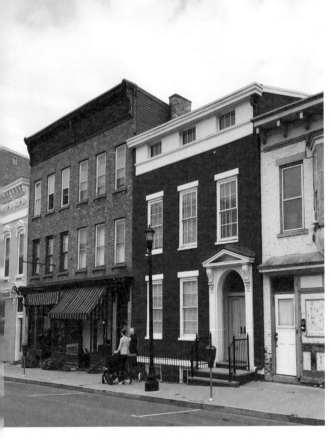

CONTRIBUTORS AND ACKNOWLEDGMENTS

All images © Siobhan Ferguson except:

@andreannu: pp. 4, 17, 131 (bottom right), 136, 167 (bottom right)

@angrybaker: pp. 68 (bottom right), 72 (top right), 138 (top two and bottom left), 223, 242 (top right)

@aya408 p. 238

@billetrouge: pp. 70, 221 (bottom right)

@brayanmesa: pp. 115, 119 (top left)

@chloejg: pp. 39, 69 (bottom right), 133, 166 (top right and bottom left), 167 (top left), 229 (top right)

@diannnnneee: pp. 24 (bottom right), 116 (top right), 179, 233 (bottom left)

@especialli: pp. 150, 151 (bottom)

@georgiannalane: pp. 208, 212 (bottom right)

@helloiamnaz: pp. 74, 135, 126 (top right), 166 (bottom right)

@heydavina: pp. 18, 43, 56 (bottom right), 109 (top right), 138 (bottom right), 148, 154 (top left), 162 (bottom right), 168, 170 (bottom right), 178 (bottom right), 182 (bottom left), 183 (bottom right), 214 (top right), 221 (top right and bottom left), 230, 238 (bottom right)

@joethommas: pp. 152, 224

@maddietsang: p. 176 (bottom right)

@mangelka: pp. 7, 51 (top right), 84, 217 (top right), 220, 228 (top left), 229 (bottom right), 221 (top left), 226 (top two)

@melissamale: pp. 228 (top right), 238 (top left), Upstate Copy and Images

@melliekr: pp. 94, 147 (top right), 182 (bottom right), 210, 214 (top left), 227 (left), 233 (top left), 233 (bottom right)

@nomnom_boston: pp. 197, 226 (bottom left)

@sdamiani: pp. 24 (top left and bottom left), 37 (bottom image), 164 (top right), 238 (bottom left) 229 (bottom left)

@skaufman4050: pp. 67 (top right), 71 (top left), 212 (bottom right)

@ss0522: pp. 67 (top left), 122 (bottom left), 162 (bottom left), 178 (bottom left)

@_tamarapeterson: cover

@themichellekunz p. 238
@thenameistesa: pp. 15, 154 (top right), 167 (top right and bottom left), 191 (top left)
@tom.white: pp. 61 (bottom), 96 (bottom), 140, 188, 191 (bottom left and top right)
@_wanderlustandwhiskey: pp. 68 (bottom left), 207 (bottom right), 212 (top left), 226 (bottom right), 227 (right), 228 (bottom left and right), 229 (top left), 245 (top right)
@yorkavanue_: pp. 58, 186 (except top right), 191 (bottom right), 192 (top right and left), 206

Whitney Brown, **@billetrouge**, is a personal stylist-turned-photographer living in the San Francisco Bay area.

Chloe Chung, **@chloejg**, is a New York-based photographer.

Jackie Clair, **@yorkavenue_**, is editor and founder of interior design, photography, and lifestyle blog York Avenue. She is based in the Upper East Side of New York.

Svete Damiani, **@sdamiani**, is a food and travel Instagrammer based in Boston.

Paula Flynn, **@the_shopkeepers**, is founder of the award-winning blog The Shopkeepers, which celebrates independent shops from all over the world.

Olena Hassell, **@mangelka**, is mum to two little girls, as well as being a photographer and content creator. More of her work can be found at www.olenahassell.com and on Instagram.

Shelley Hoh, **@ss0522**, is a New York-based Instagrammer who shares beautiful lifestyle and travel content on her feed.

Susan Kaufman, **@skaufman4050**, is a native New Yorker, former fashion editor at Condé Nast Publications, and the founding editor of *People StyleWatch* magazine. She has always been attracted to architecture,

homes, and interiors with old-world charm. Susan follows one simple rule: if her pictures can't be hashtagged #socharming, they won't make it into her feed. Being able to share her vision and love of New York City with people around the world is why she's so passionate about Instagram.

Georgianna Lane, **@georgiannalane**, is a bestselling author and photographer of a number of travel and floral books, including *New York in Bloom*, *Paris in Bloom*, and *London in Bloom*. More of her work can be found on her website www.georgiannalan.com.

Melissa Male, **@melissamale**, is a New York-based content creator and social media manager.

@melliekr is a New York-based photographer.

Brayan Mess was born in Medellin, Colombia, and raised in Boston. Brayan fell in love with photographing the beauty in the world after discovering a little app called Instagram. Follow along on his journey **@brayanmess**.

Naz, **@helloiamnaz**, is a weekend photographer based in Brooklyn. His main focuses are travel, food, and lifestyle, and he also works as a creative director at an ad agency.

Andrea Nunez, **@andreannu**, a former New York local, is currently based in Miami.

Dianne Pavletich, **@diannnnneee**, is a full-time teacher and part-time lifestyle photographer from New York. When she's not teaching, you'll find her hopping on a plane to her next destination – making strides toward her goal of visiting all seven continents by the age of 40.

Tamara Peterson, **@_tamarapeterson** is a New York based photographer who is famous for utilising her iPhone to effortlessly blend cityscapes, travel, food, and intimate lifestyle scenes into one feed.

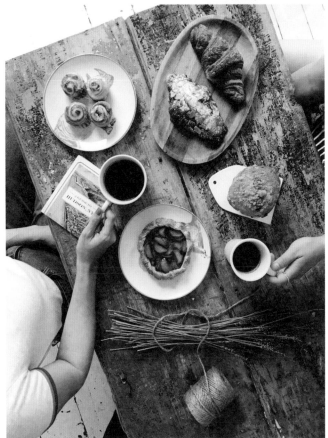

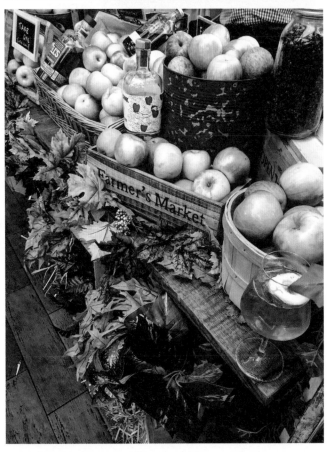

Jessica Pineda, @_wanderlustandwhiskey, shares beautiful photos of her travels on her Instagram feed. Formerly based in New York, she now lives just outside London.

Davina Tan, @heydavina, is a content creator and iPhoneographer currently living in New York City. She shares her Brooklyn home with her Instagram husband @helloiamnaz and their Shiba Inu fur baby, Miso Honi. In her spare time, she photographs NYC's façades, interiors, cafes, restaurants, and the occasional caffeine- or booze-fueled brunch. If she's not doing that, she's probably off on an adventure somewhere around the world ...

Tesa, @thenamestesa, is a digital content creator based in New York.

Joe Thomas, @joethomas, is a travel and urban landscape photographer based in New York City. With a passion for exploration, curiosity has led him to create work across all seven continents. His clients have ranged from non-profits to luxury hotels in Asia, Europe, and North America. Joe's work is marked by his ability to capture details that show new perspectives of both lesser-known and iconic locations. His work has been recognized in publications such as the *Washington Post*, *Boston Globe*, and *Suitcase Magazine*.

Madeline Tsang, @maddietsang, is a New York City-based lifestyle photographer and visual content creator currently balancing her creative ventures with her profession in healthcare. As well as Instagram, you can find her work at www.maddietsang.com.

Mendy Waits has been making travel and lifestyle content for social media for the past five years. She is primarily a photographer who focuses on detailed editing and real-life composition rather than a flawless styling narrative. When she's not taking care of her kids, or taking care of her photos, Mendy's current focus is consulting with small businesses and brands to develop their social media strategy for organic and meaningful growth. You can find her personal Instagram account @angrybaker, and she also manages and curates the @prettycitiesnewyork account. For more information you can check www.angrybaker.co.

Tom White, **@tom.white**, is a New York-based Instagrammer.

Yusra, **@nomnom_boston**, is a photographer based in Boston.

Street Art:

p.117 Created by Sonny.

p.121 Created by Eduardo Kobra.

p.126 Created by Tristan Eaton.

p.129 Created by Hektad.

p.131 Created by Surface of Beauty.

p.148 Created by Eduardo Kobra.

p.149 Created by B.D. White.

p.151 Created by Shepard Fairey.

p.159 Bottom left Artist unknown.

p.159 Bottom right: Created by Woodz.

ACKNOWLEDGMENTS

Thank you to Noel and my boys, Jack, Charlie, and Louis, for their endless love and patience while I completed this exciting project. Thank you to my mum and dad for their constant ability to drop everything and come to London to mind my boys while I took off to New York for weeks at a time. Thank you to my friends in London for also looking after my boys when I was most stressed and trying to finish the project (especially Sofia, Mihaela and Angeles). Thank you to all the wonderful contributors listed above who submitted their amazing photographs and insights to the city they call home. A special thank you to my best friend Mendy Waits, for guiding me through the city, entertaining me every step of the way, understanding my ethos, and curating the Instagram feed **@prettycitiesnewyork** over the last couple of years.

A very special thank you to Holly Webber, my talented illustrator, for the flawless and indeed speedy interpretation of my brief.

Thank you to all my followers on Instagram and all who have bought my first book *Prettycitylondon: Discovering London's Beautiful Places* and my colouring book too. Thank you to my publisher, The History Press, for your patience and support, and finally to all the wonderful shop owners, florists, hotel managers, baristas, and residents I met on every single visit to New York, who made it extremely easy to gather content for this wonderful book.

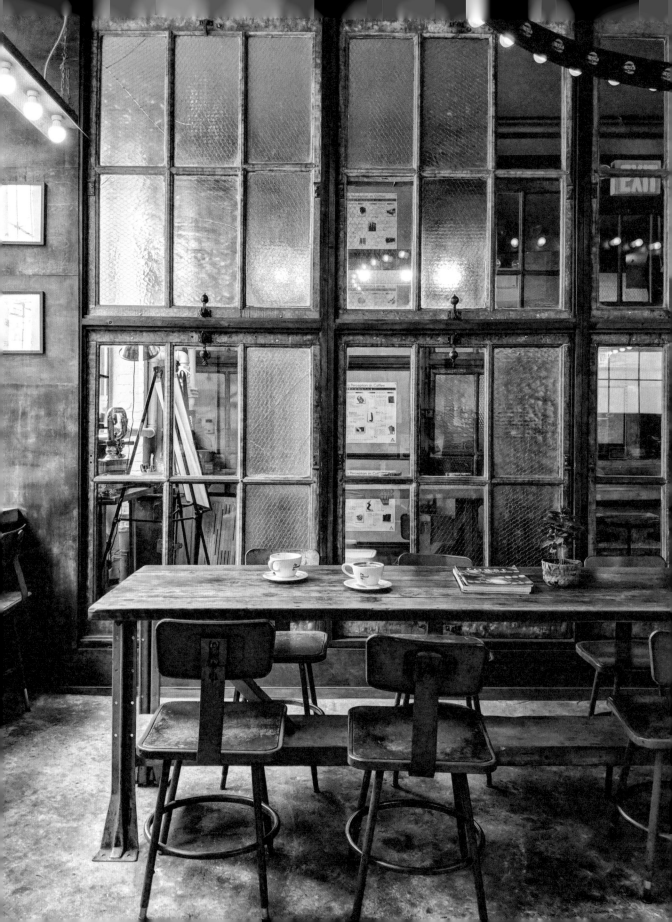